P9-EDA-880

50
OSCAR
NIGHTS

TCM

50 OSCAR NIGHTS

ICONIC STARS & FILMMAKERS ON THEIR CAREER-DEFINING WINS

DAVE KARGER

RUNNING PRESS
PHILADELPHIA

Running Press
Hachette Book Group
1290 Avenue of the Americas, New York, NY 10104
www.runningpress.com
@Running_Press

Printed in China

First Edition: January 2024

Published by Running Press, an imprint of Hachette Book Group, Inc.
The Running Press name and logo are trademarks of Hachette Book Group, Inc.

The Hachette Speakers Bureau provides a wide range of authors for speaking events. To find out more, go to www.hachettespeakersbureau.com or email HachetteSpeakers@hbgusa.com.

Running Press books may be purchased in bulk for business, educational, or promotional use. For more information, please contact your local bookseller or the Hachette Book Group Special Markets Department at Special.Markets@hbgusa.com.

The publisher is not responsible for websites (or their content) that are not owned by the publisher.

"OSCAR®," "ACADEMY AWARDS®," and the OSCAR statuette design are registered trademarks, and the OSCAR statuette a copyrighted property, of the Academy of Motion Picture Arts and Sciences, and are used with permission. This book is not affiliated with the Academy.

Print book cover and interior design by Amanda Richmond

Library of Congress Cataloging-in-Publication Data

Names: Karger, Dave, author.
Title: 50 Oscar nights: iconic stars & filmmakers on their career-defining wins / Dave Karger.
Other titles: Fifty Oscar nights
Description: First edition. | Philadelphia: Running Press, 2024. |
Includes index. | Summary: "Dave Karger—Turner Classic Movies on-air host, entertainment media darling, and the Oscars expert—offers a one-of-a-kind collection of original interviews with an A-list lineup of Oscar winners discussing the highs, lows, and never-before-told tales of Hollywood's most storied awards show"—Provided by publisher.
Identifiers: LCCN 2023004488 (print) | LCCN 2023004489 (ebook) | ISBN 9780762486328 (hardcover) | ISBN 9780762486335 (ebook)
Subjects: LCSH: Motion picture actors and actresses—Interviews. | Motion picture producers and directors—Interviews. | Film composers—Interviews. | Screenwriters—Interviews. | Motion picture art directors—Interviews. | Costume designers—Interviews. | Award winners—Interviews. | Academy Awards (Motion pictures)—History.
Classification: LCC PN1998.2 .K38 2024 (print) | LCC PN1998.2 (ebook) | DDC 791.43079—dc23/eng/20230413
LC record available at https://lccn.loc.gov/2023004488
LC ebook record available at https://lccn.loc.gov/2023004489

ISBNs: 978-0-7624-8632-8 (hardcover); 978-0-7624-8633-5 (ebook)

APS

10 9 8 7 6 5 4 3 2 1

To Terry,
who loves movies
as much as I do

CONTENTS

INTRODUCTION

My obsession with the Oscars began in 1985, when I first happened upon the ceremony on television as an eleven year-old. I remember seeing Haing S. Ngor win Best Supporting Actor for *The Killing Fields* and wondering, *Who is this interesting man?* (Years later I would learn more about him.) I also remember witnessing *The Times of Harvey Milk* being announced as the winner of Best Documentary Feature and saying to myself, "There's a man called Milk?" (Again, in the future that name would mean much more to me.) And I remember watching Ann Reinking perform Phil Collins's nominated song "Against All Odds (Take a Look at Me Now)" and thinking, *Why is this other person singing when Phil Collins is right there in the room?* (I've never managed to find out the answer to that one.)

For almost a century, movie fans like me have been fascinated by the Academy Awards and all the legendary stars who have won Oscars. There's a reason it's historically been called "Hollywood's biggest night." For months each year, actors and filmmakers attend festivals and events to campaign for prizes, while prognosticators chart the rise and fall of the likely nominees and winners, all leading up to the much-anticipated gala ceremony. Much has been written about the history of film and the legacy of the Oscars, but I wanted to create a book where the Oscar winners themselves tell the stories of the night they won

their trophies. I wanted to hear how they got ready, how they decided what to say, how they celebrated, and how they feel about their life-changing moment now, years later.

It's been an absolute pleasure tracking down and chatting with the dozens of actors, singers, filmmakers, and craftspeople whose stories fill the pages of this book. The artists featured in these pages cover almost sixty years of Oscar history, ranging from Rita Moreno (Best Supporting Actress, 1962) to Olivia Colman (Best Actress, 2019). As you flip around, you'll learn who Nicole Kidman gave her Oscar to after she won, why Elton John thinks he won his first Best Original Song Oscar for the wrong tune, and which Academy Award winner told Cameron Crowe to sleep with his brand-new Oscar under his pillow (which he did).

I've spent the last twenty-five years studying, writing about, and talking about the Academy Awards, in *Entertainment Weekly*, on the *Today* show and Turner Classic Movies, and on the red carpet itself. And the Oscars have certainly had their ups and downs as a cultural event, but there's no denying that winning an Academy Award remains the pinnacle of achievement for anyone pursuing a career in film. Still, writing this book has made me look at Hollywood's biggest night a bit differently. I now understand that not every winner experiences the moment in the same way. For some honorees, such as Julia Roberts, John Legend, and Octavia Spencer, the day remains a life highlight to be treasured. But for others, such as Marlee Matlin, Mira Sorvino, and Barry Jenkins, it can cause complex emotions that cloud what most people think would be a truly celebratory moment. I hope you find these fifty stories as entertaining and enlightening as I did. And I hope they add to your viewing experience the next time you sit down to watch Hollywood's biggest night.

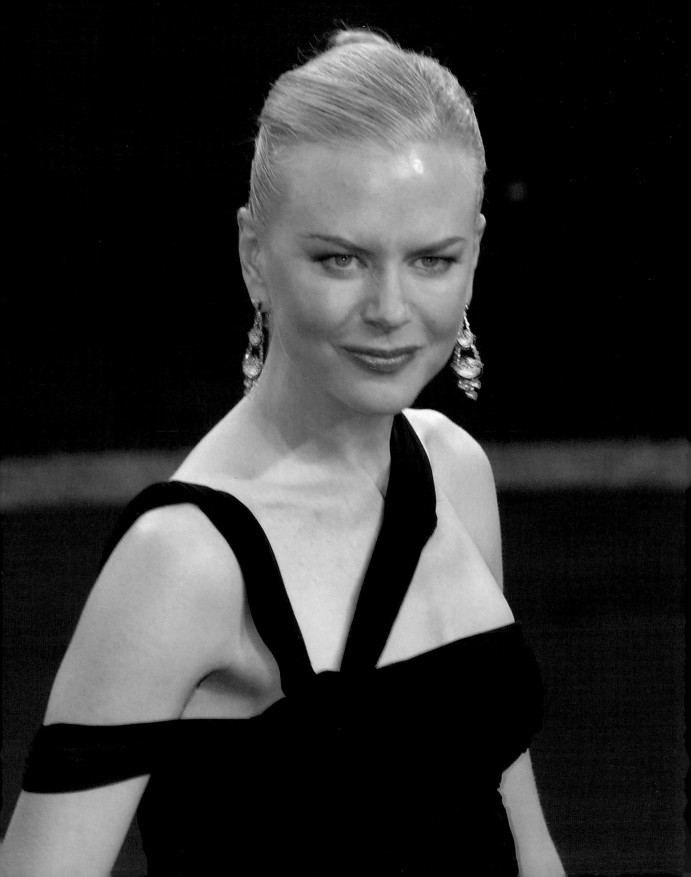

NICOLE KIDMAN
BEST ACTRESS
The Hours
2003

"Why do you come to the Academy Awards when the world is in such turmoil? Because art is important."

For Nicole Kidman, the 2003 Academy Awards ceremony was filled with conflicting emotions. She was at the peak of her profession, having earned back-to-back Best Actress nominations for *Moulin Rouge!* and *The Hours*, but her personal life was in disarray—she had recently finalized her divorce from Tom Cruise and hadn't yet met her future husband, Keith Urban. And the newly begun Iraq War stifled much of the celebratory atmosphere of the awards—event organizers even decided to do away with the red carpet that year. Still, Kidman's indelible performance as novelist Virginia Woolf, alongside performances by Julianne Moore and Meryl Streep in Stephen Daldry's time-hopping literary triptych, won her the Oscar, which she accepted in an understated deep-navy Jean-Paul Gaultier gown. Actually, she almost *didn't* accept the award: After beginning her speech, she broke down and needed a moment to compose herself before delivering the rest, and the orchestra eventually ended up playing her off before she could finish.

THE ATMOSPHERE

There was a war that year. So it was a different time and place than the year before. That gave the whole ceremony and the whole awards time a much different feel. You have to have a sense of what's going on in the world.

At the same time, there's an enormous amount of people that have put their life's work into what you're doing. We want that celebration. This is something that you hold in your hand and go, "This is a lifetime of blood, sweat, and tears, commitment, sacrifice." There are so

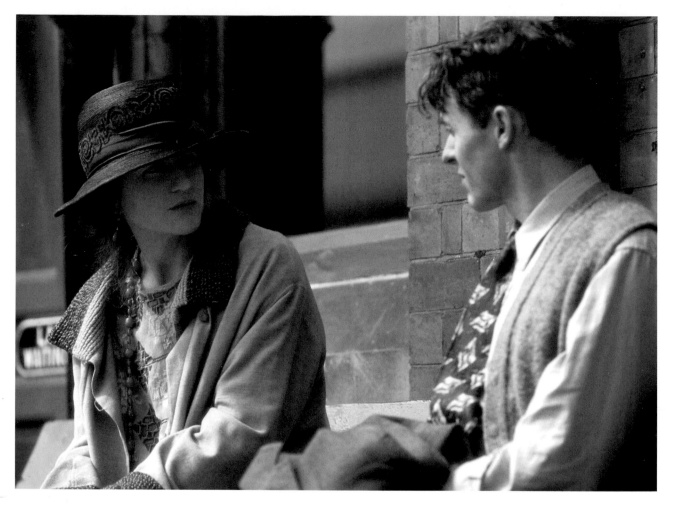

Kidman opposite Stephen Dillane in *The Hours*

many things that it represents. And I was also struggling with things in my personal life, yet my professional life was going so well. That's what happens, right?

THE LOOK

It was dignified; it was not garish. And it allowed me as a *woman* to be seen, not me as a movie star, if that makes sense. There's a time and a place when you go, "I'm going to wear something extravagant and extraordinary." And then there are other times where you go, "I actually want to be seen: I as myself and as an artist, I want to be seen now. I don't want to be overshadowed by something else."

THE SPEECH

I vaguely remember getting emotional and turning around and then going, *Get your act together and turn back. What are you doing?*

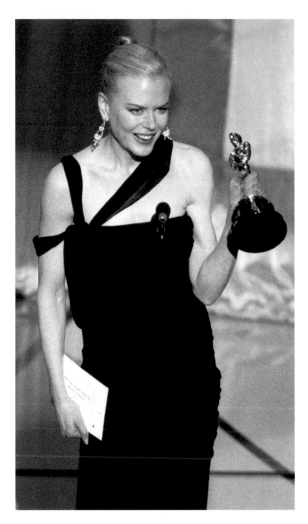

helped make my performance—I didn't get to thank him in the speech. So I'm thanking him now in your book. He's one of the great British actors of all time.

THE CELEBRATION

I'm not a big party girl, so I was going to skip the *Vanity Fair* party, and everyone was like, "You've got to go. You've got to walk through the party carrying your Academy Award." I said, "That just feels like gloating, and it doesn't feel humble." Like, *what?* You can't walk through carrying the award! That feels really inappropriate. They're like, "That's what you do." So I literally walked in, carried it around, was completely overwhelmed, emotional, shaking, and I didn't enjoy it. I was almost apologetic, which is so stupid. I wish I could have enjoyed it more. I went home and ended up ordering takeout and eating it on the floor of the Beverly Hills Hotel. I sat on the floor of the hotel eating French fries and a burger with my family and went to bed. That's when it hit me. I went, *I need to find my love; I need a love in my life.* Because this is supposed to be when you go, "This is ours." I shared it with my mom and dad, but it's a different thing than with the partner that has been there through all of it. I went to bed alone; I was in bed before midnight. If I ever won again, I'm telling you, I'd be out for twenty-four hours.

You'll be given the sign to get off and you won't have even pulled yourself together. I forgot to thank my father. But you're sort of drowned out and that's it. But this is so my father: I came off stage and I was like, "Oh, Papa!" He's like, "Nicky, this is unconditional love. Thanking me on the stage? What are you talking about?" He didn't even bat an eyelid about it. So that's what I come from and that's what I would always offer to anybody in those situations. And also Stephen Dillane, who really

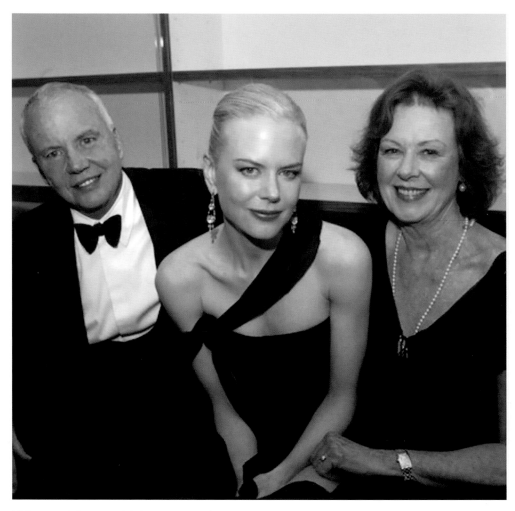

Kidman celebrates with her parents, Antony and Janelle.

THE PERSPECTIVE

I was so happy to be in a film with the women that I was in that film with. I hugged Julianne and I said, "This will be yours. You'll see. Just wait, because you so deserve it and it will happen." I'm just grateful that I was given the role and able to play Virginia Woolf, because the crux of that whole performance for me is that every human being's right is the choice to determine what they want to do with their life. And that will always be one of the most important things that I stand for.

I gave it to my mother. I wanted her to have it on her mantel. And then she subsequently said, "I'm clearing everything out of my house; I want you to have it back." So it's now with my husband's Grammys. It sits surrounded by a lot of Grammys. But it's the princess in the middle of it.

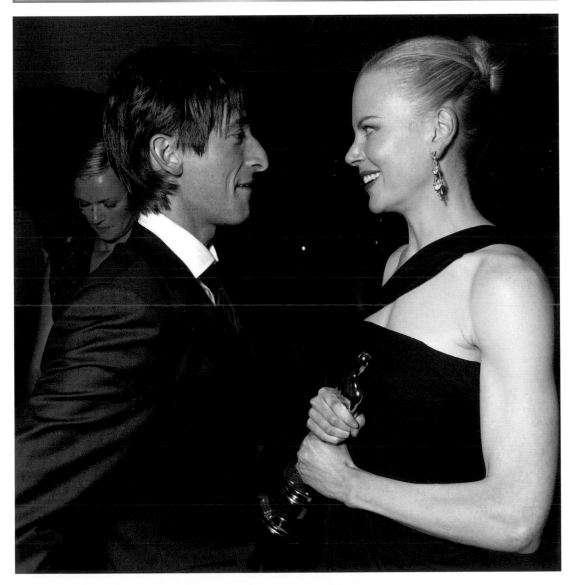

Kidman with Best Actor winner Adrien Brody at the *Vanity Fair* party

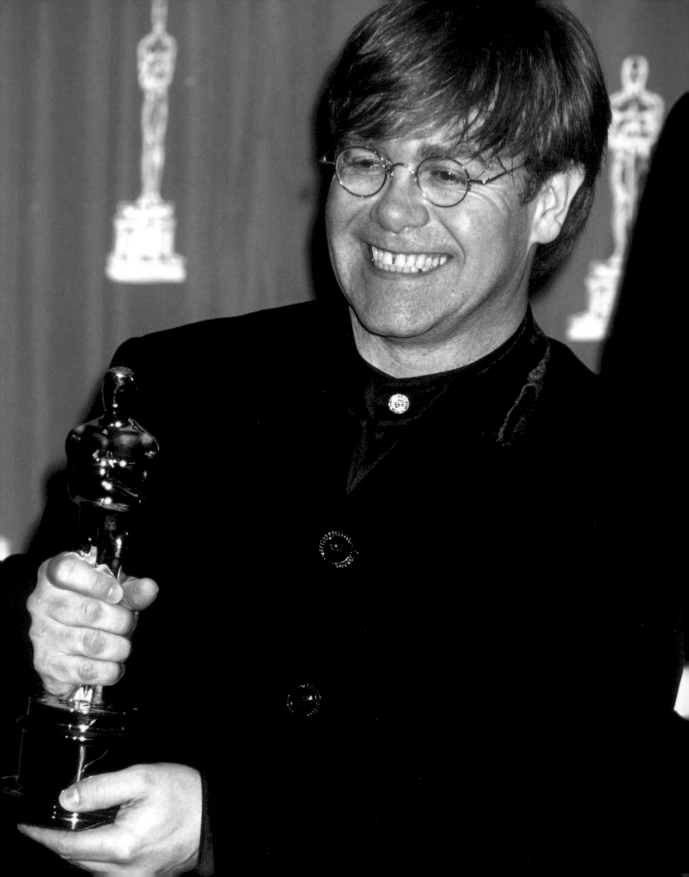

ELTON JOHN
BEST ORIGINAL SONG
The Lion King
1995

"I'd like to dedicate this award to my grandmother Ivy Sewell.
She died last week. And she was the one that sat me down
at the piano when I was three and made me play.
So I'm accepting this in her honor."

Thanks to his annual Oscar-night gala, which benefits the Elton John AIDS Foundation, singer-songwriter Elton John has become iconic to the Academy Awards. In 1995, he found himself an instant triple nominee when he and his *Lion King* collaborator, Tim Rice, received three of that year's five Best Original Song nominations, for "Circle of Life," "Hakuna Matata," and the eventual winner, the lush ballad "Can You Feel the Love Tonight," which reached number four on the *Billboard* charts and also won Sir Elton a Grammy Award for Best Male Pop Vocal Performance. Twenty-five years later, he would win a second Academy Award alongside his longtime lyricist Bernie Taupin for their *Rocketman* theme, "(I'm Gonna) Love Me Again."

THE BACKSTORY

The Oscars epitomized to me Hollywood glamour, and the statuette was the best statuette. If you're going to win something, win an Oscar, right? But I never in my whole life envisioned winning an Oscar. Why would I? I never thought in a million years when I used to go to the cinema as a young kid to see things like *Picnic* and *Doctor Zhivago* that I would ever be involved in Hollywood. I never thought I would do any film work like that.

THE PRODUCTION

It was Tim Rice who asked me to do it. He's an old friend of mine. He called me up and said, "I want you to do *The Lion King* with me.

Disney says you won't do it." I said, "Well, what's it about?" and he explained it. I said, "Of course I'll do it!" I owe Tim Rice a big favor. It was the first time I'd ever done anything like that, so it was really fun. I remember writing "Circle of Life" because I really thought it was great. "Hakuna Matata," I was just in hysterics because it starts off with "When I was a young warthog..." I thought, *It's come to this—I'm singing about fucking warthogs.* We just laughed and laughed and laughed while we were writing it. It was a really joyous process and one that I really loved. And I have to say, Jeffrey Katzenberg and everyone at Disney was really supportive. When I saw it about a month before it was going to be released, "Can You Feel the Love Tonight" wasn't in the film. I said, "Jeffrey, where's the love song? Every Disney film needs a love song." And to his credit, he reinstated it. It would've been terrible not to have had that song in it. I couldn't believe the quality of the movie. It was just a perfect movie. It really took my career in another direction, which I'm really grateful for. It changed my whole career.

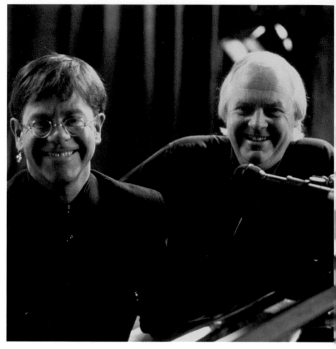
Sir Elton and collaborator Tim Rice

THE BIG DAY

It was nerve-racking to be there. People said, "Well, you could cancel yourself out and something else could win." I didn't sit in the audience. We just sat all afternoon in this Winnebago watching people arrive and it seemed an eternity to happen. But it was so exciting. I mean, come on. I'm a young kid from England who was forty-six at that time. The idea of being nominated for an Oscar was just so thrilling. Everyone was expecting us to win—that makes it awful. You think, *Supposing we don't win, we're going to be a failure.* And then when we did win it, I was so happy. It was magical to me.

THE SPEECH

I remember dedicating it to my grandmother, who had just passed away. My grandmother was kind of the linchpin of my life. She was the person that I went to if I was in trouble. Later in her life, she came to live with me. I was born in her house, and she died in my house. She was my angel; she was my rock.

I wish she could have seen it. And I thanked "my friends in Utah"—that was Jeffrey and his wife, Marilyn. I've never said that before. They were in Park City. By the time the film came out, Jeffrey had left Disney. I didn't want to ruffle any feathers at Disney.

THE CELEBRATION

I know we went through the Governors Ball as a point of respect and politeness. But I had to go back to my own AIDS Foundation party at the Four Seasons. I walked in with the Oscar and everyone went nuts. I was just grinning like a Cheshire Cat for about two weeks. I was on tour with Billy Joel, and I was playing in Toronto the next day. I came out with the Oscar in my hand. That's how much it meant to me.

THE PERSPECTIVE

I'm not going to make a fuss, obviously, but I honestly think the wrong song won. I think "Circle of Life" embodies *The Lion King*—it starts with it, it ends with it. That's the song that should have won it. I always say life is full

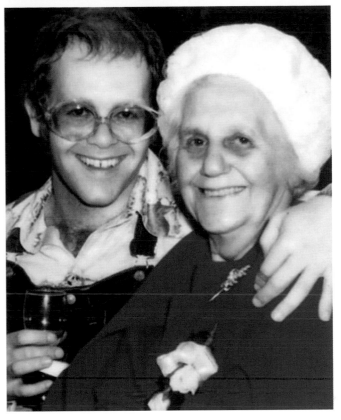

Sir Elton with his beloved grandmother, Ivy Sewell

of surprises. That one phone call from Tim changed my life and changed my career. The two things I've won Oscars for, one was *The Lion King*, which is something I'm so proud of, and the other is *Rocketman*, the film about my life. So I've been really lucky. You never know, there might be a third one. I doubt it, but you never know.

── WHERE THE OSCARS LIVE NOW ──

They're on the first floor of my house in Windsor. There are two shelves with all my Ivor Novello songwriting awards, Golden Globes, Tony, and the two Oscars. You would never notice them; it's not flaunted in any way. I don't consider the Grammys to be an award—I couldn't care less about those. And they look awful as well. They're cheap.

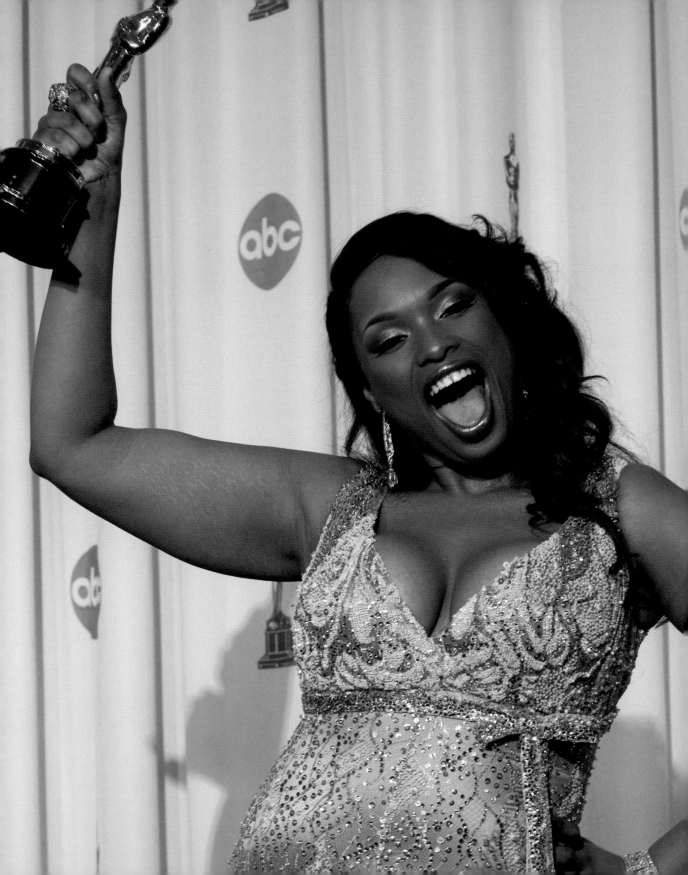

JENNIFER HUDSON
BEST SUPPORTING ACTRESS
Dreamgirls
2007

**"I thank you all for helping me keep
the faith even when I didn't believe."**

Jennifer Hudson's rise from obscurity to Academy Award winner is simply one of the most dramatic and satisfying stories in entertainment history. An immediate standout on *American Idol* in 2005, she was eliminated shockingly early, placing only seventh for the season. But director Bill Condon saw her potential and cast her in the pivotal role of the unfairly treated singer Effie White opposite Beyoncé in his adaptation of the Broadway musical *Dreamgirls*. Hudson's electrifying performance led to an awards-season sweep and the beginning of her eventual EGOT (Emmy, Grammy, Oscar, and Tony) collection, making her the youngest woman ever to achieve that feat. In her speech, Hudson paid tribute to her grandmother, who she said "was a singer, and she had the passion for it, but she never had the chance. And that was the thing that pushed me forward to continue."

THE BACKSTORY

It sounds so harsh, but I wasn't too familiar with the Oscars because my dream was to be a singer and win Grammys. So even down to the night of being there, I remember Jamie Foxx saying, "The craziest thing is she has no clue to what is going on." I was experiencing it as I went along.

THE PRODUCTION

After *American Idol*, it was kind of like starting over. I had a production deal and I was just recording music. As long as I was singing, I was happy, you know? I knew, as long as I have my voice, then I have what it takes to get to wherever I want to go. People would say, "Jennifer Hudson for Effie White." And I'm like, "Who is

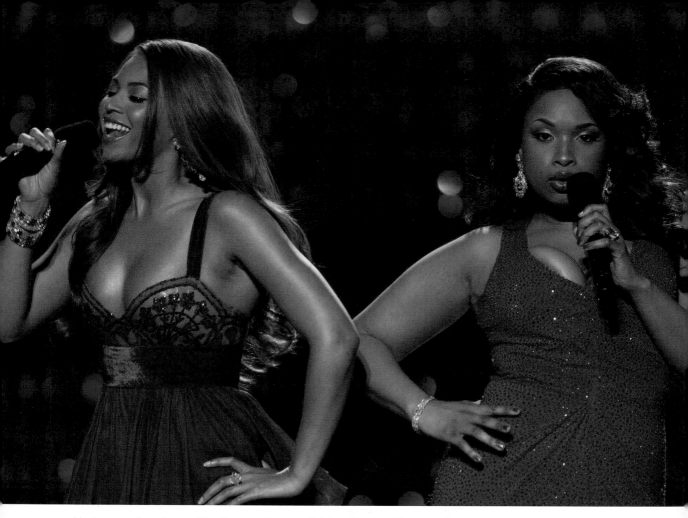

Hudson performing on the Oscars telecast with her *Dreamgirls* costar Beyoncé

Effie White?" I knew "And I Am Telling You I'm Not Going" and "I Am Changing," but I didn't know who the character was. I recall Bill saying, "You're the one who made me feel something in your audition." And that's what made the difference, you know? I didn't know what it would lead to or what the awards were for film or any of that. It was my first film project—I just wanted to get my lines right. But looking back, I think it's best that I wasn't aware, because if you know the pressures, it can freak you out, and then you become too nervous, and you can't be your best. So I think it was good that I was kind of ignorant to all of it.

THE LOOK

I wore Oscar de la Renta. André Leon Talley orchestrated the whole thing and put it together for me. It reminded me of one of my Easter dresses that I had as a kid. And it was kind of my prom colors because I wore brown and cream to my prom.

THE WINNING MOMENT

I remember my mom being too shy to want to sit in the front, so she sat far in the back with my ex-boyfriend James. Because my mom didn't want to sit in on-camera seats, I'm like, "Well, Bill Condon—I want him to be right there because he's the man who gave me this opportunity. I want to share that moment with him." And he should have been nominated. I remember freaking out because public speaking is a huge fear of mine. I know it's crazy. When they called my name, I'm like, *Don't get up because nobody heard that but you.* And then I looked up, and everybody is looking at me, and I'm like, *Oh, they called me for real? Oh, wow.*

THE SPEECH

I always connect everything to my grandmother because that's where I get my voice from. My family always says, "She sounds like Julia Kate." I'm Jenny Kate; she was Julia Kate. And they say that I inherited her voice. She always used to say she didn't want to be famous because you would have to sing even when you didn't feel like it. So I feel like it's my calling because she didn't complete it. If my grandmama could see me now, she would

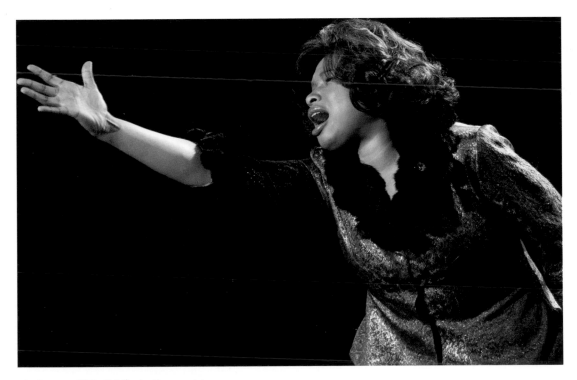

Hudson as Effie White in *Dreamgirls*

say, "Look what God can do." So any time I have to perform and I'm tired and I don't feel like it, I'll be like, "My grandmama used to say, 'You got to perform even when you don't feel like it.'"

THE CELEBRATION

We went to all the afterparties: the Governors Ball, the *Vanity Fair* party. I remember Beyoncé being a little emotional. I think she teared up a little bit. It was like watching her little sister win. And then I remember getting back home and putting my Oscar on the nightstand, and it didn't seem real. I went to sleep and woke up, and I'm like, *It's still here; I'm not dreaming.* I still have moments like that. Like, when something seems so much like a dream, I have to look around quite a bit to be like, *How I can tell if this is really reality or if I'm dreaming?* So leaving that right there

on the nightstand and waking up the next day and it was still there was confirmation: No, this really, really happened.

THE PERSPECTIVE

It made me feel a part of something—the Academy. It's been something that has made me want to raise my game and make them proud. In all my work, I want to be a great representation of the Academy, of Oscar winners, and all the people I'm in the company of. They saw things in me that maybe I didn't necessarily see myself. I was walking into a new space. Bill Condon believed in me, to give me such an opportunity. And I always say, "If you give me the opportunity, I'm going to make it work." Sometimes people dream up dreams for you. Everyone started saying it: "Oh, she could be like Barbra Streisand and win the EGOT." And I'm like, "Oh, now what's that?"

WHERE OSCAR LIVES NOW

I have an award wall in my house in Chicago, and I always said I would never reveal it until it was complete with the EGOT. So now it's officially complete, and so I may reveal it. All around it is the Golden Globe and the BAFTA [British Academy Film and Television Arts] and the Critics Choice and the Grammys. And the Oscar sits in the middle.

Hudson and *Dreamgirls* director Bill Condon

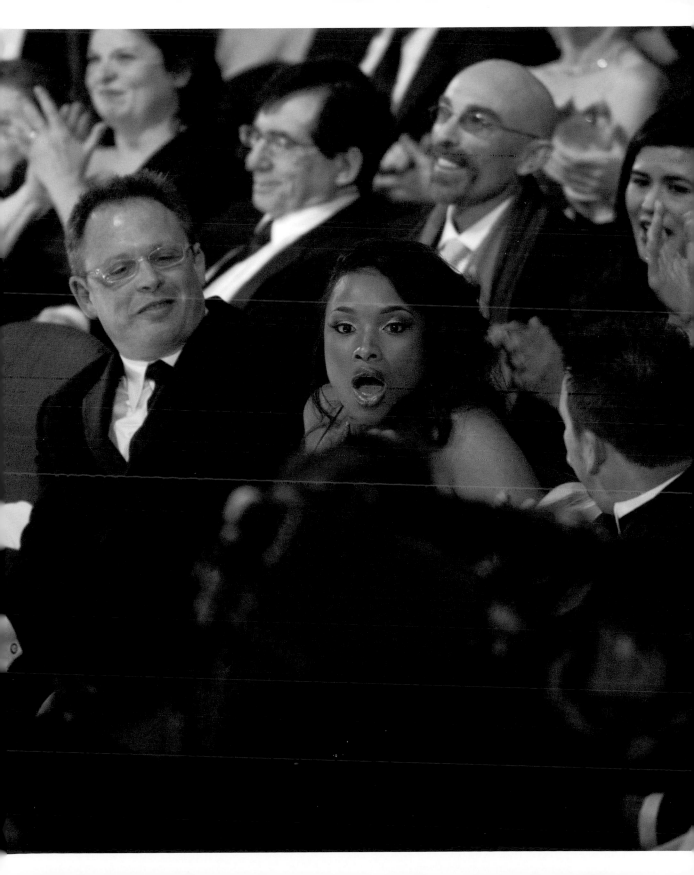

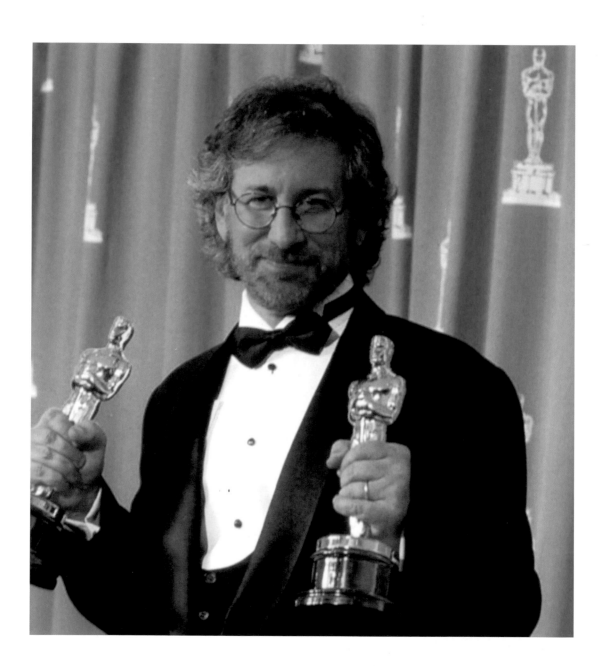

STEVEN SPIELBERG
BEST PICTURE
AND BEST DIRECTOR
Schindler's List
1994

**"This is the best drink of water
after the longest drought in my life!"**

Between 1976 and 1990, Steven Spielberg's films (including *Jaws, Close Encounters of the Third Kind*, *E.T.*, and the first three Indiana Jones movies) won a total of fourteen Oscars. But despite five prior nominations of his own—three for Best Director and two for Best Picture—and an honorary award in 1987, Spielberg himself never won a competitive Academy Award until his dual victories in those categories for his instant classic *Schindler's List*. In his Best Director acceptance speech, he revealed he had never even held an Oscar and then paid tribute to his wife, Kate Capshaw, and mother, Leah Adler. When he took the stage again to accept the award for Best Picture, he implored educators to continue teaching the Holocaust. Five years later, he would pick up his third Academy Award for directing *Saving Private Ryan*.

THE BACKSTORY

When I was a kid, the Oscars meant a chance to see the movie stars on television. You had to go to pay money to see the movie stars in movie theaters. But you got to see them for free during the Oscars. That's really all it meant to me at that time. [Winning one] was the farthest thing from my mind.

THE LOSSES

I just sort of came to terms with it with two philosophies. One: Always a bridesmaid, never the bride. And two: Well, Hitchcock never won, so what's wrong with not winning? That lasted for a good decade, until I had this overwhelming feeling of really wanting to take home an Academy Award. And yet that desire never

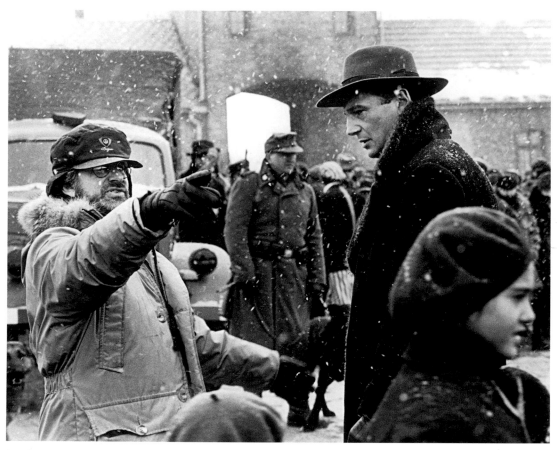
Spielberg on the *Schindler's List* set with star Liam Neeson

really motivated the choices I made as a movie director in choosing my material.

THE BIG DAY

I was really accustomed to not winning an Academy Award. And what scared me about *Schindler's List* was the number of people who told me that this was my year, that there was no way I was not going to win the Academy Award. And the more people who told me *Schindler's List* was going to win all the awards, the more doubt was sown. I just

thought, well, in a movie, when a character speaks with certainty, the opposite always happens. So the closer I came to that March date in 1994, the more I convinced myself that I was actually not going to win that night for *Schindler's List*. There were just too many people telling me that I was going to.

THE WINNING MOMENT

We had won five Academy Awards before Best Director was announced. So there was a great feeling among our nominees that it

was turning into a great night. And yet I still didn't expect to hear my name. I actually had expected to hear Jane Campion's name. [Clint Eastwood] opened the envelope, looked at the card, and the first thing he said was "Big surprise." And I didn't remember somebody named Big Surprise on the nominees list. So my first reaction was, *Who is Big Surprise?* And then I got it. I leaned over and kissed my wife. I looked over at my mom, who was there, and she had tears in her eyes and threw her head back and started laughing and crying. It was just a blur.

THE THANK-YOUS

Michael and Julia Phillips were my producers on *Close Encounters of the Third Kind.* When Michael and Julia won Best Picture for *The Sting,* they had a big party at their house. Julia came over to me, and she said, "You want to hold it?" And at that moment I felt, *No, I better not, because if I ever get one of these someday, I want to be able to see what it feels like on the day, in the moment, and not at a party.* So that began a long tradition of a lot of my friends winning and offering me, "Hey, you want to hold this thing?" And I'd always say, "Someday, but not today." [My wife, Kate,] brought humanity and civilization into my life when I returned to where we were staying [during filming] in Krakow, Poland. She basically created a comfort space. She took my mind off of tomorrow's work. I always have looked at my mom as a lucky charm. She had this wonderful way about her, of sitting across a small table and just taking my hands in her hands and leaning way forward and almost in a whisper she would tell me the truth about something. And it always brought me luck.

THE CELEBRATION

We won ten Oscars that night between *Schindler's List* and *Jurassic Park.* The subject matter took a backseat to how happy everybody was and how much everybody wanted to go from party to party to celebrate. And also, two of my closest friends won Oscars that night, Tom Hanks and Bruce Springsteen, so we basically all celebrated together. We went to all the parties as three families who had all won their first Oscars at the same time. Just partied down almost until dawn. Kate and I went home. I'm embarrassed to say what I did with the trophies, but I'll tell you what I did with the trophies. I tried to put them on the pillow between me and Kate. And Kate said, "Those two Oscars are not getting between us." So then I put them on the mantelpiece in the bedroom.

THE PERSPECTIVE

They actually mean more to me now than they ever meant to me then. Because in the whole fog of everything leading up to Oscar night,

you build up a lot of defenses. I certainly built up a lot of defenses just to protect myself in case it didn't happen. Those two wins garnered much more meaning in the following years. It is the rarest honor and the highest honor any of us could imagine achieving in this motion picture industry. Just to be in the company of some of the directors who inspired me to want to become one. My principal reason for making *Schindler's List* was to raise awareness of the six million murdered and the genocides that followed the Shoah: Rwanda, Sarajevo, Cambodia, Armenia. My goal was to try to get tolerance education taught as part of the high school social-science courses in public schools across the entire country. There's always been a sine wave to antisemitism. It peaks and then it fades, but never fades away. And then it returns. It's been that way for thousands of years.

WHERE THE OSCARS LIVE NOW

They're sitting on the mantelpiece above a fireplace in my home office. There's three of them. And then right below them is the Life Achievement Award from the American Film Institute. Those are the only awards I have at home. The rest of my honors are at the office at Amblin on the Universal Studios lot. But those are the only honors that I have at home.

Spielberg with his mother, Leah Adler, and wife, Kate Capshaw

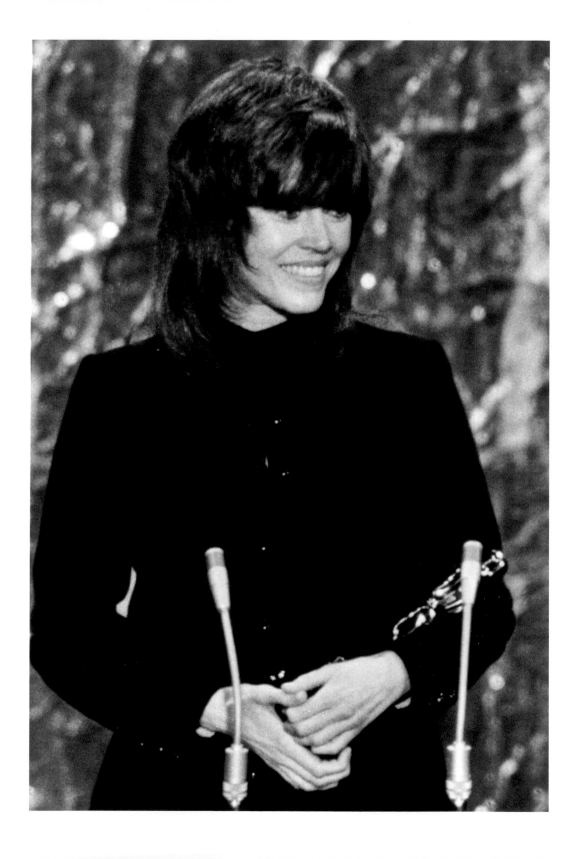

JANE FONDA
BEST ACTRESS
Klute
1972

**"There's a great deal to say
and I'm not going to say it tonight."**

Jane Fonda has long been a controversial presence in Hollywood, largely because of her liberal political activism. But the industry could never ignore her undeniable talent. Her vulnerable performance as headstrong call girl Bree Daniels opposite Donald Sutherland in *Klute* won Fonda the first of her two Best Actress Oscars (the second came in 1979 for *Coming Home*), and she famously decided not to address any political issues in her acceptance speech. Her victory meant that she earned an Academy Award before her legendary father, Henry Fonda, who eventually received an honorary Oscar in 1981 and the Best Actor prize for *On Golden Pond* in 1982.

THE BACKSTORY

My father, who I adored, was very opposed to the concept of awards. The idea of actors competing against each other—he would just say, "It makes no sense." He was nominated a few times; he never campaigned. He was completely opposed to the idea of campaigning. So I never thought about the Oscars. It wasn't part of my awareness.

THE PRODUCTION

I'd never played anybody like Bree. My focus was: How do I play this character that was so very different from any world that I ever knew? So I asked Alan Pakula, our director, to arrange for me to spend a week prior to the beginning of rehearsals with call girls and madams. One of the things that struck me about those women that I spent time with

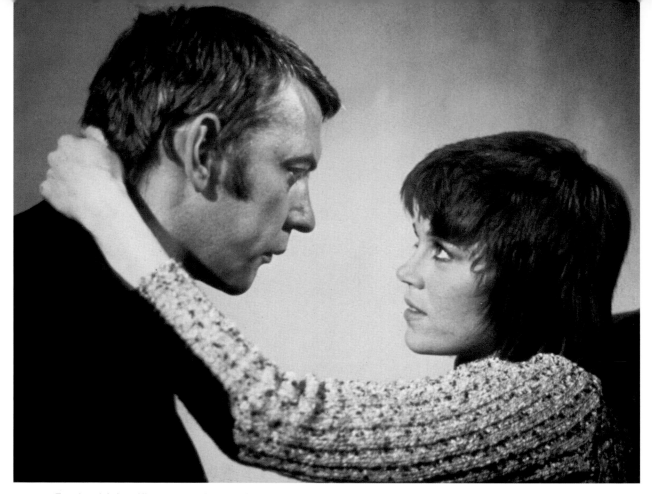

Fonda with her *Klute* costar Donald Sutherland

was their souls seemed to be dead. Their eyes were dead. I remember one of them went to get cocaine—she went to a dealer. I went with her, and I saw him pour it out on the table and measure it. I'd never seen anybody do cocaine before. I saw her cutting lines and sniffing them into her nose with the rolled-up piece of paper. This was all new to me, and it seemed very frightening. It was like, *Oh my God, what is this?* When I had finished that week, I asked to meet with Alan Pakula and I said, "Alan, I just don't think I can do this. Please let me out of my contract. I'm just too middle class. Faye Dunaway should do this." And he burst out laughing and he said, "No, I'm not going to let you out of the contract. You're going to do this and you're going to be great." I had become an activist, and in some ways that part of my life was more important to me. It was the first film that I made where they would say, "Cut," and I'd go to the phone and start trying to raise money to bail out political prisoners that were Black Panthers. There were numerous things that I was working on as a privileged actress.

That was where my heart was. Alan was very worried. He said publicly how concerned he was because I would spend so much time on the phone. There was so much hostility on the set of *Klute*. I would come to work in the morning and the American flag would be hung upside down. There was a lot of hostility from the crew. I was being accused of being a communist, that I was unpatriotic. There was a tremendous amount of hostility because I was supporting Black people's movements that were considered very radical.

THE CAMPAIGN

When we finished the movie, I hit the road to raise money for what became the Winter Soldier investigation all over the country. I spoke on campuses, I was paid $2,000 a speech, and the money went to fund the Winter Soldier investigation. I hadn't seen the movie. I wasn't even thinking about it. As the time for the Oscars approached, I really wasn't in Hollywood; I was out in the country raising money and not paying attention at all. I could hear people saying, "You'll probably win the Oscar." And I didn't think anything of it.

THE LOOK

I thought, *I don't want to wear a fancy dress.* I decided to wear a black wool suit with a Mao collar. It was a very nice suit—it was

a Saint Laurent suit. I said, "What I have on, along with what I'm going to say, will send a message."

THE SPEECH

I thought, *Yeah, I'm probably going to win.* I didn't know what to do, because the Vietnam War was still raging, and I was very much involved in trying to end that war. And if I win, am I going to talk about the Vietnam War? And what do I say in a short amount of time? I wasn't sure. I asked my dad, and he said, "Just say, 'There's a lot to be said tonight, but this isn't the time.'" That kind of satisfied my need to let people know: I'm thinking of other things besides this. There are things that are way more important going on. But I'm not going to bring that up tonight. And thank you.

THE AFTERMATH

I had the flu—I was really sick. I had a temperature of 102. I remember thanking the people who voted for me and saying exactly what my father told me to say. And then I walked off the stage, and I went in a corner backstage and cried. I was crying because of relief, because I said what I had to say, and I'd gotten off the stage, and nobody had booed. But I also cried because my dad had never won an Oscar, and it just seemed wrong. I won one when he hadn't, with all his great performances. And then I went home and

collapsed in bed. I didn't go to any parties.

THE PERSPECTIVE

I think I was confused, because there seemed to be so much hatred and yet my industry voted for me. It certainly lessened the horrible feeling that I had of being an outsider who would never be accepted. I have to admit, it's not that I said, "Oh, now it'll be easier for me to get jobs," because people weren't exactly clamoring to hire me. I just didn't think in terms of a career. I should have, because I didn't have a lot of money and I needed to work. Acting was really all I could do. Now, looking back, I really recognize what a good film it is. The music, the sound, Gordon Willis's photography, Alan's direction, the tension. It was a quintessential seventies movie. And Donald and I were having an affair, which helped. I found him really complicated and interesting. I'm very grateful that I won so many awards. I feel that, in spite of all my complicated history with Hollywood, I've been counted, I've mattered in the industry. And that makes me feel good.

— WHERE THE OSCARS LIVE NOW —

While I was married to Tom Hayden, I wanted to play down the Hollywood part of me, so I didn't have them on display anywhere. Then I married Ted Turner, and his office was wall-to-wall trophies. I thought, *He can display every frigging one of his trophies—why the hell can't I?* Now I have them very prominently displayed on a bookcase in my living room. I love it when people want to touch them or pick them up. It's really fun to watch.

Fonda with *Klute* director Alan J. Pakula

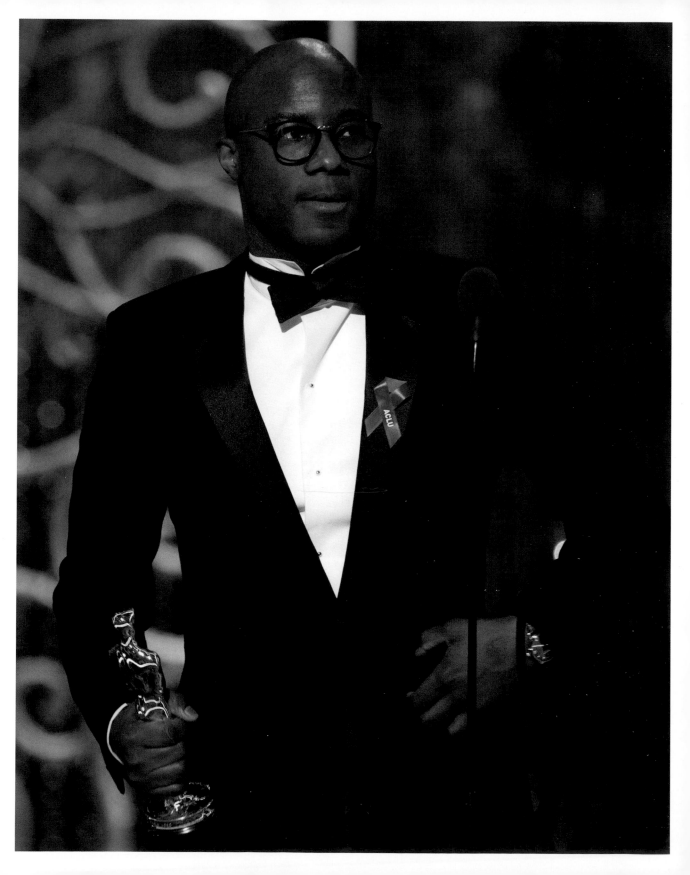

BARRY JENKINS
BEST ADAPTED SCREENPLAY
Moonlight
2017

"All you people out there who think there's no mirror for you, that your life is not reflected: The Academy has your back, the ACLU has your back, we have your back."

Calling Barry Jenkins's 2017 Oscar night a roller-coaster experience is quite an understatement. Partway through the ceremony, the director and cowriter of the sensitive, low-budget drama *Moonlight* won the Best Adapted Screenplay prize alongside his friend and collaborator Tarell Alvin McCraney. But the most memorable moment came at the end of the night, when Best Picture presenters Warren Beatty and Faye Dunaway, who were given the wrong envelope by the ceremony's accountant, erroneously announced *La La Land* as the winner, an outcome that awkwardly stood for a few minutes until *La La Land* producer Jordan Horowitz realized the mix-up and announced the actual result. (Although Jenkins accepted the Best Picture trophy, he was not technically one of the recipients of that Oscar; rather, it went to producers Dede Gardner, Jeremy Kleiner, and Adele Romanski.) Since the ceremony took place just weeks after the inauguration of President Donald Trump, Jenkins used his Best Adapted Screenplay acceptance speech to address anyone who felt marginalized or unseen in the then-current state of affairs.

THE BACKSTORY

I'd written this film under the administration of one president and assumed it would be released into the administration of another president who would be another progressive step in what this country is, what the face of this country looks like. The story of this boy and his demons, it just resonated with people who felt like they needed to see that there was room in this country for empathy for someone like this.

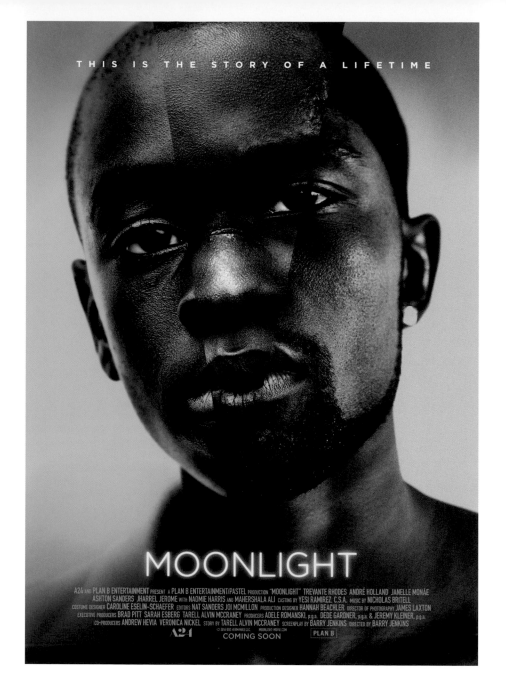

THE BIG DAY

I was staying in this building in downtown L.A. That morning I woke up, and I went downstairs and did laundry. I thought it was really cool to just go wash my T-shirt and the underwear I was going to wear underneath this very fancy tuxedo. Then Paula Woods, my publicist, came by, and we did the whole

grooming in my apartment. Then we took a bottle of champagne in the car and we rode up to the ceremony. That was the celebration.

THE WINNING MOMENT

There's nothing like hearing the room erupt when your name is called. That was the most wholesome feeling of the night. Here we are, these two kids from this housing project that we grew up at, and we're walking up on the stage to get an Oscar. Amy Adams is there presenting, and we look out at everybody standing and I can see Viola [Davis] and Denzel [Washington] in the front row and the Rock and Matt Damon. It was just really cool, man.

THE CONTROVERSY

When Damien [Chazelle] won Best Director, I thought, *Okay, that's it for us.* When the Best Picture category came up, I literally was texting my publicist, like, "Hey, where do we go after the ceremony? I'm going to want a drink, like a good drink." When Faye and Warren opened the envelope, I was expecting "And the winner is *La La Land*." Then they started playing with the envelope, and I was looking around because something just felt weird. Then they say, "*La La Land*," and I was like, *Okay, cool. That was odd.* And then I kept seeing people in headsets just running left and right. Honestly, I thought something bad

had happened, like something *criminally* bad had happened. It couldn't be that something's wrong with the actual *show*; there must be something wrong with the *world*. When Jordan finally held up the card and said, "*Moonlight*, Best Picture," people watching at home got a closeup of it. In the auditorium, you didn't see that. It was just a guy thirty feet away holding up this thing that nobody can see. I was like, "Wait, what?" It just didn't make sense. I remember just sitting there and not understanding, like, *Do we go up onstage or do we not go onstage?* I was very confused, but I trusted Jordan. So when he walked over towards us and said, "No, guys, this is not a joke, you won Best Picture, please come up," that was the one thing that got me to get out of my seat and go up.

THE AFTERMATH

It felt so great in the room when we won Adapted Screenplay, and it didn't feel that way when we won Best Picture. Understandably, there were people in the room who really loved *La La Land* and had voted for that film and wanted that film to win. When Jordan announced that we had won, there was this group of people that understood what he was saying and celebrated it. But there was also this group of people that were stunned that this other thing that they had been told had happened did not happen. So the announce-

ment of that win just has very weird energy, and I think I carried that energy with me through the rest of the night. You want to be alone when you have that kind of energy, but there's no being alone when you've won Best Picture and you're moving through the Governors Ball and then you're on to *Vanity Fair*. It was just weird, man. It was actually not an awesome night. It just wasn't. There's this whole labyrinthine path you go through to get to the press room. I remember passing Warren, and there were all these people surrounding him trying to get the card from him. He said, "I didn't want to give this to anyone but you." That was important because I still had no proof that we had actually won because I couldn't see when Jordan held it out. He handed it to me, I took a photo of it and I gave it back to him and I kept going.

THE CELEBRATION

We got to *Vanity Fair*, and I'm not used to getting into parties like this. My editor, Joi McMillon, who at that point was the first Black woman ever nominated for an editing Oscar, her whole family had come out from Florida, including her Aunt Betty, who's like this eighty-year-old Black woman who's so far removed from Hollywood. And I'll never forget, we got to the front door of *Vanity Fair* and we're like twelve, fifteen deep. And I remember the security guard looking at us and saying, "All right, who's all with y'all?" And Jeremy Kleiner said, "From Barry Jenkins all the way to Aunt Betty." And we all just moseyed into *Vanity Fair*. That was probably the highlight of the night.

WHERE OSCAR LIVES NOW

My statue is at the Academy Museum. Every now and then on social media, some kid will tag me in a photo. They're at the museum and they're so proud to take a selfie with the Oscar for *Moonlight*. That's what it's meant for, you know? If I can get one of these things, then they can too.

Jenkins with co-screenwriter Tarell Alvin McCraney and presenter Amy Adams

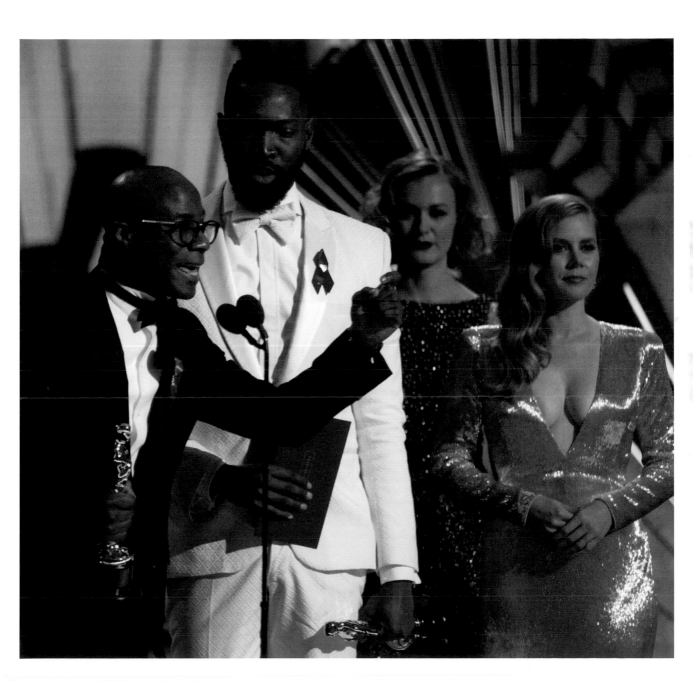

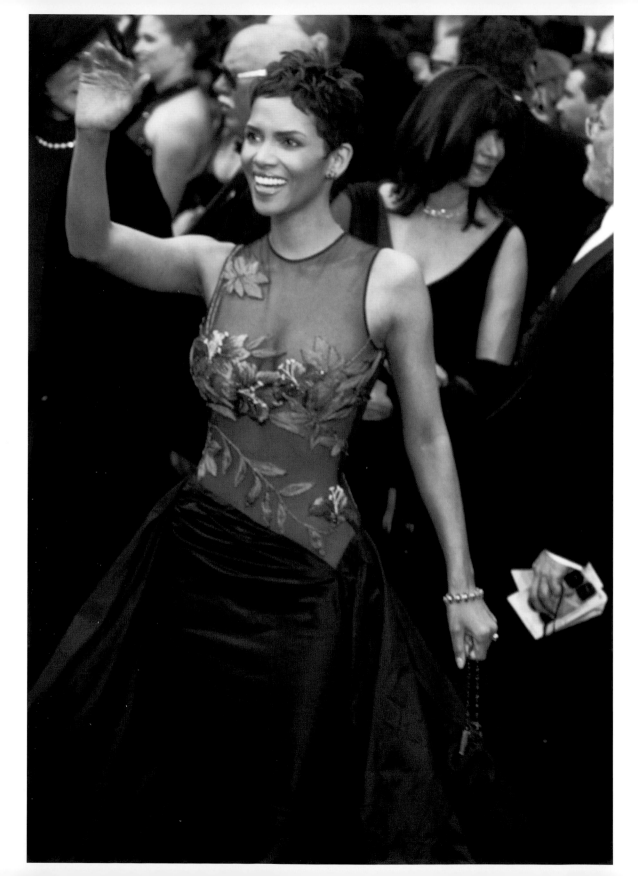

HALLE BERRY
BEST ACTRESS
Monster's Ball
2002
"This moment is so much bigger than me."

I t wasn't long in the history of the Academy Awards before a Black actress won an Oscar: *Gone with the Wind* standout Hattie McDaniel was awarded the Best Supporting Actress prize at the twelfth ceremony in 1940. But it took another six decades before a Black performer won in the Best Actress category. That honor went to Halle Berry, the former Miss USA runner-up who had shocked and impressed the film industry with her stripped-down turn as a struggling mother in the sexually charged bayou drama *Monster's Ball*. Security was especially tight since the ceremony took place just months after the 9/11 attacks. When presenter Russell Crowe called her name, Berry, stunning in a floral-embroidered Elie Saab gown, struggled to compose herself at first, but went on to deliver a powerful speech in which she acknowledged such actresses as Dorothy Dandridge, Lena Horne, and Diahann Carroll, who came before her but were unable to match her recognition from the Academy.

THE BACKSTORY

The Oscars were always something I watched growing up, but I never felt like I could be a part of it. There was always a sense of sadness because I didn't see people like me reflected very much. It was something that I loved, but it was very obvious to me that people of color weren't really a part of this show in a real way. But it didn't mean that I didn't enjoy watching people be elated and making emotional and funny speeches and being honored by their peers. I really loved that aspect of it, but I did feel very much on the outside of it.

THE PRODUCTION

I remember when I first read that script, I knew that I could breathe life into the character of Leticia. I understood where she lived;

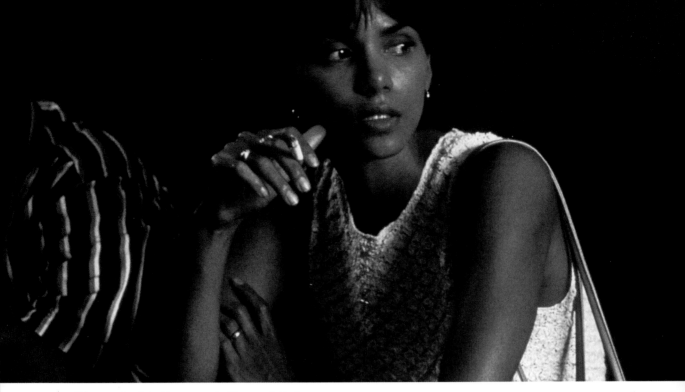

Berry as Leticia Musgrove in *Monster's Ball*

I understood where she came from; I understood her emotional pain. My well was deep. When I expressed my desire, the producer, Lee Daniels, thought I didn't look like this character. He thought I was too pretty and that my physical self would somehow detract from the believability and the authenticity of this character. It became really personal for me, because I knew I had faced so many hardships that nobody really knew about, and many people still don't know about. So I became obsessed with proving that I could do this, and I had to get this role. I realized that I needed to go around Lee Daniels because he was very against me. I had to get to Marc Forster, the director, and talk to him as an artist and try to convince him to see past the physical and really get into what I could offer as an actor. And that's how I won the day. When I fought for this movie, it was never in search of an award; it was in search of being taken seriously as an actor and playing a part that I loved and that ignited me. It was risky. It was daring. People told me at the time, "This could ruin your career if this goes badly." But that didn't scare me. That was a challenge.

THE BIG DAY

I was eerily calm because I was convinced I wouldn't win. Back in those days, the Golden Globe was really the precursor. If you didn't win the Golden Globe, you probably weren't going to win the Oscar. And I didn't win the Golden Globe, Sissy Spacek won. So I really had a sense of: I probably am not going to win, but I've gone farther than I ever could have imagined with this little movie that I had to just convince people to let me do. I got to show that I was more than just a pretty face. So I had already won. It sounds cliché, but that's what was important to me at that time. It was more about having a bomb-ass dress, going there, making a fashion statement, feeling all of myself, feeling confident, feeling empowered that I had done something that nobody thought I could do. That's what my focus was—just go there and own that carpet and own the sense of accomplishment that I made it there. And to be gracious in defeat. There was a feeling of people being a little trepidatious about being at a big gathering like that. I remember there being lots and lots of security and people being a little bit on edge about being in a group and feeling like if there would be another attack, this would be a great place to make a statement. I remember that being talked about.

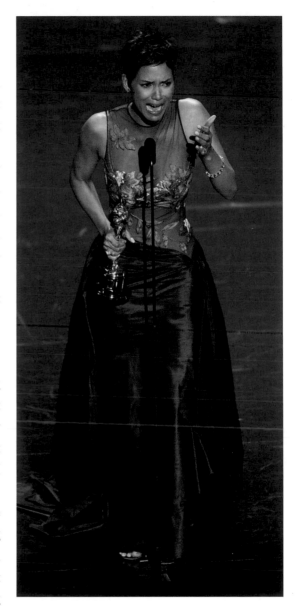

THE LOOK

I wanted to wear a different gown than I'd ever worn before. When I put on this Elie Saab dress, I felt like this was a true example of how I was feeling in this moment. I thought

it was a little risky, was a little racy, but the film was that way. So the dress was sort of in line with what the whole moment and project was for me. I remember my stylist, Phillip Bloch, saying, "It's kind of naked on the top, but we'll put flowers that cover all the bits and bobs. But, you know, people might have something to say about it." And I said, "Well, that's what they told me about making the movie. And I did it anyway, so I'm going to wear this dress anyway." It was in line with where I was at that time, feeling courageous and bold and wanting to take risks and chances. I also had on an emerald ring that one of my acting coaches, Ivana Chubbuck, gave to me. It didn't go with anything but I wore it.

THE WINNING MOMENT

When I heard my name, I sat in my seat for a very long time because I just wasn't quite sure. *Did they really say that?* I sat there for a while until I heard my manager say, "Go, go up there, go get it!" I remember seeing Russell Crowe, and I was shaking. I couldn't catch my breath. And I remember him saying, "Breathe, mate." I think he knew I wasn't breathing. And I remember taking a breath and then turning around and facing everybody and taking it all in and realizing, *Holy shit, I'm really here.* I didn't have a speech written—it was just what was on my heart and what I was feeling. That's what came out. And at some point it turned into straight babble. Then I was thanking people two times, and I was rambling. But it really was just a stream of consciousness that came out of me in that moment because that's all I had.

THE PERSPECTIVE

It was validation for me as an artist. It's something no one can ever take away from me. I knew that it was history-making, and I was extremely proud because I knew how hard I had worked to get to that point. But my career didn't magically change the next day. Twenty years later, I'm still fighting "You don't look like you can play that." I continue to struggle with that.

WHERE OSCAR LIVES NOW

It is in my bedroom. Because it's very personal to me. So when people come into my house, it's not on display. It's in my most intimate place, where I see it every day. And it empowers me. It's not to show off. It's not to remind anyone—it's to remind myself.

Berry made history with Best Actor winner Denzel Washington.

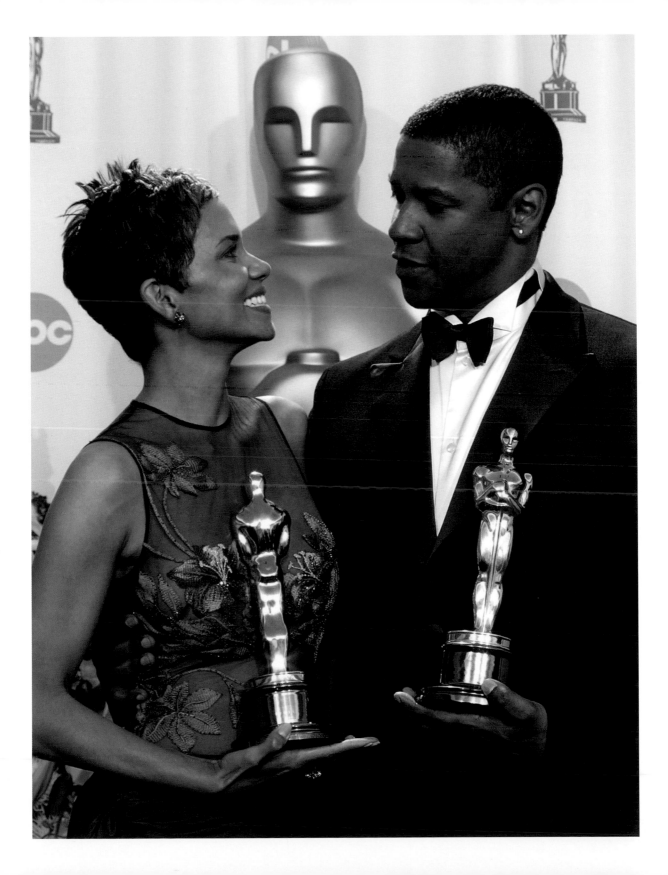

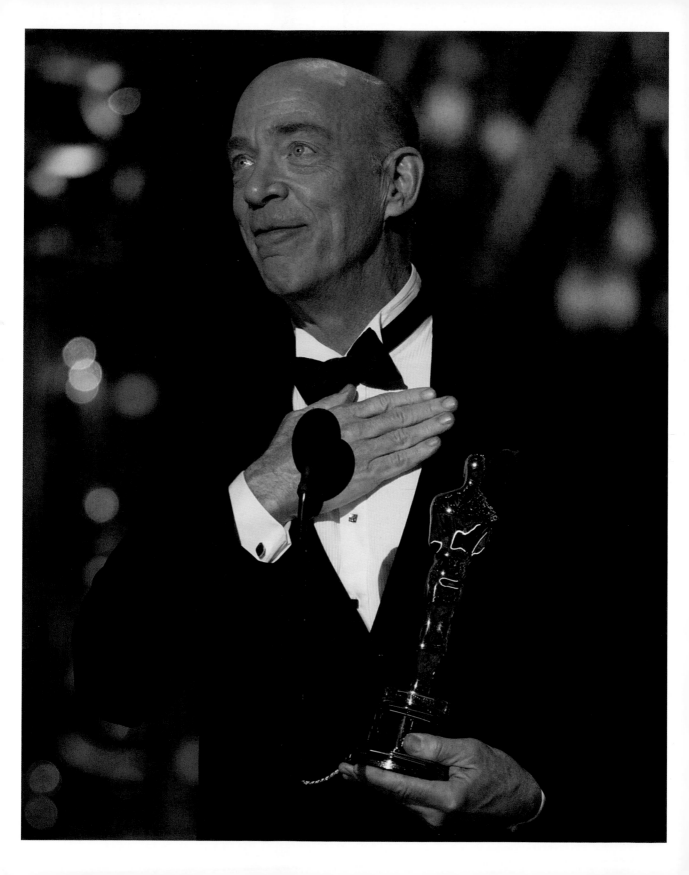

J. K. SIMMONS
BEST SUPPORTING ACTOR
Whiplash
2015

**"Call your mom, call your dad. If you're lucky
enough to have a parent or two on this planet, call 'em.
Don't text. Don't email. Call them on the phone."**

There wasn't an ounce of suspense over who would win the Best Supporting Actor award at the Oscars in 2015: Veteran character actor J. K. Simmons had already picked up prizes at the Critics Choice, Screen Actors Guild, Golden Globe, Independent Spirit, and BAFTA Awards for his riveting performance as relentlessly demanding jazz teacher Terence Fletcher in Damien Chazelle's indie *Whiplash*. But what surprised—and delighted—everyone watching was Simmons's humorous and heartfelt acceptance speech, in which he paid loving tribute to his "remarkable" wife and "above-average" children before imploring us all to call our parents: "Tell 'em you love 'em, and thank them, and listen to them for as long as they want to talk to you."

THE BACKSTORY

I cannot tell a lie. The Oscars were barely on my radar, especially because the first twenty years or so of my career was all onstage. It certainly never occurred to me as a kid or a young man that I would ever be a part of that universe at all, let alone find myself sitting in the audience, hearing my name called to go up and collect a trophy.

THE PRODUCTION

Jason Reitman was a producer on the movie. Jason sent me the script. From page one, Fletcher just leapt off the page and into my psyche and into my body. And I felt like, I am *the* guy to play this character. It was just an immediate connection with who this guy was, what motivates him, and his passion. I could see and hear myself with every

Simmons color-coordinated with his wife, Michelle Schumacher.

my voice back. We also weren't doing take seven of anything *ever*. I think it was rare when we did take three. To me, that's a good thing. I enjoy cutting loose and getting it done and nobody dropping the ball. If you get it in one take or two takes, why mess around?

THE BIG DAY

That award season had become such a snowball rolling downhill for me personally. It was weird to be going into that Oscars ceremony almost assuming that my name was the one that was going to be called. I mean, the Vegas line was pretty ridiculous, according to my gambling friends. It was pouring rain when we got out of the cars. And the first thing that we noticed was that they had set up nice tents covering the red carpet, but they didn't quite reach to where everybody was getting dropped off. So my wife and every other woman who had spent hours getting their hair and makeup just right were trying not to look like drowned rats as we got to the edge of the carpet. I had my fedora and obviously my hair was not in danger of being messed up. So it was much less of an issue for me.

THE LOOK

I did have a couple of unique items in my apparel. One was an antique pocket watch that my wife, Michelle Schumacher, had bought for me when we were theater actors

syllable that I read of Damien's screenplay. When we were shooting those ridiculously long days, it was physically draining sometimes just because of the vocal and physical explosions of vitriol that fly out of Fletcher. I didn't feel like I could do anything in terms of protecting myself or trying to have any kind of proper vocal technique or anything. It just had to be absolute throat-wrenching emotion spewing out of the guy. So one of the many things Damien did wisely was he scheduled the screaming scenes a couple of days apart so I could literally physically recover and get

in New York. It was an extravagant gift that she could barely afford at the time. And I took a piece from the dress that she was wearing and my wonderful costume pal Emilio helped fashion that into a pocket square. So my pocket square matched my wife's dress and my watch was just a nice touch that went back to the very early days of our relationship.

THE SPEECH

It was a very meaningful moment for me. I had gone all the way through the award season without ever really writing a speech. I had lost both of my parents in the previous year and a half or so leading up to the Oscars.

What I knew I wanted to focus on was what's most important, which is our loved ones, those closest to us. I knew that I wanted to acknowledge and thank my wife, Michelle, and our kids. So I just went up there knowing that I wanted to talk about her and to let it be known how much I love and appreciate her in my life, and our kids. And then it led kind of organically to thinking about my mom and my dad. It all just kind of spewed out of my mouth from there. It wasn't necessarily a script that was in my head going up there to say, "Call your mom." But I'm so glad that those are the specific words that tumbled out of my mouth.

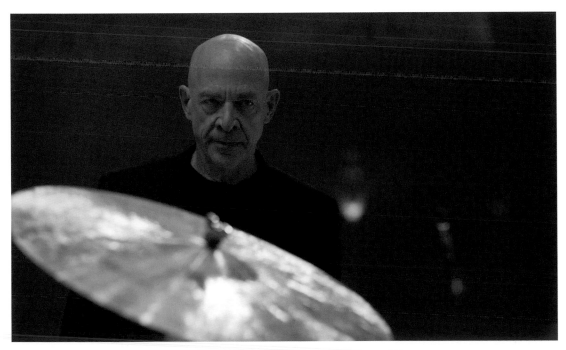

Simmons as Terence Fletcher in *Whiplash*

THE AFTERMATH

[The speech] became kind of a meme there for a while. It really impacted people—some people I know, some people that I will never meet—all over the country and the world. I heard stories of people who were estranged from their parents and because some bald journeyman character actor in a tuxedo said, "Call your mom," they called their mom and their dad. I heard stories of relationships that were rekindled and repaired as a result of my expressing my love and appreciation posthumously for my parents. I can't imagine a more gratifying thing than that.

THE PERSPECTIVE

My career built so gradually, from doing regional theater for $275 a week, through little bit parts in television and film, and better parts and series regulars. It had been such a gradual progression that, not long before *Whiplash*, I got to that point where I wasn't having to audition most of the time anymore. The biggest change in the eight years since *Whiplash* is just the sheer number of offers that continue to just land in my lap. Not all because I won an Academy Award, but certainly that's a significant factor in that. I was ridiculously fortunate in my career and more so in my life before the Academy Awards shone the spotlight on me, and even more so since then.

WHERE OSCAR LIVES NOW

Michelle and I had a little mini-fridge in our bedroom. It lived on top of the mini-fridge for a while until a few days later we started looking around going, "I guess we should probably figure out where this thing is going to actually live in our house." We didn't want it prominently displayed downstairs partly because of my modest Midwestern upbringing. I didn't want people to walk into the house and the first thing they see is a bunch of acting trophies, including an Oscar. So, it's on display upstairs on a bookcase, surrounded by family mementos and photos of the kids.

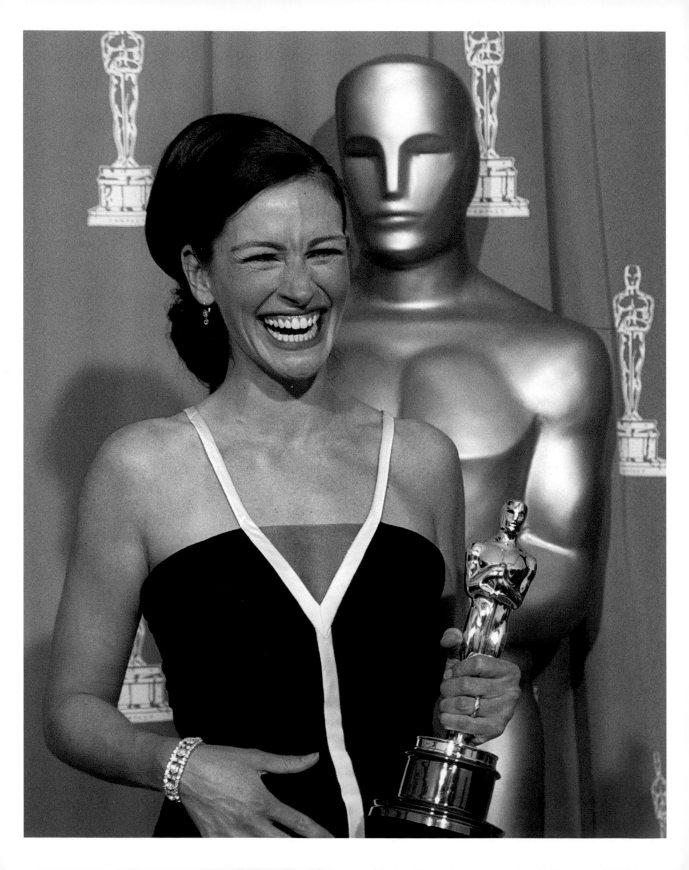

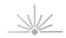

JULIA ROBERTS
BEST ACTRESS
Erin Brockovich
2001

**"Sir, you're doing a great job, but you're
so quick with that stick, so why don't you sit,
'cause I may never be here again!"**

A decade before winning the Best Actress Academy Award for *Erin Brockovich*, Julia Roberts was nominated for back-to-back Oscars for two of her earliest performances, in *Steel Magnolias* and *Pretty Woman*. She lost both of those respective years to *My Left Foot*'s Brenda Fricker and *Misery*'s Kathy Bates. But her fierce performance as the titular activist and mom in *Erin Brockovich*, directed by Steven Soderbergh, led to a clean sweep of the entire awards season. Once onstage, Roberts, wearing a vintage 1992 Valentino dress, delivered a euphoric and free-wheeling four-minute speech, in which she charmingly admonished the orchestra conductor, Bill Conti, not to raise his baton to play her off. She later sent him a box of chocolates by way of an apology.

THE BACKSTORY

When I got nominated for *Steel Magnolias*, it was just a complete shock. I absolutely knew that I would not win. I would have voted for Brenda Fricker as well. And a true part of me did not want to win. You know when you're in high school, and you're the most popular and the most athletic, and you're the smartest, and you're on the honor roll, and then all of a sud-

den you're twenty-two years old, and you've peaked? I had that fear inside of me. But I have to say, I was even more shocked to be nominated for *Pretty Woman*. It's just not the kind of movie that gets nominated. It's borderline silly, you know? I mean, Garry Marshall knows what makes people laugh, and it's not always sophisticated. I just remember so clearly when he had me blowing my

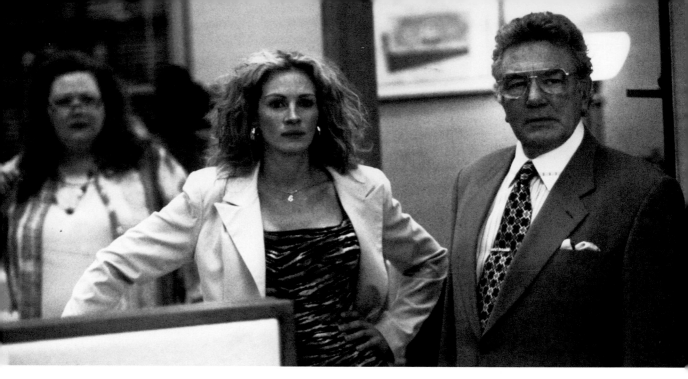

Roberts with costars Conchata Ferrell and Albert Finney in *Erin Brockovich*

nose into this handkerchief in this scene with Héctor Elizondo. I was like, "Really, Garry?" He goes, "Oh, they're going to love this in Ohio."

THE PRODUCTION

When I think back to the filming, it was one of these experiences where you really do pinch yourself and think, *This is my job? I get paid for this—to be with these really dynamic, creative people.* It had constant flow. It never felt like effort. It just felt like flow all the time. My mom was a single mother with three kids. And it's that sense of a person who never stops putting out effort and never sees any result of it. It's just so heartbreaking and exhausting. I felt that I really appreciated that in her, and I appreciated how much tenacity she had

and just what a relentless human in all forms she was.

THE LOOK

I was at the L'Ermitage Hotel. And the day before the Oscars, I had two really beautiful dresses that I was choosing between. Then this incredible stylist, Debbie Mason, showed up and says, "Oh, I found this dress." She had just stumbled upon it in the basement at Valentino. And she pulls out this dress, and I was like, "Oh, my heavens," it was so beautiful. I put it on. It fit like a glove. We didn't make one alteration to it. As for my hair, I think [my hairstylist] Serge [Normant] and I had probably talked about it being up because it's such a fancy occasion, you know?

THE EXPECTATION

Soderbergh calls me and we're chatting. And it's such a big and beautiful time for both of us. And I have such admiration for him. We're getting off the phone, and he says, "Just remember this: There's always an upset." And it was the greatest thing anyone had ever said to me to that moment in my life. In that moment, I realized, "Oh yes. That's what I'm going to be: the person who everybody thought was going to win and didn't. And it freed me. I was not nervous, I was not worried. I was freed. I went and had a great time because I wasn't going to win. I didn't have that pressure on me anymore. I just had a great time. And then I won.

THE SPEECH

I never write speeches. It's like videoing something; you're watching it, but you're not really having the experience. So I really don't know what I said. I know I was so elated, and I was literally beside myself. So that's what everybody got to experience, as opposed to me being that excited and then trying to contain it so that I can read something. I don't know

how to do that. I don't know how to contain. I do remember seeing [Bill Conti]. He had his baton. I don't know what it was that made me panic that they were going to get the hook out. But I do remember thinking, *Oh God, I'm supposed to get off and I haven't even started talking yet.* I called him "Stick Man." And that's not cool. I wrote him a note to the point of "Mr. Conti, I thank you for not playing me off."

THE AFTERMATH

I went back to work, on *Ocean's Eleven*. We went to Las Vegas the next day. My sister and brother-in-law came with me and they were there for a few days with me. And then when they left, because we live in the same apartment building, I said, "Well, you guys take [the Oscar] with you because I didn't want to just have it in my hotel room. So they reluctantly took it home, and it stayed in their apartment, I want to say maybe five years. And everyone that came over to their apartment to visit would take a Polaroid, whether it be the super of our apartment building or a friend. And so they have this whole scrapbook of Polaroids of people with the Oscar.

WHERE OSCAR LIVES NOW

It's in what we call the piano room because there's a piano in here and it makes it sound fancy. [It's next to] the Icon Award that the Academy [Museum of Motion Pictures] gave me and a picture that [my husband] Danny took of me and Mike Nichols.

JOHN LEGEND
BEST ORIGINAL SONG
Selma
2015

"We wrote this song for a film that was based on events that were fifty years ago, but we say that Selma is now because the struggle for justice is right now."

Singer-songwriter John Legend was already a nine-time Grammy winner when "Glory," which he wrote with rap artist and actor Common, was nominated for Best Original Song. Their stirring theme from the civil rights drama *Selma* was the movie's only real shot at a victory since the film's director, Ava DuVernay, and star, David Oyelowo, weren't nominated—omissions that spawned that year's "Oscars So White" controversy. Legend and Common's Oscar win, immediately after they performed the song on the telecast, brought Legend halfway to his eventual EGOT status (his Tony and Emmy awards would follow in 2017 and 2018, respectively), while the duo's rousing acceptance speech, often cited as one of the best in Oscar history, beautifully and powerfully connected the work of the film's subject, Dr. Martin Luther King Jr., to contemporary political protests around the world.

THE BACKSTORY

My goal was to be a musician and make records for a living. And hopefully win Grammys for the music that I made. I had no expectation or goal setting around the Academy Awards. That definitely was not on my vision board.

THE SONG

I was excited that someone was doing what I hoped would be a really high-quality film about Dr. King's life. Common and I have been friends and labelmates for years. One day I was on tour in the UK and he reached out to me and said, "I want to try to write an

Legend performing his Oscar-winning song, "Glory," at the ceremony

Selma star David Oyelowo and director Ava DuVernay, both overlooked on Oscar nominations day

end-credit song for *Selma*. I'm in the film." He sent me a rough cut of the film and some title ideas for the song, and one of the title ideas was "Glory." That was the one that I immediately was attracted to. I sang something in my phone that was kind of a rough idea of what a chorus for a song called "Glory" could be. The final chorus is pretty similar to what I sang originally on my phone. I went to the studio in London and recorded a final version of the piano and my vocal and then sent it to Common: "So what do you think?" He loved it and went off and wrote the rap verses. It was less work for me because normally I'm writing an entire song with my own verses. Just writing the chorus and the bridge and recording the piano track was literally probably two hours total for me.

THE BIG DAY

We had won quite a few of the predictive awards that one might win, so we had the sense that there was a good chance we could win the Academy Award. You have to remember what was happening in the world at this time: Ferguson and Michael Brown, the Black Lives Matter protests. There was this kind of urgency baked into the song because we were

referencing the moment as well as the historical inspiration for the moment. So I was very focused on saying the right thing were we to win. A lot of my energy and thought was around writing and memorizing what I was going to say. We had given speeches before, but obviously this was the most important one. So I wanted to really focus on saying something that lived up to the moment, lived up to the importance of the film and who is being depicted in the film—and connect it to the urgency of the present moment. I was more nervous about that than about singing. I was like, *I want to get this right. I don't want to fumble, I don't want to mumble, I don't want to stumble.* I was saying it to myself in my head, like, the whole day and into the evening.

THE SPEECH

Everything leading up to it was so powerful and beautiful and emotional. After our performance, you could see so many of the Academy members and attendees with tears in their eyes. It was just a very moving and powerful moment. And then literally right after we performed, the award was announced. Anything that's for songwriting has our government names on it. So Lonnie Lynn and John Stephens won, not Common and John Legend. A lot of people were confused when "Lonnie Lynn" won. They were like, "Who the fuck is

Legend accepting the Oscar alongside co-songwriter Common

that?" We were hoping the Academy wouldn't cut us off because we definitely went over time. They were gracious enough to give us the time to say what we needed to say in that moment. There weren't going to be a lot of folks that look like us on the stage winning that night. So it just made what we represented even more singular and more important.

THE CELEBRATION

My wife, Chrissy, was with me the whole night. We went to *Vanity Fair* and some of the other parties afterwards. And the whole time, we're holding the trophy. I like the Oscars as compared to the Grammys because you get to hold your Oscar; you get the engraving on it that night. Whereas with the Grammys, you've got to wait a couple of months before they ship it to you. We took a lot of good pictures, had a lot to drink, had an amazing night. Oh, we took pictures in bed with it too.

THE PERSPECTIVE

David and Oprah and Ava—we had all campaigned together for the film. We had marched together in Selma on the anniversary of the march from Selma to Montgomery. We had spent a lot of time together and felt this strong connection to each other. I always tell people it was the most singular and special moment of my career. After we won the Oscar, one of my production team partners was basically like, "Now it's my goal to get you the EGOT."

WHERE OSCAR LIVES NOW

We have a whole bar whose centerpiece is a piano. It's in that piano bar with my other awards. It's kind of like my version of a man cave.

Selma star and producer Oprah Winfrey congratulating Legend

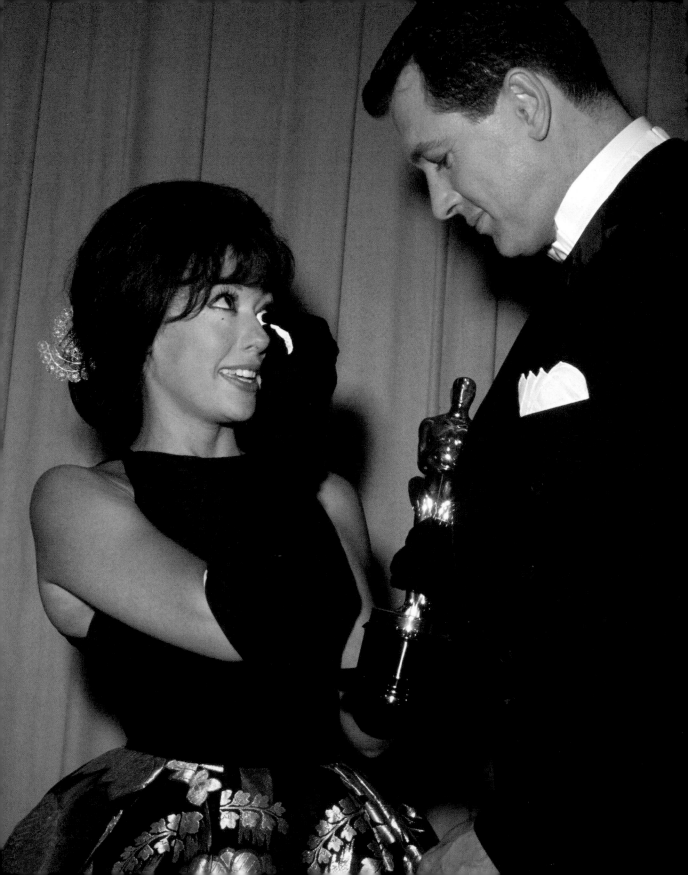

RITA MORENO
BEST SUPPORTING ACTRESS
West Side Story
1962

**"I don't believe it! Good lord.
I leave you with that!"**

Much of Rita Moreno's early film career consisted of playing stereotypical ethnic roles devoid of substance or complexity. But as the fierce Anita in *West Side Story*, she was finally given the opportunity to show the extent of her talent. On Oscar night in 1962, *West Side Story* won a total of ten Academy Awards, including for Moreno and George Chakiris as Best Supporting Actor. Her dumbfounded reaction resulted in an eleven-word speech that remains one of the briefest of all time. Moreno's Oscar victory set her on the path to becoming the first Latina EGOT winner, a feat she completed in 1977 with her Emmy win for *The Muppet Show*.

THE PRODUCTION

Anita was the apex of an attention-getting role in my professional life. It was one of many Hispanics that I had played in too many inferior movies. But this girl, Anita, actually became my role model. She had a lot of things that I didn't have at the time that I did the movie. She had a sense of dignity. She had self-respect. She had opinions that she was not afraid to voice. I wasn't like Anita at all. I was like Anita in the sense that I had a sense of humor and I had flair. And I was able to portray a great sense of joy because that is so much a part of me anyway, no matter how hard things were. That's what was Anita about me.

THE LOOK

I was in Manila, the Philippines, where I was playing yet another island girl [in *Cry of Battle*], a guerrilla girl from World War II, which

Moreno with presenter Rock Hudson

Moreno as Anita in *West Side Story*

I just hated doing. But I had to pay the rent. I had a gown made by a very famous designer in Manila—his name was Jose "Pitoy" Moreno. He did all the gowns for all the famous rich people in Manila. I had seen a piece of fabric in his studio that was simply gorgeous. I said, "What is that?" And he said, "That is an obi," the sash that a Japanese lady wears around her kimono. I said, "I want the skirt of my gown to be that obi." It cost a lot of money. So that became the skirt, and then the top became a bateau neck, which was very popular at the time because Audrey Hepburn wore a lot of those. It was absolutely, spectacularly beautiful. I didn't have a makeup person and I didn't have a hairdresser. I just did what I could do to make myself look as pretty as possible. I remember wearing a beautiful little Spanish comb in the side of my hair, which I brought with me from the Philippines. Edith Head said it was one of the most beautiful gowns that evening. I found that out years later, but I was so proud of that. Now that gown sits at the Academy Museum in L.A. It sits on display

next to Cher's, the one where she exposes her belly button. I think it's perfect.

THE BIG DAY

The morning was comprised of talking to George Chakiris on the phone eighty-nine times. We were like brother and sister. We just loved each other, and we laughed together. He was to pick me up in the limousine. He looked just gorgeous. I mean, that face of his. We just made the prettiest couple. We desperately wanted to win. But who were we? I was convinced I was not going to win because I thought Judy Garland was going to get it for *Judgment at Nuremberg*. That's fair. I remember when we got to the theater, we were posing for photos. George said, "Look at Joan Crawford over there. Look at the way she's looking at us." It was the strangest kind of evil-looking smile. It wasn't so much evil; it was envious. But it showed on her face because he spotted it.

THE WINNING MOMENT

George had already won, and the movie had already won a bunch of Oscars. I remember when my name was called by Rock Hudson, my mom grabbed me and hugged me, and I stood up, and I started to walk down the aisle. And I said to myself, *Don't run—it's not dignified.* Because I had seen so many actresses just running. And I know why: You don't want

the applause to stop. I remember saying to myself, *It doesn't matter if the applause stops. Do not run.* And I didn't. And the applause didn't stop. I mean, *West Side Story* was the big deal that night. And then I get to the microphone, and I didn't know what the hell to say. There I am making the world's shortest speech. It's one of the shortest in history, I know that. You can certainly tell that I was unprepared. I've regretted it for years and years. The one thing I really thought I should have mentioned was my being an outlier, being a Puerto Rican actress in Hollywood and getting recognized and acknowledged. It would have been moving and so important. But I truly, truly did not expect to win.

THE AFTERMATH

I started to cry as I went into the wings. And there's Joan Crawford waiting for me. I'd never met her in my life. There was a photographer waiting for her to greet me, which she had arranged, I'm sure. And she grabbed me and squashed my face against her bosom. I mean, she was built like a linebacker. She wouldn't let me go. Her breath was very strong of something alcoholic; I couldn't tell what it was. And the photographer kept saying, "Miss Crawford, I can't see Miss Moreno's face." And she'd say, "Oh, but she's so upset. There, there, dear." She would not let me go. And I kept saying, "I'm not upset!" My voice

was muffled against her bosom. And my face is all being squashed against her linebacker chest. Finally, it took a couple of people to wrest me from her grasp. Then two weeks later, when I'm back in Manila, I get this note: "Darling Rita, I cannot tell you how thrilled and moved I was that at the most wonderful moment in your life, you took the time to stop and say hello to me. Thank you, darling. Joan Crawford." Isn't that wonderful?

THE PERSPECTIVE

It means an acknowledgment and a recognition of my talent. The fact that it made me the only Hispanic woman to win was a big deal. We're not going to get nominated if we're going to be playing these kind of roles—Chiquita, Lolita stuff. It's never going to happen. So it's really an example of how underrepresented we are that we don't get nominated. It's not that we don't have the talent. It's that we don't get the work.

WHERE OSCAR LIVES NOW

My Academy Award is displayed along with other awards in the living room of my home. But for the longest time, it was sitting in a carton. When my husband and I got married, he said, "Hey, where's your Oscar?" And I said, "Oh, it's in a carton in the garage." And he said, "In a carton in the garage? Why?" I said, "Well, I always get shy about it. I always think it's like showing off." And he said, "Rita, you didn't buy this. You *earned* it." When he said that, I remember I got tears in my eyes. And I said, "You know, I did." And from then on, I show my awards.

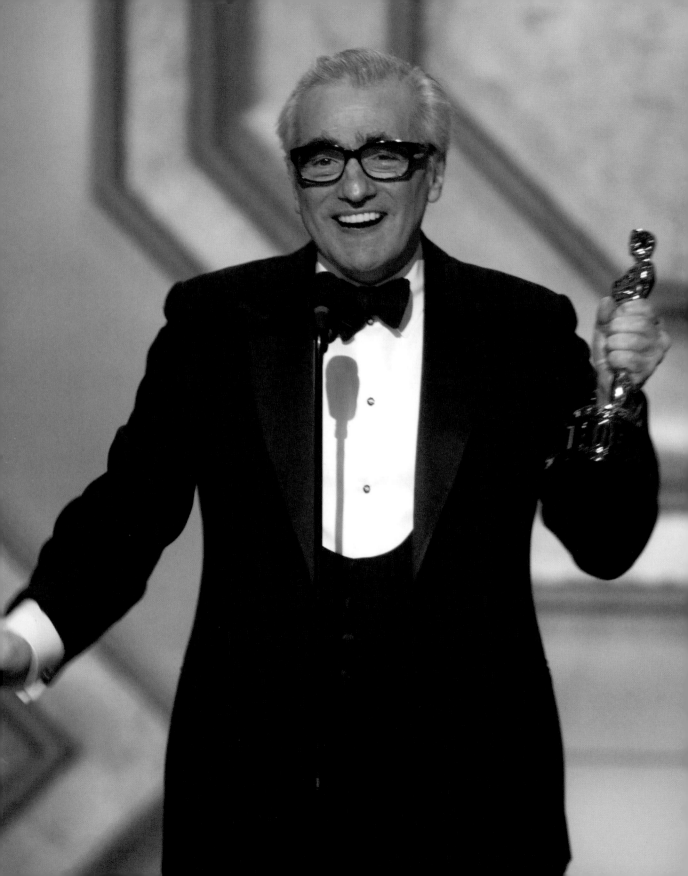

MARTIN SCORSESE
BEST DIRECTOR
The Departed
2007
"Could you double-check the envelope?"

By the time the legendary and influential filmmaker Martin Scorsese received his sixth Academy Award nomination for Best Director for his wickedly entertaining crime drama *The Departed*, it was almost comical that he hadn't won. *Raging Bull*, *The Last Temptation of Christ*, *Goodfellas*, *Gangs of New York*, *The Aviator*—he conceivably could have won for any of those films for which he was nominated, not to mention the ones, such as *Mean Streets*, *Taxi Driver*, or *The Age of Innocence*, for which he inexplicably was not. Certainly the ceremony's producers doubled down on Scorsese's chances, enlisting his pals Francis Ford Coppola, Steven Spielberg, and George Lucas to present his category. In all, *The Departed* was nominated for five Oscars, and it won four: for Best Picture, Best Director, Best Adapted Screenplay for William Monahan, and Best Editing for Scorsese's longtime collaborator Thelma Schoonmaker.

THE BACKSTORY

I cared about [the Oscars] because I loved movies, from the time that I was very young. I saw the first Oscars that was telecast. I think I was eleven at the time, and it was so exciting to see that kind of pageantry and ceremony devoted to these movies that entranced me and these people who made them: John Wayne, who accepted for Gary Cooper; Anthony Quinn; Gloria Grahame; Dimitri Tiomkin; Cecil B. DeMille; John Ford. To see those people and their films singled out and getting that kind of attention, that meant something.

THE LOSSES

Let me put it this way—the central question is: Do you belong? The Academy stands for a certain idea of what a movie is, which is very tied

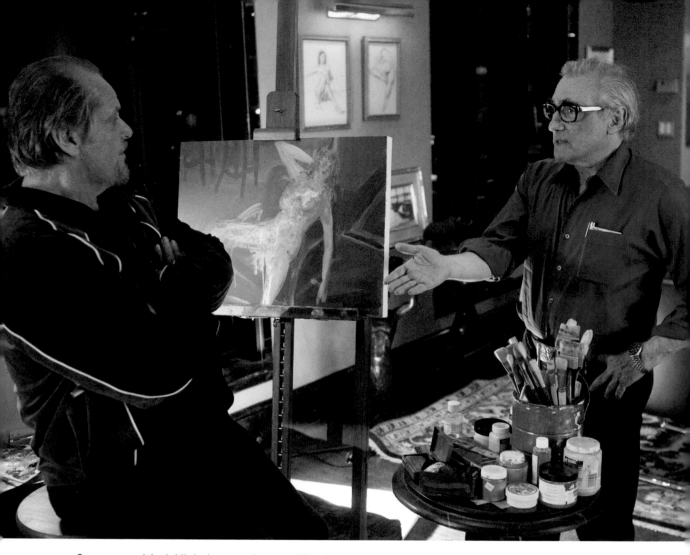

Scorsese and Jack Nicholson on the set of *The Departed*

to the movie business and how it represents itself. Within those parameters, I felt that most of the movies I'd made didn't merit an Oscar. However, I benefited from being nominated so often, and I came to accept those benefits for what they were. It helped get the *next* films made. I knew that was what it was about: getting the next film made and going home.

THE PRODUCTION

Honestly, when we were making it, I really didn't think it would be recognized by anyone, let alone the Academy. When we won all those nominations, I was surprised, but I thought that would be that. For the previous thirty-seven years, I'd been nominated and missed it so often that I felt a kind of déjà vu. We were vindicated by the nominations,

but after all those years a lot of the anxiety was gone. Meanwhile, everybody around me was saying I was going to win. People were extremely positive.

THE BIG DAY

Everyone was meaningful to me. Ennio Morricone, Clint Eastwood, Alan Arkin . . . Those are the names that come to mind among the many, many, *many* people I crossed paths with. I remember feeling that I hoped I won because I didn't want to disappoint anyone, my loved ones most of all. I wondered what I would say to everyone if I didn't win, because some of them would have been very disappointed if it had gone that way. The tension came from that, and the memory of how disappointed my parents had been that I didn't win for *Goodfellas*.

THE WINNING MOMENT

I remember seeing Jack Nicholson there in the first row, smiling at me, wearing his dark glasses. I remember how nervous I was. I was excited when Thelma won again, and she gave a beautiful speech. And then, I saw Francis and George and Steven walk out onstage in unison, smiling, doing this sweet and funny routine at the podium. Steven took the envelope, and my heart was in my mouth: "Please don't let me disappoint everyone." Then Steven opened the envelope and said, "Spread out," he smiled, and he said my name. My wife told me that the reaction in the room was like a sonic boom. I remember joking and asking if they could double-check the envelope, I thanked the people who made the picture, and then I thanked all those people who were hoping for me to win, from my wife and my daughters to the people who stopped me on the street or who operated the elevator in my office building. And then I told my youngest daughter, Francesca, that it was okay for her to jump up and down on the bed.

THE CELEBRATION

We went to all the balls: *Vanity Fair*, the Governors Ball. I had the Oscar in my hand all night. I was with my wife; my older daughters, Cathy and Domenica; my manager, Rick Yorn, and his wife, Chrissy; and Leo DiCaprio. Then they took me to another party, in a big restaurant at the end of a long driveway. It was pitch-black inside and packed with people dancing and talking. It was crazy, it was very loud, and it was joyous. I weaved through the crowd to get to the seated area, found a seat, talked to Rick, had a long conversation with Leo, a very long conversation with Djimon Hounsou about African cinema, among other things. Then, there was a breakfast with some of the people I worked with. We went back to the Hotel Bel-Air, where they opened the bar for us and made us a more

substantial breakfast. I called my Aunt Fanny, my mother's sister and the last living member of that generation, and she was in tears. We were all kind of stunned, we all felt like everything was a kind of dream, and it was quite emotional. Around seven a.m., we went back to our suite, I turned on TCM, and the titles for *49th Parallel* were up on the screen: "Produced and Directed by Michael Powell." By seven thirty a.m., I was asleep.

THE PERSPECTIVE

I do think about it from time to time. If it had to come, for whatever reason, it came at a good time. If it had happened earlier, I might not have found the strength to keep making the films I wanted to make, as opposed to the ones I would have been offered.

WHERE OSCAR LIVES NOW

It has a pride of place in my home.

Scorsese with friends and presenters Francis Ford Coppola, George Lucas, and Steven Spielberg

AND THE OSCAR GOES TO
MARTIN SCORSESE
FOR
"THE DEPARTED"

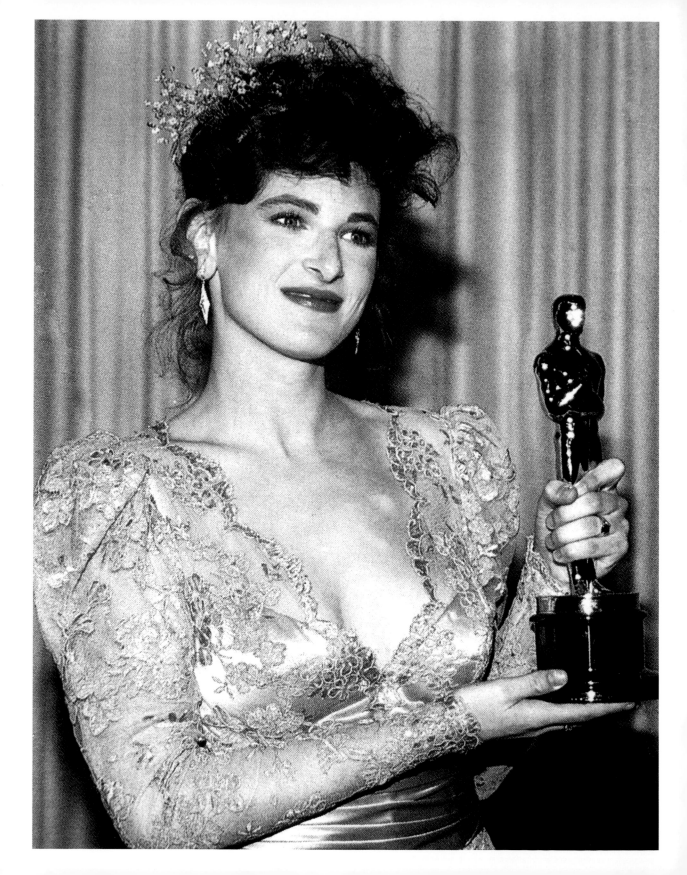

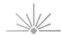

MARLEE MATLIN
BEST ACTRESS
Children of a Lesser God
1987

**"I just want to thank all of you.
I love you."**

Marlee Matlin's history-making awards season for her powerful performance in *Children of a Lesser God* came at a time of great turbulence in her personal life: She was in the throes of cocaine addiction, and her volatile two-year relationship with her costar, William Hurt, was nearing its end. As the previous year's Best Actor winner, Hurt, who was also nominated that year for *Children of a Lesser God*, presented Matlin with her Best Actress statuette. Although he gave her a sweet kiss when she accepted the prize and she acknowledged "his great support and love" in her speech, the evening turned darker between them later on. To this day, Matlin, who was just twenty-one, remains the youngest Best Actress winner ever, and thirty-four years after her victory, she starred in the Best Picture winner of 2022, *CODA*.

THE BACKSTORY

In all honesty, I wasn't in the know about the Academy and the Oscars, because I was someone who watched Miss America and Miss USA growing up. But when I did *Children of a Lesser God*, I began to go on a very fast track to learning what Hollywood meant. When I did the movie, everything was completely new. I was learning as I was working on the film—I had no previous experience. I had no understanding of what it would be like to make a movie—anything like that. I had a lot of learning to do at nineteen years old. Bill Hurt and I started dating the week of my screen test for the film. Not the most appropriate time, but it is what it is. I really wasn't told what the PR campaign was going to be for the film. I didn't even know that there was even going to be an

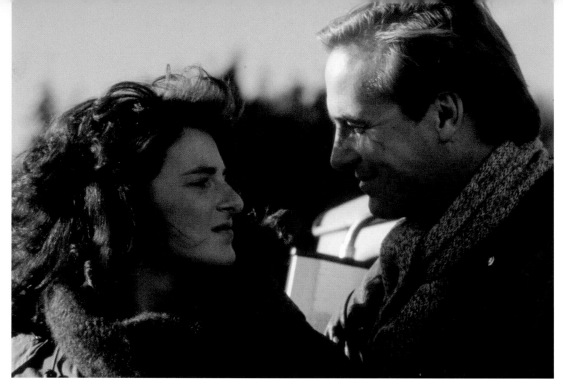

Matlin with costar William Hurt in *Children of a Lesser God*

awards campaign for the film. I had no idea. No one told me until the Golden Globes. And I had to deal with my own personal stuff, which needed my attention. And before I did anything else, I had to take care of it. So I decided the day after the Golden Globes to put myself in rehab for a month for my drug-addiction issues. I wasn't even thinking about, maybe there's going to be an Oscar campaign after the Golden Globes, if there's going to be interviews, if there's going to be photo shoots, if there's going to be magazine appointments, nothing. I didn't think about that at all. There was even a premiere in England with Princess Di and Prince Charles. I said, "I'm sorry, I'm not going to be able to go because I need help." And that's what I did. I went to Betty Ford the next

day. And I got nominated for the Oscar while I was in Betty Ford, so I was more concerned about my own personal well-being over whatever it was that Hollywood wanted to get out of me at the time.

THE COMPETITION

I was a fan of all the women who were nominated in my category, I mean, Jane Fonda was a big deal. Sissy Spacek was a big deal. Sigourney Weaver was a big deal. Kathleen Turner. I thought one of them was definitely going to win because they were established actresses—they'd been around so long. Everybody knew them. No one knew me. I was aware of the fact that if I did win, I would be the first deaf woman ever to win an Academy

Award for Best Actress and only the fourth to win for their first film. I was told that beforehand. I thought that would have been cool if that was going to happen. I didn't know that I was the youngest recipient of an Oscar for Best Actress. And I am glad that my record still stands as we speak.

THE LOOK

I remember I was in New York, and Jennifer Beals came with me to get measured by Theoni Aldredge, who was going to make and design a dress for me. I told her that I loved purple. And anything that you want to put me in purple was fine with me. A friend of mine who was a hairdresser flew in from Chicago and did my hair. He's not around any longer, unfortunately.

THE WINNING MOMENT

I was sitting there, and my heart was beating out of my chest. I was just staring right at Bill. And I remember he looked at me. He spoke my name. I immediately thought, *Is he teasing?* But then he signed my name. And I knew when he signed my name that he wasn't kidding. I had no speech prepared. I was authentic in the moment. I remember very clearly looking at Jane Fonda in the audience. We made instant eye contact. I remember seeing her and looking at Sissy Spacek too.

THE AFTERMATH

Bill congratulated me when I got the award. After I won, I stopped to look at the monitor to see if he had won the Oscar that night. When I found out that he didn't win, my heart sank. I was afraid to see how he was going to react later at home, the fact that I won and he didn't. After the ceremony, Bill held my hand, and we found our limo. We got inside, sat down, and he was just staring at me. I could see him thinking. He was very quiet. And he said, "So you have that little man there next to you. What makes you think you deserve it?" I looked at him like, *What do you mean?* And he said, "A lot of people work a long time, especially the ones you were nominated with, for a lot of years to get what you got with one film." I didn't even dare to argue with him. I thought to myself, *Is he right?* I mean, he *was*. But was he not happy for me? I was too stunned to talk. But it made me stronger. It just bounced off my back. It was my time. It was my night. And it was the beginning of my career. So fuck off. I left him a few months afterward, on July Fourth.

WHERE OSCAR LIVES NOW

My Oscar is in my office. People can see it right behind me when I make Zoom calls. It brings a smile to everybody's face. It's a thrill for them, and it's a thrill for me to see that.

DUSTIN HOFFMAN
BEST ACTOR
Kramer vs. Kramer
1980

**"I'm up here with mixed feelings.
I've been critical of the Academy, and for reason."**

Around the time that Dustin Hoffman earned his third Oscar nomination, for the 1974 biopic *Lenny*, he gave an interview taking the Academy to task for pitting actors and performances against each other. He declined to attend the ceremony that year, but the evening's emcee, Frank Sinatra, berated him in absentia from the stage, saying, "Contrary to what Dustin Hoffman thinks, it is not a disgusting evening, it is not garish, and it is not disrespectful." Five years later, Hoffman earned his fourth career nomination for his emotional performance as a suddenly single father opposite Meryl Streep in *Kramer vs. Kramer*. This time he showed up (with his soon-to-be second wife, Lisa), he won—over Al Pacino, Roy Scheider, Peter Sellers, and Jack Lemmon—and he attempted to right the situation with an impassioned three-minute speech that started off with a couple of jokes ("I'd like to thank my parents for not practicing birth control") before turning into a tribute to struggling actors and other industry professionals who weren't given the opportunities he himself had enjoyed. In all, *Kramer vs. Kramer* won five Oscars, including for Best Picture and for Streep as Best Supporting Actress. Later in the decade, Hoffman would go on to win a second Best Actor prize for 1988's *Rain Man*.

THE BACKSTORY

I was nominated for *Lenny*, and I didn't go. I remember I was married to my first wife, and we were on Sixty-Second Street in New York, where we lived, and we were watching the ceremony in the living room with a few people, and one of the people was Lillian Hellman. I was sitting in the back. There were

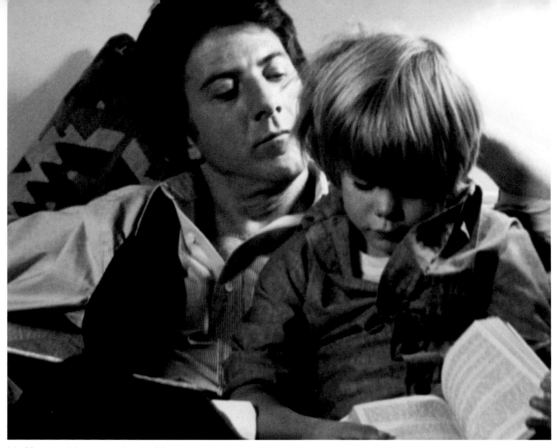
Hoffman with costar Justin Henry in *Kramer vs. Kramer*

people in front of me, and I remember when Frank Sinatra came on and literally took off on me, she turned and just looked at me and was like, "Wow." It was painful as hell. I started to tremble. And then I think the audience applauded and maybe even stood up. I thought there shouldn't be a best, because if there's a best, there's a loser. But it was stupid of me to even express what I was dissatisfied about. I should have known that things get taken out of context. That was one of the righteous feelings I had in my younger days, and I probably wouldn't say them today.

THE WINNING MOMENT

I did feel it was possible we may win, because of the awards that we'd already won. I think that was the first time Lisa and I were in public together, so I just gave her a peck on the cheek, and she tapped me a little bit on the knee. And I kissed Meryl, and she kissed me. And as I came down, yes, I kissed Jack Lemmon. It makes me emotional, because I think he was brilliant and not appreciated artistically as he should have been. He was known to be a comedian, or an actor famous for comedy, but he was a brilliant actor, I felt. And I think he knew that he wasn't going to win.

THE SPEECH

My wife had said, "You might win," because there had been a lot of awards already where *Kramer* had won, from the Hollywood Foreign Press, things like that. So I remember taking a walk on the beach by myself the day before because I had not prepared anything, and I was thinking, *What am I going to say? What should I say?* I knew I wanted to say something about how actors can't get up and just paint or write. We need a job to do what we do. The joke about birth control was just in my head. No, that was not prepared.

THE PERSPECTIVE

The Graduate was my first real film. How many actors have basically been in their first film and have it become a classic? Talk about a spin, a throw of the dice. And I was always aware; *Wow. What an extraordinary chance of luck.* I was aware people are going

Hoffman and fiancée Lisa Gottsegen being interviewed by Academy red-carpet greeter Army Archerd

to continue to judge me. Because people tend to believe what they hear. That's one of the things I heard all my career: "I hear he's very difficult." That's the nature of the beast.

WHERE THE OSCARS LIVE NOW

I was embarrassed—I don't know what other word to use—to display them. I put them in the closet, all the awards, and I had very mixed feelings about opening that particular closet door. And then there came a day—this is after therapy—and I said, "Fuck it," and I took the awards out of the closet, and I put them on my mantel in my study, and they are still there today.

HANNAH BEACHLER
BEST PRODUCTION DESIGN
Black Panther
2019

"I am stronger because of my family, who supported me through the roughest of times. I give this strength to all of those who come next, to keep going, to never give up."

Hannah Beachler had already broken new ground as the first-ever Black nominee in the category of Best Production Design. But thanks to her sprawling and ambitious work on *Black Panther*—her third film with director Ryan Coogler after the indie *Fruitvale Station* and the *Rocky* spinoff *Creed*—she also became the first Black winner. Beachler, a single mother and film school graduate who almost gave up on her professional dreams several times, accepted her Oscar alongside set decorator Jay Hart in a stunning Rami Al Ali gown. Reading her speech directly from her iPhone, she paid tribute to the friends, family, and colleagues who encouraged her along the way, ending with one important piece of advice.

THE BACKSTORY

I grew up in a very rural part of Ohio. It was just woods around us, like forests and creeks. I remember being on the shoreline of the creek with my brothers and sisters and we'd build a little shelter that was our castle. We just had our own little world in the forest. I was constantly making up games and worlds because there was nothing else to do. There weren't video games at that time in the mid-seventies.

THE PRODUCTION

Ryan gave me this opportunity and brought me into this moment, and I needed to really live up to that. I felt like, *Now I have this responsibility that's bigger than me, a responsibility for women in the industry to be able to do these types of films, for Black women to be able to do these types of films and lead a department.* I wanted to make sure that I was on point and doing my job, but of course,

Part of the *Black Panther* world Beachler created

it was lots of fun. If I really sat down and thought about how big it was, it probably would have stopped me in my tracks.

THE BIG DAY

I had gone to sleep like the next day was Christmas. It was not lost on me that I would stand in the mirror with my brush when I was eight years old and say, "I'd like to thank the Academy." And then to feel like, *Could that be something I'm going to say in real life?* It's hard for anybody to understand how that rubber-bands your mind. A little girl from rural Ohio—who would ever think? Certainly not I. So there was a lot of emotion going on that day.

THE LOOK

It was a little bit of a nightmare trying to find a dress. I got a phone call the day before the Oscars from the stylist, and she's like, "A dress just came in. Nobody has claimed it. Can you get over here right now and try it on?" She pulls out the red dress from Rami Al Ali. The outside was red and the inside was hot pink. And we're just like, "Okay, please let this fit." And it fit perfectly, like a glove. I just remember I was looking in the mirror, I turned around, my agent snapped a shot, and I just had the biggest smile on my face. It was like a wedding dress. We all started hugging and crying. That dress came in like an angel on a cloud. A friend of mine, Douriean Fletcher,

made the jewelry. She did some of the jewelry for *Black Panther*. And when I started talking about jewelry, I'm like, "I'm not the girl who wears diamonds or anything like that. I just want to do something that feels Wakanda but is simple and elegant." And she's like, "What about a face chain?" It was just one statement piece because the dress was enough.

THE WINNING MOMENT

In my heart of hearts, in my truth of truth, I honestly did not think I was going to win. I thought it was going to be *The Favourite* or *Mary Poppins Returns*. I felt like those were more the type of films that the Academy votes for. *Panther* was a superhero movie—I didn't know that there was an understanding of what I did. I just remember holding my son's hand. And my son was looking at me like, *Get up, you won!* It took a second for me to process. I was like, *Oh, my gosh, this is happening.*

THE SPEECH

I remember my agent saying, "Did you write something?" I just felt like, *How presumptuous of me to write something.* So I defiantly wrote it in my phone, thinking, *Well, I can just delete it.* It was really crazy when I went up there. I'm like, *Where is my speech? Oh, it's in my phone. How embarrassing.* It was a mess. I really was thinking about Ryan and the opportunity that he had given me, and my best friend from film school, Carol Trevino, who had passed away. We had talked about this, like, "When we get to the Oscars . . ." That was just our dream. And that little piece of advice at the end is what [Marvel executive] Victoria Alonso said to me. All the way through *Panther*, nothing was perfect enough and I'd be upset and I'd say, "It's not good enough." And she said, "Every day, say to yourself, 'I did my best, and my best is good enough.'"

THE CELEBRATION

Right afterwards, I ran into the cast. Lupita Nyong'o and Danai Gurira—they're my girls. So I cut it up with my girls at the Governors Ball, did a little dancing on the dance floor. And I was star-watching with my son. I'm not going to lie. We totally are those people. He'd be like, "Mom, there's Kylo Ren." And I was like, "Adam Driver! Can I get your picture with my son?" After we left there, we went back to the hotel and did a bunch of group family pictures. I go upstairs, and I'm going to change because I was going to Beyoncé's party, the Gold Party, and I'm just like, *Let me just lay down for like five minutes.* I had had some drinks, and it's probably like one or two in the morning at that point. I have this sequined dress on and these beautiful matching sequined shoes. I lay down, and then I woke up at six in the morning. And I had the Gold Party ticket in my hand. My assistant

came in, and she's like, "You were, like, snoring asleep. I didn't want to wake you up." And I was like, "I missed the Gold Party! Don't tell anybody. If anybody asks, I was there." But I literally fell asleep. I am the most boring person on the face of the earth.

THE PERSPECTIVE

At the time, it was this beacon of representation—it felt very much bigger than me, so I was a little disconnected from it because of the historical weight of that. That's when I started to understand: This is a moment of people seeing themselves in a place that they have not seen themselves, on a very large platform—and I need to lean into that moment. I started doing a lot of speaking with high school kids, elementary school kids, and focusing on city planning and design, showing that young Black and Brown kids can be in these fields. So I didn't really accept it for myself. Now, I look at it, and I think, *There's an acknowledgment that I am one of the best at my craft.* Saying something like that is hard to say because you don't want to be arrogant. As I get older, I start to learn and understand that it's okay for me to look at that and feel like I earned it. I earned it by my hard work. I earned it by my loyalty to my friends who trusted me with something very special and precious to them. I earned it over the twenty years that I've been in this business and started from the very bottom and worked my way up. So I deserve it. And now I'm starting to learn how to accept that fact.

WHERE OSCAR LIVES NOW

I have my Oscar right in my living room, in my little MasterCraft bronze curio cabinet that I got for it. I giggle sometimes when I see it. I look up, and I'm like, *Oh, that happened.*

Beachler celebrating with *Black Panther* stars Danai Gurira and Lupita Nyong'o at the Governors Ball

CAMERON CROWE
BEST ORIGINAL SCREENPLAY
Almost Famous
2001

"The movie was a love letter to music and to my family. So I dedicate this to all the musicians who inspire us, and to my family."

In 1997, *Jerry Maguire* garnered two Oscar nominations for writer-director Cameron Crowe, for Best Picture and Best Original Screenplay. Four years later, his personal, music-heavy film *Almost Famous*, featuring Best Supporting Actress nominees Kate Hudson and Frances McDormand, seemed destined for repeat nominations in those same two categories but ended up missing the cut for Best Picture. Still, Crowe's screenplay emerged victorious over heavy hitters *Gladiator*, *Erin Brockovich*, and *Billy Elliot*, as well as critical favorite *You Can Count on Me* by Kenneth Lonergan. Crowe later adapted the screenplay, which was largely inspired by his advice-spewing mother, into a Broadway musical, which premiered in 2022.

THE SCREENPLAY

The love-letter-to-music part of *Almost Famous* is just the power that a piece of music can have in your life: hearing it at the right time, becoming obsessed with the message of it, realizing it's a souvenir of a time of your life that you'll remember forever. I wanted to marry that with the cracks in my family dynamic and how much music healed my family. This little reporter character bubbled up to the top, and it became about my family and the same theme: loving music.

THE EXPECTATION

There was a lot of momentum for the movie to get a picture nomination and it didn't happen. People said, "*Chocolat* got your slot." My mom had been saying, "Practice your speech,

from the
writer / director of
"Jerry Maguire"

A CAMERON CROWE FILM

ALMOST FAMOUS

DREAMWORKS PICTURES PRESENTS A VINYL FILMS PRODUCTION OF A CAMERON CROWE FILM "ALMOST FAMOUS" BILLY CRUDUP
FRANCES McDORMAND KATE HUDSON JASON LEE PATRICK FUGIT ANNA PAQUIN FAIRUZA BALK NOAH TAYLOR and PHILIP SEYMOUR HOFFMAN
MUSIC SUPERVISOR DANNY BRAMSON SCORE BY NANCY WILSON COSTUME DESIGNER BETSY HEIMANN EDITORS JOE HUTSHING, A.C.E. SAAR KLEIN DIRECTOR OF PHOTOGRAPHY JOHN TOLL, A.S.C.
CO-PRODUCER LISA STEWART PRODUCED BY CAMERON CROWE IAN BRYCE WRITTEN AND DIRECTED BY CAMERON CROWE

 www.almost-famous.com DREAMWORKS PICTURES

practice your speech" all day. I had been like, "No, I really don't have to practice my speech." Kenneth Lonergan was in my screenplay category, and he was picking up every award. Kate Hudson was on a big ride, and you could feel that she had a lot of momentum. It was a beautiful awards season for her; she got a lot of attention and handled it so well and was just so elegant. So the dream was Frances or Kate, something might happen with them. So it was jarring when the first award of that night went to Marcia Gay Harden. The story I heard that was so cool was that after Kate lost, Kurt Russell just leaned over to her and said, "Congratulations, now you have a career." Which is pretty wise. When Kate didn't win, it was like, "I told you. Come on, let's enjoy ourselves and not get pulled into the competition of it. It's not going to happen." That was good because I have a huge fear of public speaking. So there was a kind of a relaxation thing that took over.

THE WINNING MOMENT

Tom Hanks was giving the award. That was kind of cool because *Jerry Maguire* had been written for Hanks, but I think he had a structural issue with Jerry getting married at the end of the second act. I had the greatest conversation with him, but he passed. So I knew him a little bit. It just felt like, *Here it goes, I'm going to lose. I'm going to cheer.* And then

Hanks said my name, which was completely psychedelic. I got up, and I started going up the steps, and he clearly saw terror in my eyes. I remember that moment. And what he said was "This is going to go really, really well." It was the most soothing voice you've ever heard. It was like, *There's St. Peter,* you know? He was Mr. Soothing Man. Best bedside manner ever.

THE SPEECH

I remember looking at my mom and my sister and loving that they were together after a significant amount of estrangement. I mentioned Billy Wilder and his wife, Audrey. I had been interviewing him, and it became the greatest film school session that I could have dreamed of. I learned so much about character, and about laughing and crying and the marriage of those two things. I felt like *Almost Famous* was in some ways a tribute to Billy Wilder. *The Apartment* was a big influence in the whole thing, so it felt right.

THE CELEBRATION

We went to the DreamWorks Party. I remember meeting a rather unimpressed Ridley Scott. I think he wasn't happy with my win. And that's where I saw Steven Spielberg, and he said, "Sleep with the Oscar under your pillow." I remember that. And I did it. It was lumpy, but it was the right thing to do.

THE PERSPECTIVE

Original Screenplay is my favorite category—it represents a blank page filled with a new idea. It's just a really satisfying thing to know that you're part of this line of people that have gotten that award. I still have to pinch myself. That list is a mighty list, and the fact that it came in that same little era where I had the privilege of hanging out with Billy Wilder. It really felt like a total shock and surprise. If ever you're set up to not expect something, that was what the *Almost Famous* award season was.

THE AFTERMATH

Some projects win an Oscar, and they peak there. I feel like not that many people realize that *Almost Famous* actually won the screenplay Oscar. What they do know is that somebody turned them on to the movie. They never saw it in the theater. But somebody said, "Check out *Almost Famous*—it's a movie I love." Through streaming and VCRs and stuff, that's why *Almost Famous* is where it is, because fans have embraced this movie about being a fan. Our family story won an Oscar. And it's hugely wild that it would go to Broadway. I take none of it for granted.

WHERE OSCAR LIVES NOW

It's downstairs in my writing office. But not, like, in a place where you just look at it all the time. It's just tucked away in a corner there, in a place where it surprises me from time to time that it exists. That's a thrill that keeps coming back. And it never gets old. The movie and the play brought my family together in a big way. So that's a rare award, really.

Crowe with *Almost Famous* star Kate Hudson

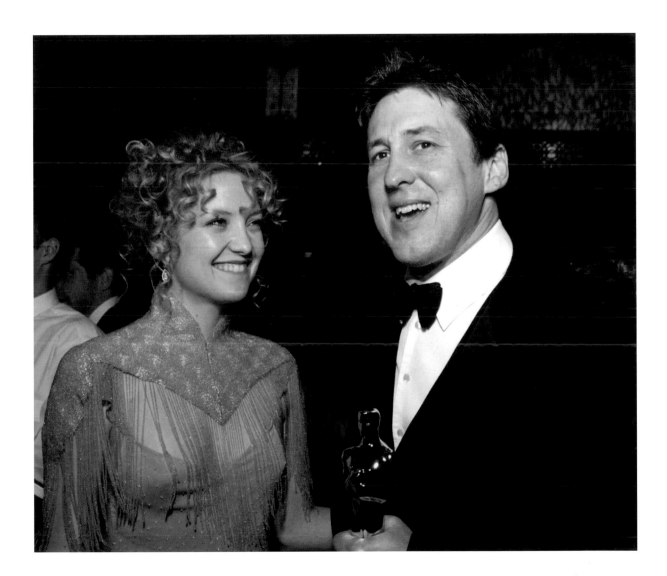

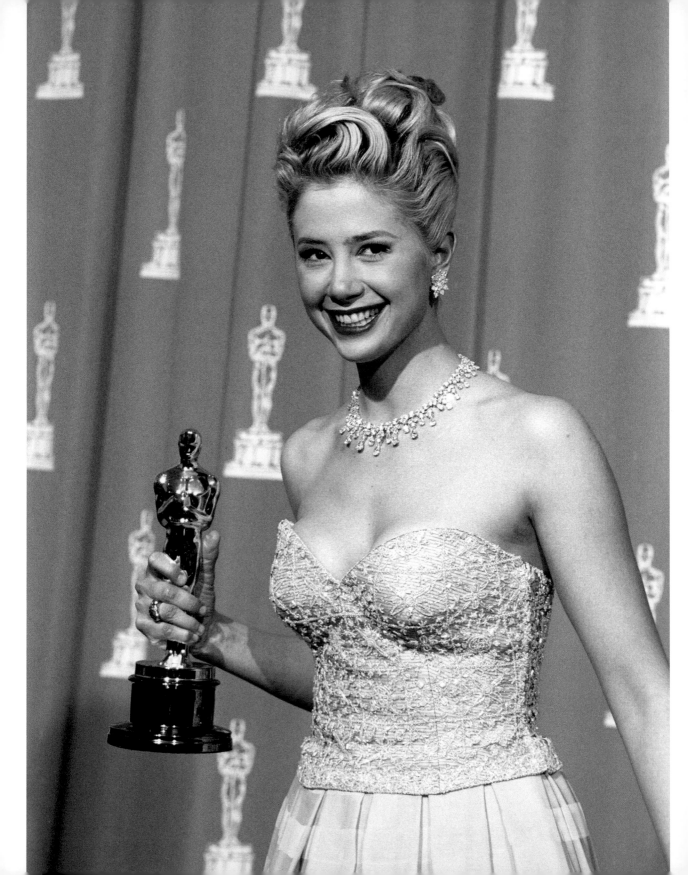

MIRA SORVINO
BEST SUPPORTING ACTRESS
Mighty Aphrodite
1996

**"When you give me this award,
you honor my father, Paul Sorvino, who has
taught me everything I know about acting.
I love you very much, Dad."**

Mira Sorvino's Best Supporting Actress win for her multifaceted performance in *Mighty Aphrodite* is intertwined, for better or worse, with three older male Hollywood figures. In one of the sweetest moments in the history of the Academy Awards, she took time in her acceptance speech to acknowledge her father, veteran actor Paul Sorvino, causing him to break down in the audience. But Sorvino's triumphant moment is tainted by the complicated and problematic legacies of two of the people most responsible for bringing the film to the screen: writer-director Woody Allen and Miramax studio chief Harvey Weinstein.

THE BACKSTORY

I just loved watching old movies. That was something I would do with my dad—I would watch the old, beautiful Ginger Rogers–Fred Astaire films. I was intoxicated by that glamorous period. I say this with reverence for him, but my father, since he was never nominated, I think maybe he had a little bit of an attitude about the Oscars, like, *If they're not interested in me, I'm not interested in them.* So he downplayed their importance. We didn't religiously watch them every year because I think it made him feel bad not to be invited to the club.

THE PRODUCTION

I didn't know beforehand how big the role was. At the audition I didn't even know what the character did for a living. I asked, "Is she a massage therapist? Is she a call girl?" And

Sorvino as Linda Ash in *Mighty Aphrodite*

they reluctantly answered that she was a call girl. Only after I got the offer was I allowed to read the script. When I read it, I was like, *Oh my gosh, this is the best role I've ever read.* It had so much heart.

THE LOOK

I wore a runway dress from Armani. It had a much fuller skirt, and we took out some of the pleats and some of the puffiness of it because it just didn't flatter me that way. But I just loved that beautiful, embellished, crystal-gray bustier. I know I was working out the night before vigorously on a treadmill to try to fit into it. We wanted to go, as I often do,

for an old Hollywood glamour. That's just my favorite. I had just played Marilyn Monroe in *Norma Jean and Marilyn* with Ashley Judd, so I was coming from that very platinum-blond glamour style, and I think my head was still in that era a little bit. I believe the necklace was Harry Winston. What an incredible treat. I must have been wearing a king's ransom around my neck.

THE BIG DAY

The whole thing was very dreamy but very stressful, because the eyes of the world are on you. I had never felt that comfortable in front of a still camera. It made me very nervous.

I had a one-bedroom, modest apartment in New York; I didn't have a car, I was not a rich person. I think I made $10,000 on *Mighty Aphrodite*. I just was like a deer in headlights. I almost had a panic-attack feeling. It's very overwhelming. I was with my boyfriend at the time, Quentin Tarantino. I think we must have drunk at least a bottle of champagne in the car on the way over.

THE WINNING MOMENT

I wasn't going to write a speech because I thought it was ostentatious. I didn't think I was going to win because I was young and a first-time nominee. And then the night before I had a dream that I should write a speech, so while I was in hair and makeup in my room, I wrote some stuff down on a card. I remember thinking to myself, *Okay, remember, they always film people as the other person wins, so just be gracious and happy for whoever wins.* And then they called my name, and it was so crazy. I felt like I floated up the stairway. I felt like I didn't use my feet, like somehow the big skirt just carried me like a puff of air. I got up to the top and I felt a wave of love. I'd never felt anything like that.

THE SPEECH

It is true that my dad gave me all my formational acting instruction. When I was eight, my dad used to have me sit on the stairs and think about something very sad until I was in tears. That was the weird childhood I had. I was burning those neural pathways to sadness. I have such an easy access now to sadness and pain. But it started there on that stairway on Boulder Road in Tenafly, New Jersey: "Don't come down until you're really crying." When I said that in my speech, he burst into tears and started sobbing. I think he was very proud, but he was also very touched and surprised that I would take my moment and kind of give it back to him. So many people posted that after he died.

THE PERSPECTIVE

Winning was such an unexpected honor and a validation that I was on the right path career-wise, that I was good at what I did, that I was giving people happiness through what I did. Sadly, a couple of years later, Harvey Weinstein blackballed me. He started his sexual harassment on the tour for *Mighty Aphrodite* at the Toronto Film Festival. I really pinpointed it to the third time that he came on to me and I rejected him in Cannes in 1998. From that point on, I was shut out of studio movies. It really messes with your head. It's different when fate takes something from you, or a *person* takes something from you. If something just doesn't go your way, well, that's the way it breaks. When it's a bad *person* trying to hurt you because you don't want

to sleep with them, and he manages to poison the well for you across the industry, that's tough. I don't talk much about him, and I have very mixed feelings that that's how I won my Oscar. So everything in my life is a little bit mixed up. But having the Oscar to look back on means I am that person who delivered at that performance. And no one can take that away from me.

WHERE OSCAR LIVES NOW

I have an antique Steinway grand piano from the nineteenth century that I found in an auction in Los Angeles. It's just sitting on top of that. We've got a house full of cats and dogs and kids' stuff and toys, and our life is very messy and full. And sometimes I even feel guilty, like, *Oh, there's Mommy's Oscar—I should hide it away.* It sets a standard for my kids that's hard to live up to. Sometimes I worry about that. But I should be proud of it, you know?

Sorvino with her father, Paul Sorvino

KEVIN O'CONNELL
BEST SOUND MIXING
Hacksaw Ridge
2017

**"Mom, I know you're looking
down on me tonight, so thank you."**

Kevin O'Connell seemed destined to make it into the Oscar history books—just for the wrong reasons. From 1984 to 2008, O'Connell, a prolific and sought-after post-production sound mixer (or re-recording mixer), received twenty nominations in the categories of Best Sound or Best Sound Mixing for such sonically impressive films as *Dune*, *Top Gun*, and *Twister*. And he lost all twenty times. It wasn't coming home empty-handed that bothered him; he truly felt honored to be nominated each time. But the years of press coverage labeling him "the biggest loser in Hollywood" or "the Susan Lucci of the Oscars" took an emotional toll on him. After a nine-year period in which he didn't earn any nominations, he found himself back in the running for the twenty-first time in 2017, thanks to his meticulous work on director Mel Gibson's visceral war film *Hacksaw Ridge*. His surprising victory for Best Sound Mixing over presumed favorite *La La Land* provided a heartrending moment in which O'Connell was able to pay tribute to his late mother, Skippy O'Connell, who had helped him break into the industry decades earlier.

THE BACKSTORY

When I was eighteen, I went through fire department training and became an L.A. County firefighter in the Brush Division. I was still living at home at that time, and I would come home, and my mother would see me burnt to a crisp after I spent three days on a fire. My mother worked in the sound department at 20th Century Fox from the mid-sixties all the way up until the late eighties. And everyone in the business knew Skippy. She said, "Listen, I really hate this career for

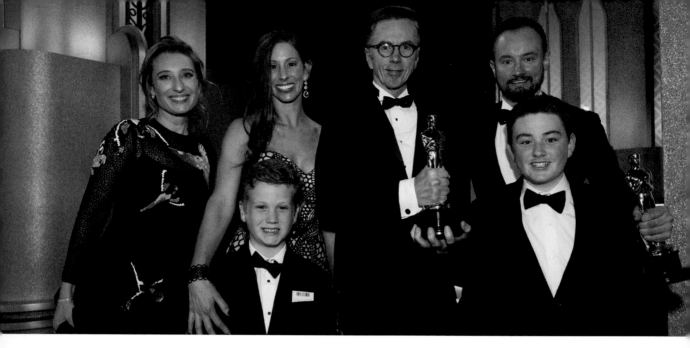

O'Connell with fellow winner Andy Wright and their family members

you. Why don't you try the studio?" So I made the leap, and in January of '78, I went to work at Samuel Goldwyn Studios, which later became Warner Hollywood. I got to work on some great movies, like *Grease*, *Raiders of the Lost Ark*, and *The Empire Strikes Back*. I said to my mom, "How can I ever thank you?" She was just having a beer that night at the table, and she goes, "I'll tell you how you can thank me. You work hard, you work really hard. Then you go win yourself an Oscar. You can stand up on that stage and thank me in front of the whole world." Those were her exact words. And that's what I said in my Oscar speech.

THE FIRST TWENTY NOMINATIONS

I'd gone to every single ceremony. The only one out of all the twenty that I thought I had

a shot at was when we were nominated for *Top Gun*. There were ones where it's probably better that I didn't win because I drank too much. There were ones that I was frustrated that I didn't win, and I left after our award and walked down the red carpet and went home and watched the rest of the show in my pajamas. And then there was one in 2007, unfortunately, where my mother was in the hospital. I left right after our category to go be with her in her final moments when she died that night—on Oscar night.

THE COMPETITION

Traditionally in our category, musicals are always tough to beat because people in the Academy at large associate Best Sound with music. The prognosticators had *Hacksaw Ridge* losing to *La La Land*, which I totally

thought was going to happen as well. I had no preconceived ideas that we were going to ever beat *La La Land* that night because we lost both our guild award and the BAFTA to *La La Land*. Pretty good indicator of how the Oscar was going to go, in my opinion. My children were, like, ten and fourteen years old. I wanted to take them to the Oscars, but I knew what it would feel like when I lost, and I didn't want them to have to feel that. But then I thought of it as a teaching moment for them to learn how you can lose gracefully and still hold your head up high, which I was fully intending on doing that night.

THE WINNING MOMENT

I was absolutely shocked. I just ran down to the stage as fast as I could because it was the greatest moment of my life, to be honest with you. I remember that I stood there and I looked out at the audience. For thirty-three years, I was always the guy sitting in the stands, clapping, watching somebody else onstage. I just took it in for a minute, and the feeling coming over my body was completely overwhelming.

Andrew Garfield in a scene from *Hacksaw Ridge*

If I could bottle up the feeling that I had that night and share it with the world, nobody would ever need to do drugs ever in their life. It was the most euphoric, amazing feeling that anybody could ever have.

THE AFTERMATH

I remember going home. My wife went up to bed. I'm sitting in the kitchen just by myself with the Oscar sitting on the table. And I just remember sitting there, just having this moment of like, *I can't believe this finally happened.* I said a little prayer and talked to my mom about it. And then I went up and went to bed.

WHERE OSCAR LIVES NOW

It's such a personal thing for me. It's not a "look at me" moment for me. For three or four years, it sat up in my closet behind my shirts so that if a burglar came in the house, they'd have to go everywhere in my house and look in the closet and then slide the shirts over to find it. It took so long to get it, I just didn't want to lose it. Then about a year ago, my wife remodeled our downstairs and took it and put it on a shelf. And I said, "Okay, I'll live with it being down here for a while." So now it's residing downstairs in our TV room on a shelf.

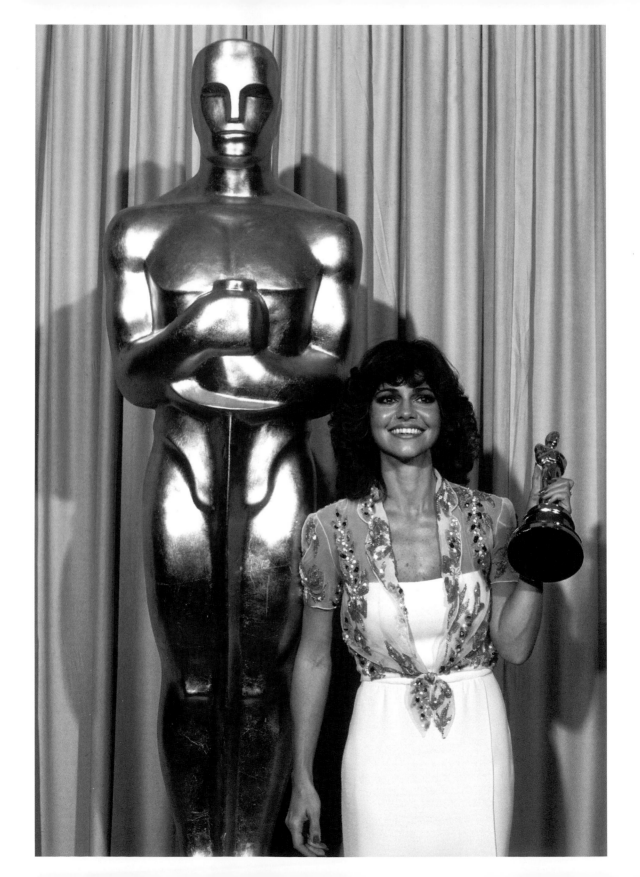

SALLY FIELD
BEST ACTRESS
Norma Rae
1980

"They said this couldn't be done."

So much attention has been paid to Sally Field's 1985 Best Actress win for *Places in the Heart* and, specifically, her perpetually misquoted "You like me" acceptance speech, that it's easy to forget that she won her first Oscar five years earlier for her career-changing titular performance in Martin Ritt's *Norma Rae*. The film premiered at the 1979 Cannes Film Festival, where it won the Best Actress prize and set Field on an awards sweep of the National Board of Review, New York Film Critics Circle, Los Angeles Film Critics Association, National Society of Film Critics, Golden Globes, and Academy Awards. "*Norma Rae* was a real gift to me," said Field in her speech, acknowledging all the collaborators who helped her make the rare leap from TV sitcom darling to respected, Oscar-winning actress.

THE PRODUCTION

It was the first film I starred in. It was so hard to get out of situation-comedy television to real work in the sixties. Men did it—Steve McQueen and James Garner and Clint Eastwood—but they were all in hour-long episodic things, and they were men. Marty wanted to meet me [about *Norma Rae*]. He said that they had offered it to five other actresses, and they had all turned it down. "This should be yours. The studio does not want you, but I want you. I will fight for you, and I will win," he said. So when I went to work on this, I finally got to do what I had studied to do. I had worked so long and so intensely with Lee Strasberg, I was so ready. It changed my life both as a human and as an actor. It was absolutely the most acting fun I'd ever had, because I could finally feel what performance muscles I had built that I had never had the opportunity to use.

Field on the *Norma Rae* set with director Martin Ritt

THE BUZZ

Then came the word that it was going to go to Cannes. I'd never been to Europe. I had seen the film with my mother, just a screening with she and I. And my mother said, "That's it?" But there we were, in Cannes, watching it with an enormous audience. They put the cast right in the front of the balcony. I was drenched with sweat by the time it was over. And it is a moment in my life that will never be replicated. I will never feel that again. The lights went off. There was a beat, beat, beat, and then the entire audience rose to its feet and applauded. Marty made me stand and they kept applauding and applauding and it went on. Alan Ladd Jr., who was the head

of Fox at the time, timed it—like ten minutes or something. And I started to cry and Marty moved away and made me stand there, alone. It was life-altering, to feel that the work that I'd worked so hard to be able to do was being appreciated. After that, everything just started to fall into place that year. I won every single acting award that was possible.

THE BIG DAY

I remember I went someplace and had my hair done. I don't believe I had anybody do my makeup. In those days you just did it yourself. I did have Bob Mackie make the dress for me— he used to do all the clothes for Cher and for *The Carol Burnett Show*. He offered to do it,

Field with her Oscar dates, David and Judy Steinberg

and he was such a lovely guy. But it was a lit-
tle white suit. And I remember thinking, *Oh,
don't I get a princess dress?* He said he thought
I wasn't that fancy. So I put that on. I had been
dating Burt Reynolds at the time, but Burt was
not happy with what was happening to me. He
did not want me to go to Cannes at all. He said,
"You don't think you're going to win anything,
do you?" Then when the Oscars came around,
he really was not a nice guy around me then
and was not going to go with me. David Stein-
berg was a friend of ours, and I adored him
and his then-wife, Judy. I didn't know what
to do, then David said, "Well, for God's sakes,
we'll take you." He and Judy made it a big cele-
bration. They picked me up in a limousine and
had champagne in the car. They made it just
wonderful fun.

THE SPEECH

No one thought I could do this. And Marty saw something—he handed the opportunity to me. All of it was this enormous gift. By the time the Oscars arrived, I think I was just kind of numb. When I heard my name, all I could think was, *Just get this done.* I couldn't feel it then. And I think that ultimately affected my speech when I won the second time, because I wanted to be able to feel it—that the work was being recognized and that it mattered so much.

THE CELEBRATION

There was a party up at the old Spago. I had my Oscar in my hand, and I was so excited to go. But by the time I had done all the press, everybody was leaving and getting in their cars. I went, "Oh no! I missed the party!" But I went into Spago and there were a few people there. We were looking for a place to sit down and somebody stood up and said, "Over here!"

And I looked over and it was Cary Grant. I had run into him once doing *The Flying Nun.* I was dressed in my nun's outfit and I was also eight months pregnant at the time. And he said something to me like, "Oh, sister, does the big man know about this?" I don't think he remembered, but I sure as hell did. I sat at the table and I looked and I was next to Cary Grant and Audrey Hepburn. And I kind of went, "Hi!" I turned into Gidget again. It was almost too much to take. I wish I'd had my wits about me.

THE PERSPECTIVE

When I was doing it, I could feel my own struggle. When I could live in Norma, I had to stand in her feet and I started to own some pieces of myself. [The Oscar] changed people's attitude towards me. I was more included in the thought process of casting or whatever. But it was still up to me to keep trying to get better, keep trying to fight to get to the work.

═ WHERE OSCAR LIVES NOW ═

I have it in the family room. It's on the bookshelves with books and a picture of my mother. I also put it together with a wooden bobbin spindle that the mill workers gave me. That means almost as much to me as the goddamn Oscar that's sitting next to it.

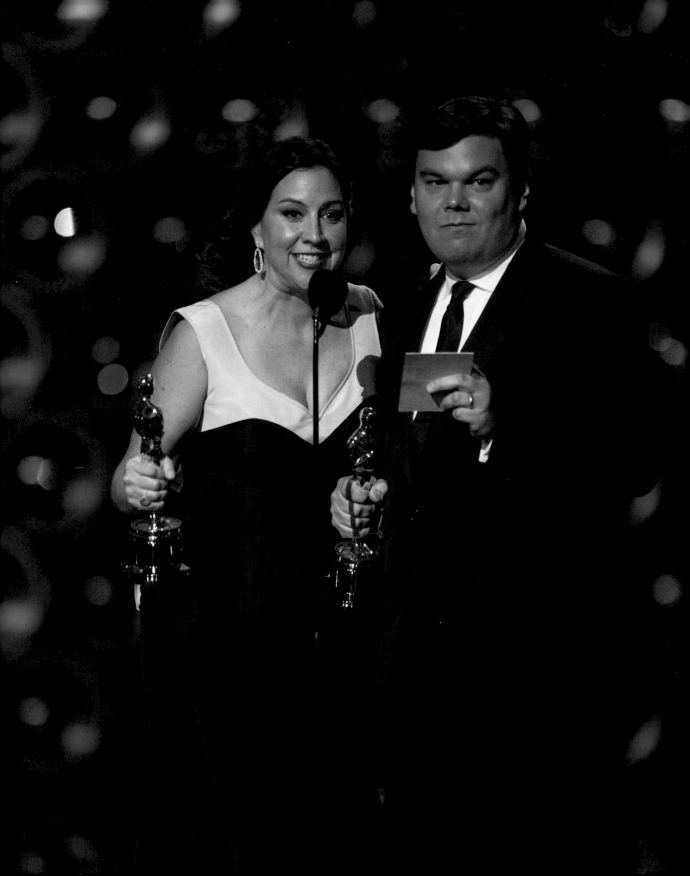

KRISTEN ANDERSON-LOPEZ & ROBERT LOPEZ

BEST ORIGINAL SONG
Frozen
2014

"To our fellow nominees:
You are all rock stars. Literally."

Husband-and-wife songwriters Kristen Anderson-Lopez and Robert Lopez may have created one of the biggest movie songs of all time, but at heart they were just Brooklyn parents who found themselves rubbing shoulders with icons at the Academy Awards ceremony. With their Oscar win for their inspiring and ubiquitous *Frozen* theme, "Let It Go"—performed in the film by Idina Menzel as the character of Elsa—Robert, part of the team behind the hit Broadway musical *The Book of Mormon*, became the youngest person ever to complete the EGOT, at age thirty-nine. For Kristen, the Oscar was her first major awards win, followed in subsequent years by two Grammys and an Emmy.

THE SONG

KRISTEN: We knew that Elsa needed to have a transformation into the Snow Queen, and we knew that our job was to write a kick-ass transformation song that came with a wonderful clothing change. On the outline, it was called "Elsa's Badass Song." I pitched the three words *let it go* in a meeting. I was like, "I think the song is called 'Let It Go' because she's letting go of her past, but she's also letting her powers go."

ROBERT: We were keen to write a song that would stick, because we had already written

Frozen heroine Elsa

a couple of songs that had fallen away. When we finished "Let It Go," we thought, *This will be the song of this movie for sure.* Then once it came out, people kept discovering it, and it kept growing. It was just incredible. I never imagined any success in my career. I always thought I'd be scraping by as an Off-Off-Broadway composer.

THE PINCH-ME MOMENT

KRISTEN: There was a party the night before the Oscars that we went to, and my hero is Oprah. She had this mantra, "You are not

your thoughts; you are the *thinker* of your thoughts," that was helping me through this very anxious time of being up for an Oscar with Pharrell and Bono. And there she was at this party and she came up to us and was like, "The universe is shining on you!" I gave her a big hug and we just got into this wonderful conversation that blew my mind.

THE BIG DAY

ROBERT: We were there with our kids, who were nine and five at the time. They were very much in that *Frozen* demographic. They

had been in the movie, they did voices. So it all felt like a big celebration of our family.

KRISTEN: I realized I hadn't signed my daughter up for softball. So I woke up at three in the morning and went to this bathroom in this big California house we had rented, and I was trying to fill out all the forms online to sign up my daughter for softball, but I missed the deadline. Then it was, like, four thirty and I wasn't able to go back to bed. It was the first time I ever had a stylist. And she had gotten this very fancy makeup team to come. I had never experienced that. The kids were all really excited watching that transformation: "Oh look, she's got eyelashes on!"

THE WINNING MOMENT

KRISTEN: One of the people we were with had snuck in a plastic flask. I was like, "You know what? I want to stay clearheaded. I want to be able to remember every second about this evening." But five minutes before our award, John Travolta introduced Idina Menzel as "Adele Dazeem." The minute that happened, I was like, "Pass me the flask!" So we had both taken a shot of whiskey before we had to go up there. We had to pass almost everyone we were nominated with. I wanted to give Pharrell a hug, but instead, it sort of looks like I hit him. And then I had this purse, and I didn't know what to do with it so I gave it to Jamie Foxx. It was definitely, like, Kristen

Anderson awkwardness there for a second.

ROBERT: I had been the one with the big career, and Kristen hadn't really gained recognition yet. To see her recognized with the award, I just felt so good just to know that the world was getting to know her. I was just incredibly excited by it. Our marriage was changed for the better, I think.

KRISTEN: Other men might have been threatened by it, but Bobby seemed to be turned on by it. So that was good.

THE EGOT

KRISTEN: We really didn't think it was going to happen. We had already lost the Golden Globe to Bono, and we were up against Pharrell, and "Happy" had been the song of the Olympics. But just in case, the girls and I made him an EGOT necklace out of cardboard and pasta and string. I had to keep it hidden from him.

ROBERT: I was excited that it might happen. But when it happened, I felt like maybe I was a little too young. I wasn't really in the class of people who were also in the club, you know? They were all legends and great artists. And I still had a long way to go, and still do.

THE AFTERMATH

KRISTEN: We had to go right back to Brooklyn because the kids had school. We got home, and then it was right back to, like, yoga

pants and school drop-off and very, very normal lives. Then the doorbell rang the next day, and there was somebody with a whole case of Ace of Spades champagne and three hundred pink roses, with a note from Oprah that just said, "Told you so." Every time something exciting would happen over the course of the next year, we'd be like, "Is it worthy of Oprah champagne?" The three hundred roses were the kind that just lasted and lasted and lasted. Like, somehow, Oprah's roses don't die.

WHERE THE OSCARS LIVE NOW

ROBERT: We had them in different places in our house. And then we realized it sends a weird message. It's just weird to have awards kind of confronting you as you come in. And our kids doing their homework—they don't need to be in the presence of this stuff all the time. So we put them in a cabinet in our office. The only shelf they'll fit on is the top shelf. So they're all standing across the top.

KRISTEN: Our friend sewed them sweaters, so they each have their own sweaters. There's a *B* and a *K*.

Robert Lopez sporting his homemade EGOT necklace, alongside Kristen

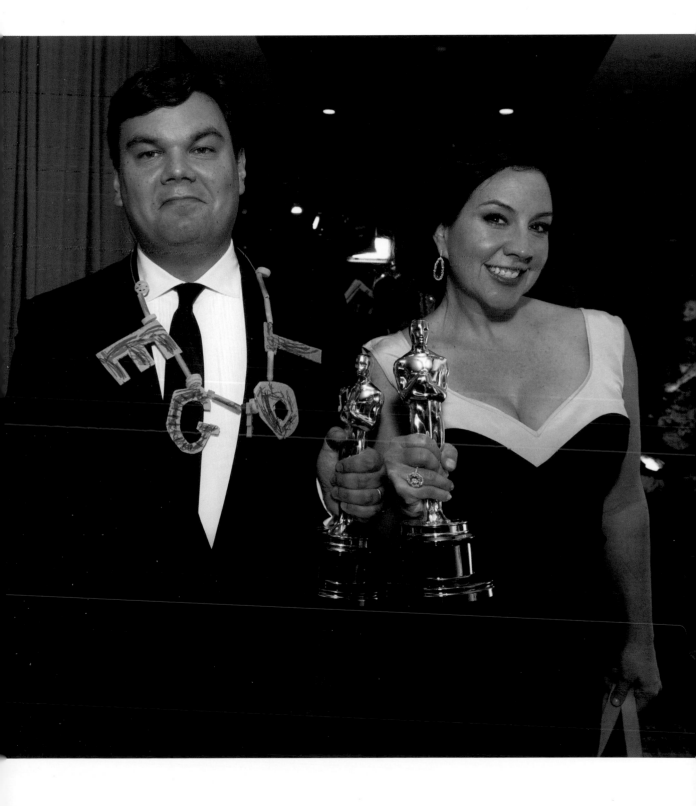

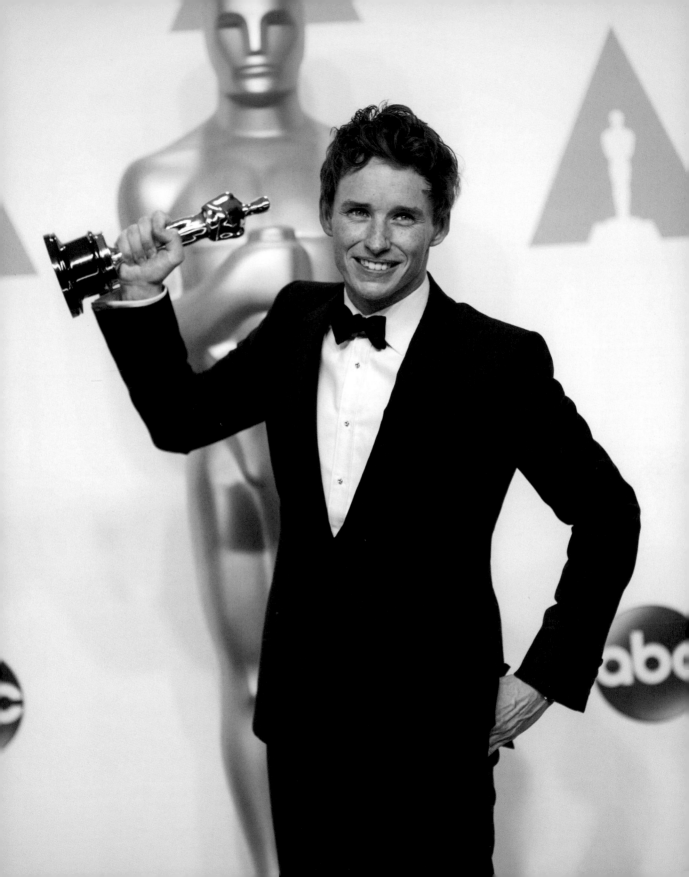

EDDIE REDMAYNE
BEST ACTOR
The Theory of Everything
2015

"I don't think I'm capable of articulating quite how I feel right now, but please know this: I am fully aware that I am a lucky, lucky man."

For Eddie Redmayne, the winter of 2014–15 was packed with eventful moments: He completed his global press tour for *The Theory of Everything* (in which he gave a riveting performance as scientist Stephen Hawking), got married, and won the Oscar for Best Actor despite being nominated against Michael Keaton, the beloved star of that year's eventual Best Picture winner, *Birdman*. The season was not without controversy: There were no performers of color among the twenty acting nominees that year, leading to the hashtag #OscarsSoWhite and a substantial change in the membership demographics of the Academy. But for Redmayne, it was a night filled with special moments—even if he blacked out for several of them.

THE BACKSTORY

The level of pressure that I felt from when I was cast—I'll never forget there was an article in one of the trades saying something like, "Eddie Redmayne is cast as Stephen Hawking, the sort of part that wins Oscars." From the second that it was announced, I was like, *You basically fail if you don't win an Oscar.* That whole period was overwhelming. It was stimulus more than I could almost cope with, going from the extremes of putting this film that I was passionate about out into the world, feeling a responsibility for Stephen Hawking and his family, going on this gigantic promotional trail, then coming back and getting married just before Christmas, all the while prepping for *The Danish Girl.* It was an extreme moment in my life. I remember being underweight because I had to lose weight for *The Danish Girl,* being jetlagged, and my body

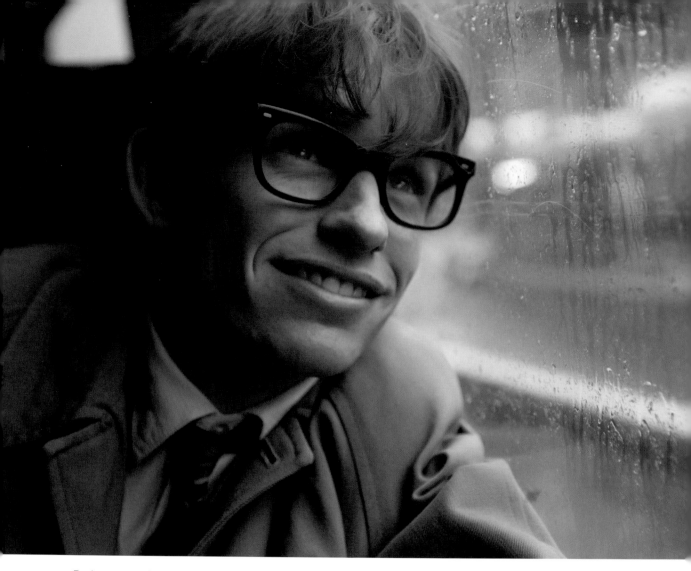

Redmayne as Stephen Hawking in *The Theory of Everything*

being quite exhausted, but being so excited at the prospect of going to the Oscars.

THE CONTROVERSY

I absolutely understood the anger. One of my favorite performances of that year was David Oyelowo's towering turn as Martin Luther King in *Selma*, and his was a particu-larly glaring omission in the acting category. Awards are inherently strange things—every year there are slights and snubs, and we understand that, given there are often more deserving people than nominees. But histori-cally, artists of color, and Black artists in par-ticular, have been short-changed, not because of talent, but because of implicit bias. I think

#OscarsSoWhite became a turning point. It awakened people to the fact that the pool of decision makers in our industry needed to be urgently expanded so the industry itself could be more reflective of the world we live in.

THE PINCH-ME MOMENT

I remember doing an interview on the red carpet and suddenly Cate Blanchett grabbed me. I'd worked with Cate on one of my first films—I played an assassin trying to murder her as Queen Elizabeth. She gave me a gigantic squeeze and wished me all the luck and told me that she was going to be reading out my category. That suddenly made the thing very real.

THE WINNING MOMENT

Cate Blanchett suddenly walked on. My wife, Hannah, and I had this double take that this was the moment. I absolutely thought Michael Keaton was going to win, so the moment came as a complete shock. From then is a complete blur. My next memory is being whisked into a press room and someone asking me a question in an Australian accent about two of my favorite actors from *Neighbours*, which was my favorite soap opera growing up. That was the moment when life became real again. I then remember going from there to do a photograph with Julianne Moore, who won Best Actress. I did a film called *Savage Grace* playing Julie's son many years ago, which was a film that was little seen but an extraordinary moment for me. It was her support that got me the part, and it was a real leg up in my career. I hadn't seen her for an age and that was very emotional, the fact that we had both won. And I remember her saying, "Now maybe someone will see our little incest movie."

THE CELEBRATION

Suddenly I was in a minivan with Kylie Minogue, this extraordinary pop star who I had never met before, and we were on our way up to Madonna's manager's house. It was the party to end all parties. It was the moment in which I witnessed Beyoncé dancing to Beyoncé. At the end of that, my wife, who is always the life and soul of the party, had managed to congregate a group of friends, and we all drove down back to the Sunset Tower Hotel and went to our room. Tom Sturridge and Rob Pattinson and Sienna Miller, we were all in my room at the top of the Sunset Tower, drinking. And then I'll not forget, the sun started coming up overlooking Sunset Boulevard and that was the moment that it may have just begun to sink in. The following day after the Oscars, I had to get straight back on the plane. When I arrived, I went straight from Heathrow Airport in a car being chased by the paparazzi to the car park of a super-

market on the Cromwell Road in London to get back into a trailer to get dressed up as my character Lili and to go and do a scene in which she was in a hospital, naked. So it was quite a lot to take in.

THE PERSPECTIVE

I just look back on how many doors it opened. Before then I was a jobbing actor who auditioned for things, and if I got the part, I did it. And after that, I got this very, very rarified thing called *choice*. And I'm hugely grateful for that. My entire family were on holiday at the time. My brother, his children, and my mum and dad. And my brother did this amazing thing: He put a phone at the back of the room filming my family watching the awards. I've got a little video of them watching me win the prize. Their reactions—that's the stuff which for me is very moving.

WHERE OSCAR LIVES NOW

Mine is at home in London. It sits on my Yamaha baby grand piano that I bought with the money that I made from *Les Misérables*. It's such an iconic thing that still doesn't feel real.

Redmayne greets presenter and friend Cate Blanchett.

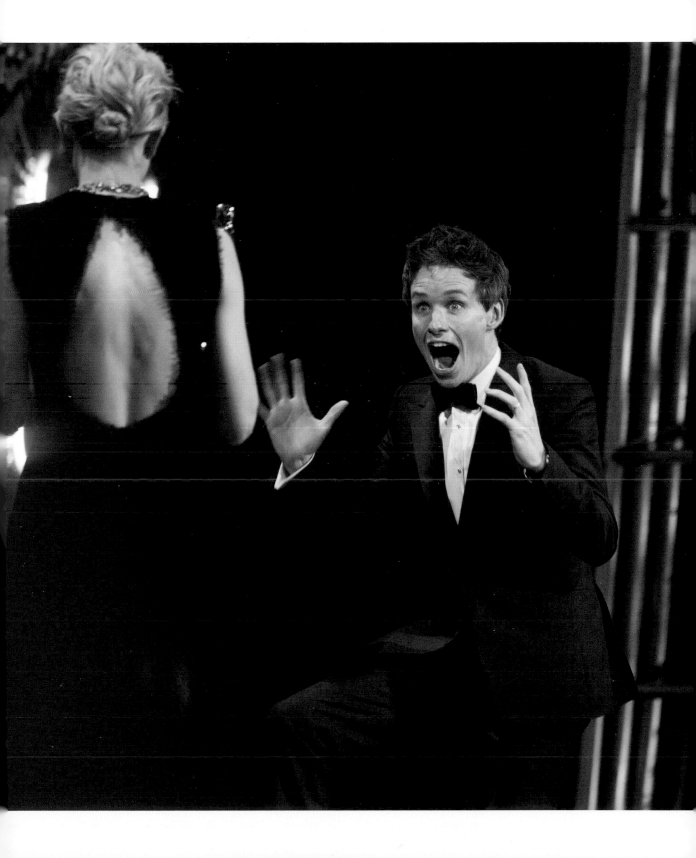

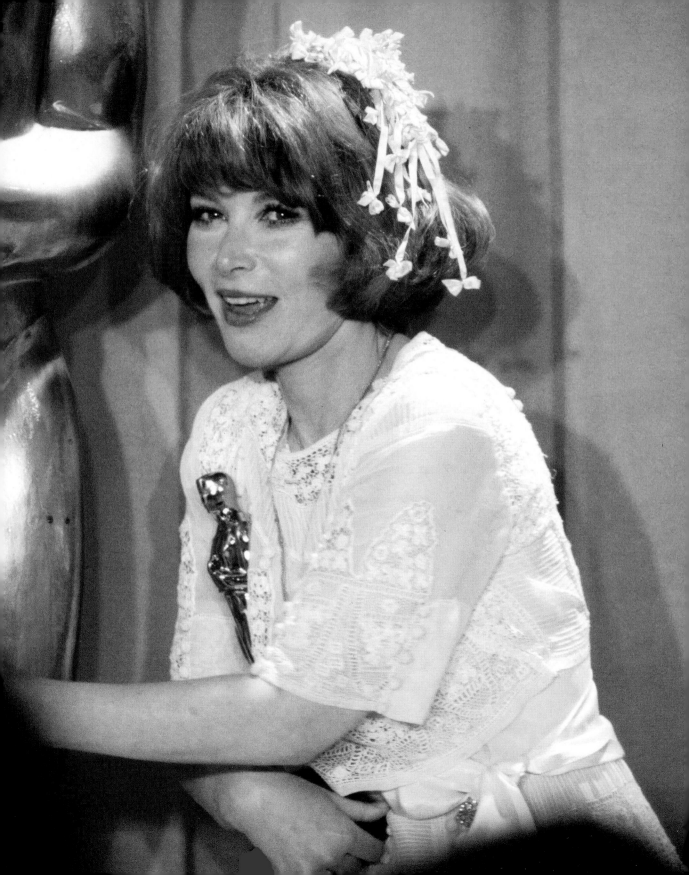

LEE GRANT
BEST SUPPORTING ACTRESS
Shampoo
1976

**"I really must have won it; otherwise,
why would I have worn an old wedding dress?"**

When Lee Grant won the Best Supporting Actress Oscar for her alluring performance as Warren Beatty's fabulously bored mistress in *Shampoo*, it wasn't simply a victory for her in the race between her and the other four nominees; for her, it was a victory against the entire Hollywood industry, which had blacklisted her for most of the fifties and early sixties. Grant had earned an Oscar nomination early in her film career for 1951's *Detective Story* but was then blacklisted for twelve years. She would score another nomination for 1970's *The Landlord*, but it was her performance in *Shampoo* that finally brought her to the Academy winner's circle. On Oscar night, she agreed to be filmed by a documentary crew throughout the evening and recruited her *Shampoo* costar Goldie Hawn to accompany her all night long. Since her win in 1976, Grant has turned her attention to directing; she helmed the 1986 documentary *Down and Out in America*, produced by her husband, Joseph Feury, which won the Oscar for Best Documentary Feature.

THE BACKSTORY

I don't think I had any awareness of the Oscars growing up. I was raised on 148th Street and Riverside Drive and I was a "girl on the block." My mother would haul me to the Met for ballet class, but I had no connection with it at all. When I was an adolescent,

I started singing and did a nightclub set when I was fifteen in Philadelphia. Outside of singing, which was all I wanted to do, I wanted everybody's boyfriend. The need to be seductive was a part of my adolescence. All of that became focused when I went to Juilliard and then the Neighborhood Playhouse. If I had

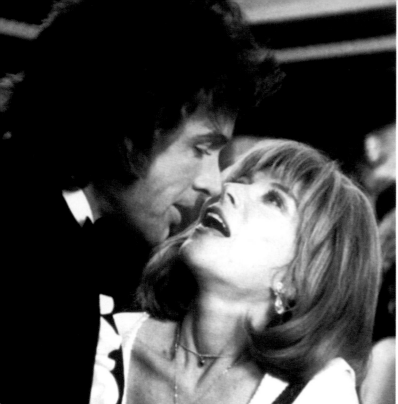

Grant with costar Warren Beatty in *Shampoo*

gotten married and gone to the suburbs, I would have wrecked every life around me. Because the need to prove something was not healthy. But in acting, it *was*. I was blacklisted from the time I was twenty-four to thirty-six. I taught acting all through the blacklist. The theater never had a blacklist. So I would be on Broadway every other year. It was the free state of Broadway. What that period did to me was make me a really good fighter.

THE PRODUCTION

By the time of *Shampoo*, everybody in Hollywood wanted to work with me. Everybody was saying, "How can we make it up to you?" I went

straight from the blacklist to *Peyton Place*, which went on the air five days a week. You couldn't miss me. Warren came around when I was doing *The Prisoner of Second Avenue* on Broadway and said, "I want you for this movie that I'm cowriting and I'm going to make." Warren is a very, very advanced guy as a liberal. He knows exactly what's going on. I would be surprised if the fact that I had been blacklisted didn't come into it.

THE BIG DAY

It was Goldie and me in the limo and it was fun. It sure was a lot more fun than driving from Malibu into L.A. by ourselves. I was rehearsing how I would act if someone else won. I was practicing being a good sport, practicing not crying or showing how bitter and angry I was. Don't forget, I had been nominated before. I'd been there, done that. I'd been lauded when I came up the carpet: "Oh, Lee, over here." And then when your name isn't called: "Oh, Lee, can you get out of the way, please?" It's so delicious and funny to be wanted and unwanted so strongly in the same night.

THE LOOK

I picked it out. It was somebody's old wedding dress. I wanted something that had its own

history, that had gone through as many things as I had. And it felt right. I was finally the bride. That must have been why I rented the bride's dress! That must have been it. There was an instinct. I never realized it until now. I said, "I'm going to be the bride this time!"

THE WINNING MOMENT

I didn't think I was going to win. It was like God looked at me and said, "You have been treated very badly; I am going to make up for it by giving you heaven." And He did. I remember thinking as I went up to accept it, *I'm forty-nine*, which was the closing age of an actor in Hollywood. I managed somehow all my life to look ten years younger. My chemicals just worked for me, and I had a good run. But I knew that I was going to direct. I knew it as I was walking down. I was saying hello to the Oscar and goodbye to acting, and I wasn't sad at all. Those were the rules. I would never get the kind of director, the kind of part, the kind of fascinating world that I had before.

THE AFTERMATH

I won. I beat them. I beat all the people who tried to keep me from working. It was like, *This is for us who were blacklisted. This is for*

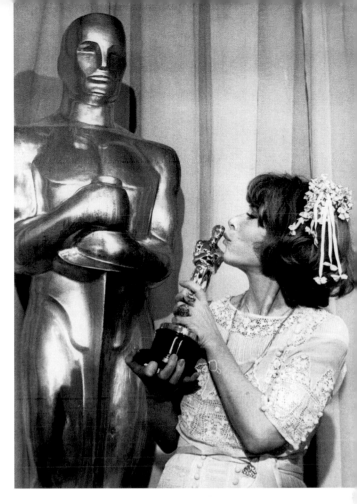

all the people who you destroyed. And I made it. Very quickly afterwards, the American Film Institute called—it was the same week almost—and said, "We're starting a directing workshop with six women." And I was like, *Wow, hello, life!* I was not an old actress anymore; I was a young director. My whole thrust in life is to make up for the blacklist.

── WHERE THE OSCARS LIVE NOW ──

It's in the sunroom in my apartment in New York. I have a whole cabinet where I keep pictures and things that I like to look at and care about. And at the top are the two Oscars and other awards that Joey and I have won along the way.

LOUIS GOSSETT JR.
BEST SUPPORTING ACTOR
An Officer and a Gentleman
1983

> "You know, when you prepare a speech,
> it's no use, because it's all gone."

Before 1983, only two Black actors had ever been nominated for Best Supporting Actor: Rupert Crosse for 1969's *The Reivers* and Howard E. Rollins Jr. for 1981's *Ragtime*. Thanks to his towering performance as the intimidating drill instructor in Taylor Hackford's *An Officer and a Gentleman*, Gossett—by then a Broadway veteran and an Emmy winner for the TV miniseries *Roots*—not only became the third Black nominee in that category but also the first-ever Black winner. To this day, Gossett, who accepted the trophy from presenters Susan Sarandon and Christopher Reeve, remains in awe of the acting titans alongside whom he was nominated. But he also soon realized that winning an Oscar didn't magically change the way some people perceived him in the real world.

THE PRODUCTION

I won't mention his name, but they had already signed a white actor [R. Lee Ermey] for the part. But 85 percent of those drill instructors teaching those naval people to fly jets are Black. So Taylor Hackford, trying to make it authentically, fired that actor, paid him off, sent him away, and started looking for that [Black] DI. Because of *Roots*, I guess, and my agent, Ed Bondy, God rest his soul, my name was on the top-five or -six list. I went down to the San Diego Marine Corps Recruitment Division—that's where they train the DIs. A man by the name of Bill Dower was in charge of the DI school. He sounded like Louis Armstrong because he was screaming at people for fifteen or twenty years. He taught me for three weeks how to be a DI. After three weeks

Gossett with costar Richard Gere in *An Officer and a Gentleman*

and one day, I'm back on the plane going up to Port Townsend, Washington, to play this character. I showed up as a DI. It wasn't me anymore.

THE WINNING MOMENT

I was in the top five with people I admire so much. Robert Preston—*Victor/Victoria*. James Mason—*The Verdict*, with my man Paul Newman. That was an Oscar-worthy performance. Charles Durning—*The Best Little Whorehouse in Texas*. Wow. And of course, there was John Lithgow—*The World*

According to Garp. And then me. I was sitting there with my son on my left and my agent on the other side of my son, kind of in the seventh-heaven dream. I was happy to be in the top five. That's where I was at. And when they said my name, I don't think I heard it. My agent hit me in the chest and said, "They said your name!" I looked at my son, who had promised to come up with me if I won. He was about eight. He said, "I ain't going up there!" I walked up, and I got a kiss from Susan Sarandon, a handshake from Superman, and the Academy Award.

THE CELEBRATION

That night I got a lot of phone calls, and then I went home and watched the Lakers game—Elgin Baylor and Jerry West. When I want to celebrate, that's what I do. And I fell asleep about an hour and a half later.

THE AFTERMATH

It was Hattie McDaniel and Sidney Poitier, and then the third was myself. That's very prestigious. The next day, I walked into the local supermarket, and the whole super-market stopped what they were doing to give me this applause. I got my food and I was going home to walk my dogs. And there was a homeless man—Paul Newman, we called him—who was out there waiting for hand-outs. He had a long beard, blue eyes, no shoes. He said, "Who were they applauding?" I said, "They were applauding me." He said, "What did you do?" I said, "I won the Academy Award last night." He said, "Congratulations. You still got to behave yourself though." I won an Oscar, and even a homeless man with no shoes thinks he's better than me because of the color of his skin. All I could do was laugh. I'm not superior to him, and he's not superior to me. And God has planned those awards, not for my ego, but for the ability to open my mouth, for what it's worth, and hopefully save some other young people from thinking the old way of that homeless man. That nobody's better, nobody's worse.

THE PERSPECTIVE

That Oscar gave me the ability of being able to choose good parts in movies like *Enemy Mine*, *Sadat*, and *Iron Eagle*. I've been around the world maybe nine or ten times. I feel I've been there, done that now. Now is whipped cream time. I'm a spokesperson for a group of marines here in the South called the Montford Point Marines. They're all Black out of South Carolina. It is really a privilege to represent that unit of the United States government. I also represent the American air force. So all of a sudden, I've gotten this symbol. It's a pleasure. There's something in my system that they put there that I can never lose until I pass away. I'm very proud to know those people.

⎯ WHERE OSCAR LIVES NOW ⎯

It's in storage. I'm going to donate it to a library so I don't have to keep an eye on it. I need to be free of it.

HILARY SWANK
BEST ACTRESS
Boys Don't Cry
2000

**"I pray for the day when we not only accept
our differences but we actually celebrate our diversity."**

I n 1999, Hilary Swank was known for lighter film and TV fare like *The Next Karate Kid* and *Beverly Hills, 90210*. But her heart-breaking, career-making, and Oscar-winning performance as transgender man Brandon Teena in *Boys Don't Cry* changed not only the perception of her as an actress but her life as well. Only twenty-five years old and wearing a shimmering gold Randolph Duke dress, she delivered a speech that paid tribute to Brandon Teena's legacy as well as the people who had supported her along the way, but forgot to acknowledge her then-husband, Chad Lowe. She rectified that oversight when she won her second Best Actress Oscar for *Million Dollar Baby* five years later.

THE BACKSTORY

I drove down to California from Bellingham, Washington, with my mom when I was fifteen. We had $75, and we were living out of our car. It was a big, big step for my mom to take to embark on this dream of mine. I remember everyone in my small town being like, "Go, Hilary, go! We'll be watching for you at the Oscars!" I don't think that was ever really like an end goal. I just really wanted to make movies.

THE PRODUCTION

I couldn't break into movies—only movie stars would get movies at that point. Then this thing called the independent film came along, and movie stars weren't doing it because it was too much of a risk for their career, and they weren't making any money. So it opened the door for other people, like me, to get a chance to break into movies. I remember reading [the *Boys Don't Cry* script]

Swank as Brandon Teena in *Boys Don't Cry*

and it blew my mind on every level. I mean, not only as a challenge as an actor, but how it opened up my blinders about other people who live in the world. It really transcended gender and just became about love and wanting to give and receive love. We were working eighteen-hour days in order to make this movie on budget and on time. I made $3,000, which didn't matter—it wasn't about money. When Fox Searchlight picked it up, I remember an executive saying, "We're going to really do an Oscar push for this." That was the first time I'd ever heard anyone speaking of doing that for anything that I was in. I remember

someone said, "*Entertainment Tonight* just asked Sigourney Weaver, 'Who do you think should win the Academy Award?' and she said you!" I couldn't believe that Sigourney Weaver knew my name. It was this really beautiful, crazy, unbelievable, special time in my life.

THE LOOK

The day before the Oscars, I still didn't have a dress. I remember my husband at the time was like, "Look, we'll just wake up tomorrow, we'll go to Barneys, and we'll get you a dress. Don't stress about it; you need to sleep." And

then that morning, a stylist brought a rack of dresses in and I just picked whichever one was the best. I would not say I put it on and said, "This is the dress." I just said, "This is the best dress that's in this selection." It was a bit frustrating just because it was so last minute.

THE WINNING MOMENT

My whole life I've felt a little bit like an outsider. So I was like, *What am I doing here?* Right before they were calling out Best Actress, my heart was beating so fast that I could feel my neck pulsating. I remember thinking, *Oh my gosh, it's pulsating so much that everyone can see my heartbeat in my neck.* When they called my name, I remember thinking, *Hurry up. I got to get up there.* I was almost like a horse with blinders on—I barely said hi to anyone on the way.

THE SPEECH

I had a responsibility to be a voice, to say something that continued the conversation of what the movie was about. I didn't want to mess up that opportunity if I was so lucky to be on that stage. Brandon Teena was a person who lived. This was someone whose life I wanted to respect and honor. Of course I thought I was going to remember [Chad]. No one wants to forget that person that's the most important in their life at that time. But I had a whole thank-you for him that morning; I gave

him a gift and a special thank-you for his help and support. I think his feelings were hurt. That was not a highlight for sure. A lot of people were like, "Oh, Hilary wasn't emotional at all. It must not have been that big of a deal for her." I just thought to myself, *Wow, you really cannot win for winning.* Then I realized that no one would ever say that about a man. When I won for *Million Dollar Baby*, I didn't cry either. But I did cry my eyeballs out when I got my star on the Walk of Fame!

THE CELEBRATION

I remember having a wonderful conversation with Meryl Streep at the Governors Ball, and she said, "Oh, I forgot to thank my husband *twice*. Don't worry a second about it." I was just going around the room, and I wasn't really eating, so we went to Astro Burger. We went there the year of *Million Dollar Baby* too, and I guess we got followed. But I did that with *Boys Don't Cry*, and the first time it wasn't documented. We go in and everyone thought we were going to get it to go. But no, we sat and ate and just had another celebration before heading over to the *Vanity Fair* party. I was like a walking zombie by the end of *Vanity Fair*. I remember getting home to the Bel-Air Hotel and my feet were *killing* me, so I got in the bathtub. I had placed the Oscar in the bathroom on the counter. And I remember being in the bathtub and just looking over at it and just being

like, *What?!* Like it hits you again. I was just covering my face in complete astonishment. Then I put it next to my bed and slept right next to it on the bedside table.

THE PERSPECTIVE

It was an exponentially huge moment. Getting this role changed my life, not because it made me famous. That's one of the things, yes. But there are copious amounts of things that it did for me. It let me see into different ways of walking in the world. It meant that the world was changing, because a movie like that had received something like that. And then on a personal level, it meant that I was going to get more opportunities to do what I love—this was going to open a door to continuing this dream. But there's nowhere up to go from Best Actress. The expectations felt a little overwhelming. And I had to remember why I was doing it, and to just get back in the sandbox and not be afraid to make mistakes. After the Academy Awards, I needed to go in and get a prescription filled and they said, "That's $260." I was like, "No, I have insurance with SAG." They're like, "There's a problem. You have to call them." I called them and they said, "You need to make $5,000 a year in order to have health insurance." So I had an Academy Award and no health insurance.

WHERE THE OSCARS LIVE NOW

I had them on a bookshelf at home in Colorado. Then I moved them into my movie theater room. I have a movie theater because going back to *Boys Don't Cry*, I'm just so grateful that so many people watched it. It made me not want to vote, now that I am a member of the Academy, until I saw every movie properly. So I now have a movie theater where I can watch movies as they're supposed to be seen. So I moved them in there. Now that I have a place in Washington, I split them up. There's one there and one in Washington.

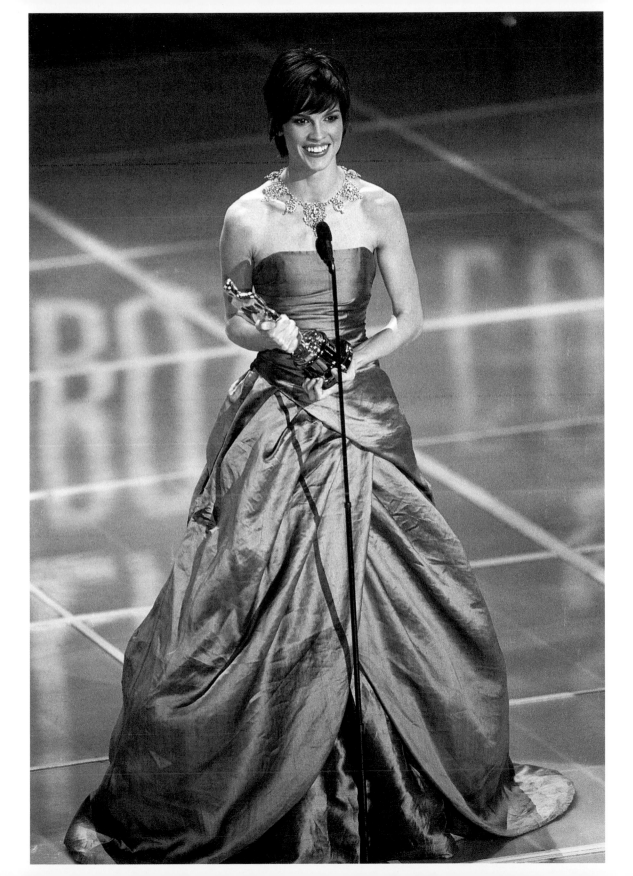

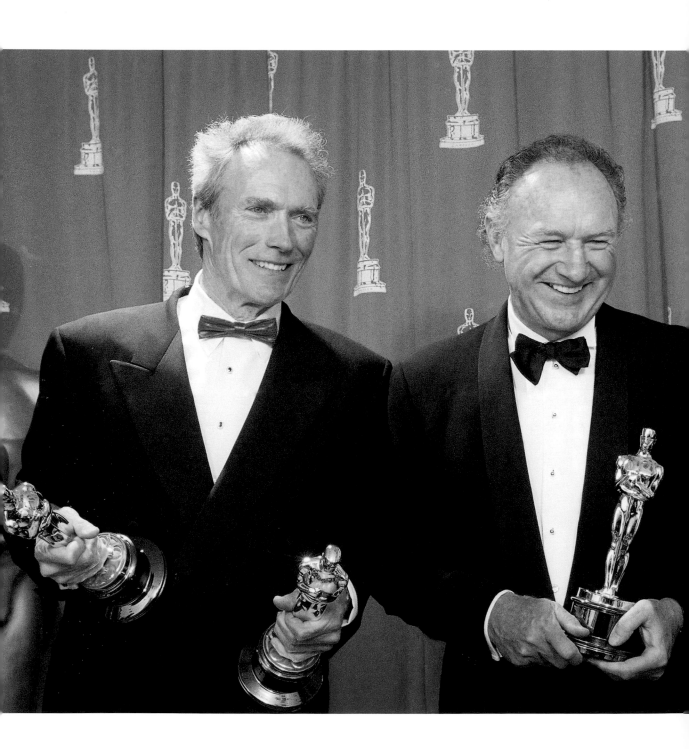

Eastwood and fellow *Unforgiven* winner Gene Hackman

CLINT EASTWOOD
BEST PICTURE
AND BEST DIRECTOR
Unforgiven
1993
"This is pretty good. This is all right."

lint Eastwood had been working steadily as an actor and filmmaker for almost thirty years when he finally earned his first three Academy Award nominations (Best Picture, Best Director, and Best Actor) for his brutal yet sensitive Western *Unforgiven*. In the weeks leading up to the Oscar ceremony, *Scent of a Woman* had won the Golden Globe and *The Crying Game* had taken home the Producers' Guild prize, leaving Eastwood's film as a bit of a dark horse. But early in the night, *Unforgiven* took home the prizes for Best Editing (for Joel Cox) and Best Supporting Actor (for Gene Hackman). By the end of the proceedings—which were dubbed "the Year of the Woman," inspired by a group of female politicians who had recently been elected to the United States Senate—Eastwood, who attended the ceremony with his eighty-four-year-old mother, Ruth, would become a double Oscar winner, a feat he would repeat twelve years later with *Million Dollar Baby*.

THE BACKSTORY

I was making films that I didn't think were that kind of thing that people would vote for. I didn't have any nominations before *Unforgiven*. I read the script, and I really liked it, but it had a horrible title. It was called *The Cut-Whore Killing*. I put it in a drawer some-

where, and I did three other pictures. I hadn't done a Western for a while and I thought, *I think I'll do that one, but nobody will want to see it because it's kind of far out.* Gene Hackman turned it down. He read it, but he was on a kick at that time where he said he wanted to do no violence. I said, "You don't have to worry

this?" And I said, "It's me. It's Clint Eastwood." He says, "No, it isn't." And I said, "Yes, it is. And I've got this part for you." He said, "You're joking." And I said, "Why am I joking?" He says, "Because I'm down in the basement now watching a Clint Eastwood Western." It was a very easy picture to make. Nobody had big ideas about it.

THE BUZZ

There's a certain prejudice against Westerns. I didn't expect much from the Academy. But after *Unforgiven* came out, I saw Sidney Poitier at a restaurant. He says, "You know, you're going to have an amazing moment on that film." And I said, "Really? I don't think so. I mean, I think it'll be considered a good Western." But several people predicted [its success].

THE BIG DAY

about the violence. There's a certain amount in there at the beginning. But basically, it's the story of these people. I really think you should think about it." But when he got into it, he was terrific. I called up Richard Harris, and he was somewhere in the Bahamas or something. He gets on the line and says, "Who is

I took my mother. She lived in Oakland at the time. Joel Cox won—that was the first one called that night, and he won it. I said, "Maybe we're somewhere." All of a sudden, Gene Hackman wins for [Best] Supporting Actor. I figured that was good enough, but then it just went on from there. I was surprised that

it was going this way. In my mind. I was definitely not going to get [Best] Director; I was the least likely guy to get it. So when I got it, I was discombobulated. I thanked the audience. And then I realized, *Jesus Christ, it's the year of the woman, and I was up there and I thanked everybody except my mother. What an idiot. And now I probably won't win the other one, the Best Picture.* I said to her, "I'm sorry." She said, "Don't apologize—I'm just glad to be here." I said, "Even if they call somebody else's name, I'm going back up there." And then they said we won Picture. So I got up there right away. Fortunately, I got another chance to thank my mother, and that made everything perfect. She's the greatest woman in the world, from my point of view. She was just laughing. She knew I was all screwed up.

THE PERSPECTIVE

It was just great that I had my mother there, because I'd never done anything great for

Eastwood with his mother, Ruth

her, and that's something that she might find amusing. She got to meet Barbra Streisand, but she was totally blasé about that kind of stuff. She loved the fact that it happened, but she didn't know what the Academy was.

— WHERE THE OSCARS LIVE NOW —

They're all on a shelf in the den along with some other stuff you get along the way, over the years.

JESSICA YU
BEST DOCUMENTARY SHORT
Breathing Lessons:
The Life and Work of Mark O'Brien
1997

**"You know you've entered new territory
when you realize that your outfit cost more than your film."**

Most years, the Best Documentary Short category doesn't generate much water-cooler talk the morning after the Academy Awards. But most years, the award isn't won by someone as dynamic as Jessica Yu. Not only did Yu direct a moving film about journalist and poet Mark O'Brien, who contracted polio as a boy and spent the rest of his life confined to an iron lung, but her acceptance speech—in which she quipped that her rented outfit cost more than her entire film, before eloquently paying tribute to O'Brien—was the hit of the night and is featured today in the Academy Museum as one of the most memorable speeches in Oscar history. In the years since her Oscar win, Yu has gone on to become one of the most sought-after television directors in Hollywood, helming episodes of *The West Wing*, *Grey's Anatomy*, *Parenthood*, *In Treatment*, and *This Is Us*.

THE BACKSTORY

At that time, documentaries were such a labor of love. It was always hard to get the funding for them, it was hard to access equipment. The project really had to be something that you just couldn't go through life without. The film cost under $40,000, all in. That film was funded on my own little savings. My grandfather had given us grandkids each a couple of gold coins; I had cashed those in to be able to pay for the film stock. It was really a shoestring kind of thing. Friends chipped in, we rented some really old cameras where you're like, "How does this one work?" It was like stone soup.

Breathing Lessons subject Mark O'Brien

THE LOOK

I knew from a friend of mine who had won an Academy Award that there are places where you could borrow a fancy dress. It was from Fred Hayman's in Beverly Hills. I remember that it was a Mary McFadden dress, and it was made for somebody who's, like, seven feet tall. But I was just borrowing it for the night, so we had to fold it all the way back up, because it had about four feet of extra material. The jewels were from Harry Winston—earrings and a bracelet. They make you sign this thing that says that you understand that this stuff is worth $165,000 or whatever. Then there's a security guard that walks out with you. At that point I was thinking, *Why did I feel like I needed* this *to be part of this experience?* It was fun, but I was a little nervous about it. I was adding it up and thinking, It's like $200,000 worth of stuff! And then I thought about my little film and it was amusing to do the math.

THE WINNING MOMENT

I remember when I was walking up, there were these white steps leading up to the stage. And I remember seeing that they were kind of scuffed where people had walked—they were a little dirty. And I thought, *Oh, they're just stairs.* For some reason that really helped me, that little moment.

THE PINCH-ME MOMENTS

I remember my husband saying, "I just peed next to Al Pacino," which was something to talk about. Afterwards, once you're carrying around the statuette, a lot of people come up and say hello and congratulations, and that is a delightful experience. I remember it was such a whirlwind and I hear, "Congratulations!" And I turn and I said, "Oh, thank you." And it was Woody Harrelson. I said, "Hey, thanks." And then I was like, "Oh, I don't actually know you!"

THE CELEBRATION

I called Mark right when I got off stage. Mark at that time was very much confined to his iron lung, and breathing was always a problem. And he yelled so loud in the phone, I didn't know that he was capable of such volume. Just a huge scream. That really made it all worth it.

THE AFTERMATH

When I was coming up, there were not a lot of women in episodic directing. I'd never met another Asian American woman who was working in that capacity at that time. So I do feel that just being recognized in that very public way helped open the doors a little bit. I felt like there were other avenues I could explore, and I had a little bit more confidence that I could rise to that occasion. I also attach that experience very much to my friendship with Mark O'Brien, because it also really changed things for him in terms of people being interested in his story. His story then was turned into a wonderful film called *The Sessions*. That part is really meaningful to me.

WHERE OSCAR LIVES NOW

It's on a bookshelf in our living room and it's low enough that if anybody wants to hold it or practice a speech, that's fine.

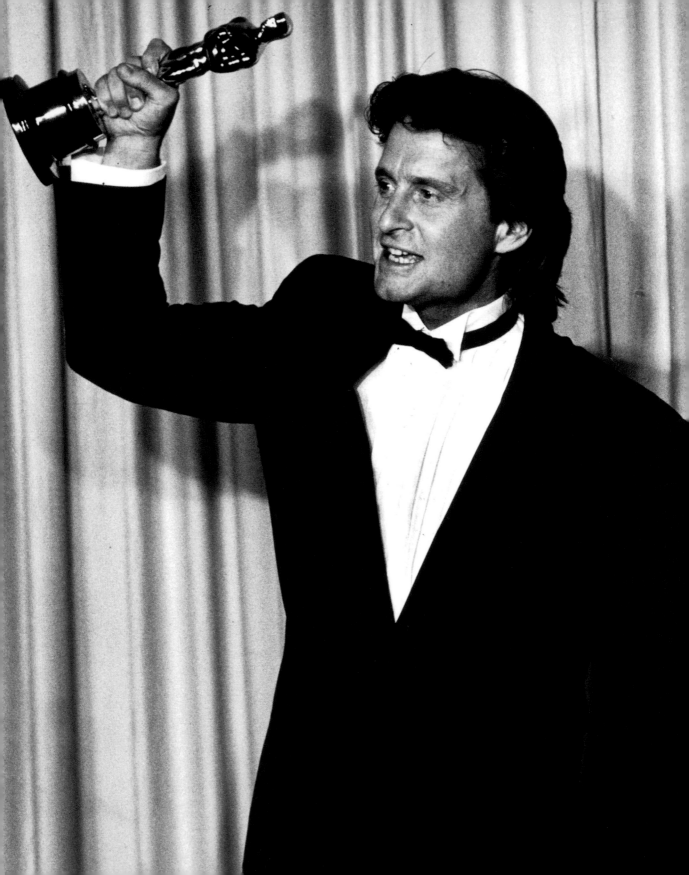

MICHAEL DOUGLAS
BEST ACTOR
Wall Street
1988

**"A large part of this award belongs to Oliver Stone,
not only as the director, but having the courage to cast me
in a part that not many people thought I could play."**

Michael Douglas was no stranger to the Oscars stage when he won the Best Actor prize for his iconic performance as the ruthless Gordon Gekko in writer-director Oliver Stone's *Wall Street*. In 1976, at a time when Douglas was best known as the star of the television series *The Streets of San Francisco*, he took home the Best Picture award as producer, alongside Saul Zaentz, for *One Flew Over the Cuckoo's Nest*, which became only the second film ever (after *It Happened One Night*) to sweep all the major categories. Twelve years later, he found himself competing with his *Cuckoo's Nest* leading man, Jack Nicholson, who was nominated for *Ironweed*. Douglas's performance in *Wall Street* allowed audiences—and the industry—to see him in a different light from the action comedies he had been making in the mid-eighties. And his Oscar victory meant that he accomplished a feat his legendary father, Kirk Douglas, did not; although the elder Douglas did earn three Best Actor nominations throughout his career and received an honorary Oscar in 1996, he never won a competitive Academy Award.

THE BACKSTORY

Obviously, being a second-generation Hollywood person, the Oscars were the ultimate. Earlier on, when I wasn't thinking about acting, I never thought about being nominated. I would say it was a long way into my career when I ever considered, *Wouldn't that be exciting?*

THE FIRST TIME

Cuckoo's Nest was completely independently financed by Saul Zaentz and Fantasy Films.

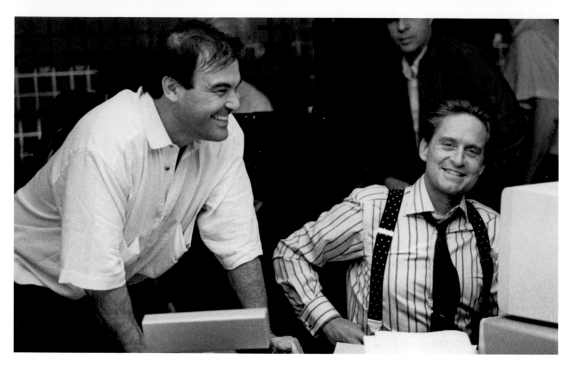
Douglas with director Oliver Stone on the *Wall Street* set

The picture that was nominated for nine Academy Awards—that picture was the same one that was shown to all the major studios, who turned it down. So to then get the nine nominations, we were just on the ceiling. As far as that night was concerned, one of the things that was most important was getting Jack Nicholson there. Jack had been nominated four times before that and lost. So he was really gun-shy, did not want to go through that one more time. I gave him a big hoo-hah pitch about, you know, we have nine nominations and all that. That night Jack was sitting right in front of me at the ceremony as we lost our first four nominations. I remember him turning around to me and saying, "I told you, Mikey D. I told you. This is not good. This is not good."

He was sure that was just going to be a complete loss. And then we won Best Screenplay. And then we went on and won Director, then Actor, then Actress, and Best Picture. So it was beyond words, and the irony was that I was coming out of a television series and then winning an Oscar for Best Picture. It was amazing. And it took me on this producing career. About ten years later was when *Wall Street* and *Fatal Attraction* happened.

THE PRODUCTION

At that time, as a television actor, you were perceived in a different way than if you were a film actor. So as a producer, I was at the top of my game in motion pictures. But as an actor, I was a television actor trying to get into films, and there

were a lot of projects that I was not approved for by the studios. So that built up some animosity in me. The parts were somewhat limited for a few years, basically leading up to that year of *Wall Street* and *Fatal Attraction*. On the *Wall Street* set I was terrified. I felt too young for the part, no sense of gravitas; I was very, very nervous. The irony is that Oliver later said that he was looking for an actor with some business acumen. So actually, because I was a producer, he thought I knew more about business than I did. And Oliver I say this as a real compliment—he doesn't placate actors or act like the father figure. He treats you like you're in Vietnam in the trench together. He pushes you. He'll say things to you that you may not want to hear particularly, but it makes you work harder. I really worked hard on that film, and I have to attribute a lot of that to Oliver pushing me.

THE SPEECH

I had written down some stuff because I am not inherently a good public speaker, and I'm certainly not one to wing it. I thought that if I won it, I wouldn't even remember what my name is. So I wrote down names and everything.

THE COMPETITION

Jack and I met on *One Flew Over the Cuckoo's Nest*. We went through that experience and became good friends over the years after that. We did a lot of sports together: skiing and golf and things that friends do. Also, I admired him and considered him one of the major film actors of our generation—of any generation, for that matter. It was nice to really know inherently that there was another person who was rooting for you or was happy for you, even though we were competitors. Afterward, we all went to the *Vanity Fair* party. Jack and I crisscrossed a number of times. There was not an ounce of resentment on his part. He had obviously won his fair share by then.

THE PERSPECTIVE

It was a big, big moment for me, both personally and in my career in terms of how I felt about myself as an actor and, obviously, the things that followed after that. At the time, it got me out of the shadow of my father. What does it mean to me now? It's like I was in the military and this is a medal. We did it. We succeeded.

━ WHERE THE OSCARS LIVE NOW ━

They're displayed on a shelf in my study in our apartment in New York. They haven't moved anywhere for about thirty years. I can't say there are any lights shining on them, but they do draw attention. People like to hold both of them and do dumbbell curls.

CATHERINE MARTIN
BEST COSTUME DESIGN AND BEST ART DIRECTION
Moulin Rouge!
2002

"To the extraordinary Baz Luhrmann, who has got us up here, who cares as much about the embroidery detail on a cancan skirt as he does about lens size or dialogue: It was your vision; this is your Oscar, Baz."

The personal and professional partnership of spouses Catherine Martin and Baz Luhrmann—she designs the sets and costumes while and he writes and directs—is one of the most lasting and successful in modern film history. While her husband has never won an Academy Award, Martin took home two in 2002 for her eye-popping work on *Moulin Rouge!*—first for Best Costume Design (along with Angus Strathie) and later in the evening for Best Art Direction (with Brigitte Broch). Twelve years later, Martin would win two more Oscars, for Best Costume Design and Best Production Design, for another Luhrmann adaptation, *The Great Gatsby*, making her the most Oscar-awarded Australian ever.

THE BACKSTORY

I met Baz at the end of '87. We just started talking, and it was a conversation that ranged from Bertolt Brecht to Madonna. What constituted good taste, bad taste—was taste even important? It was a conversation that went on for hours and hours. Baz describes our relationship as a conversation that's never ended.

It does end up sometimes in very loud voices, sometimes arguments here and there, but it is enormously satisfying to find someone artistically that you are on the same wavelength with.

THE PRODUCTION

Baz describes me as one of his first audiences. I remember when he said, "I'm really inter-

Martin with husband and collaborator, Baz Luhrmann

Stars Nicole Kidman and Ewan McGregor among Martin's elaborate sets and costumes in *Moulin Rouge!*

ested in doing an Orpheus myth. I'm not sure where I'm going to set it." He was interested in the Moulin Rouge and this fin-de-siècle monde in France. The first time he mentioned cancan dancing, I just was, like, terrified. I went, "How are we going to make that good? That's terrible." But that's Baz's magic—he's able to take moribund things or things that you think can't be fresh or modern and forces you to look at them in a completely different way. He coined the phrase wryly "a world of entertainment under women's skirts." But how do you translate that in a way that isn't X-rated? Because that's not what it was about. My job was to translate ephemeral things into reality. And I love that. Baz can give me a little sketch of something and that actually becomes an image on screen? It's magic.

THE WINNING MOMENT

Baz was going, "It's your name! It's your name!" You just can't believe it. And the walk down the aisle is the longest walk ever. You just think, *I just don't think I'm going to get there. I'm just not going to get to the stage.* It's so overwhelming. It's the ultimate dry-mouth moment. And then the first time you get to hold an Oscar, it sounds so cliché, but you go, "Oh my God, this is so heavy!"

THE SPEECH

I was very superstitious and thought, *I'm not going to win.* I was convinced by my father, who was there as well, to write a speech. He said to me, "You're probably not going to win, but that's not the point. It would be bad if you hadn't prepared a few words because you're

in front of all those people, and you owe it to your collaborators." So he put the pressure on me. And Dad was right! I'm not saying I don't have my talent or I'm not good at what I do. But the incredible creative adventure that I have had the privilege to be on is absolutely connected to Baz's singular vision as a filmmaker and the fact that he puts such emphasis on collaboration and how to express story through images. I have just learned so much from him and from the process that we've gone through.

THE SECOND WINNING MOMENT

I go back to my seat and there was no way I thought I was going to win a second one. Tick, I've won one, it's happened early on in the proceedings, so I can now relax. Maybe at the next commercial break I'll go out and get a glass of champagne and just have a minute to myself. And I'm sitting there and I hear my name again and I'm like, *What?!* It was crazy. Baz was overjoyed. He was jumping out of his seat, hysterical.

THE CELEBRATION

We went to all the parties for a bit of time. Then we ended up back at our penthouse at the Chateau Marmont, and I don't think we went to bed 'til six a.m. It was a bit of a slightly louche party. By this point, Baz's mother, who's a ballroom dancing teacher, was in a purple catsuit, and she was dancing expressively. Baz and his cowriter, Craig Pearce, were taking photos of themselves with the Oscars, being stupid. And I remember our casting director, Ronna Kress, and I sitting on a couch in our pajamas, squeezed between couples who were making out, having hot cocoa and cookies and just thinking, *This is living!*

THE PERSPECTIVE

Well, in everyday life, I rarely think about having four Oscars, because I have two children and they don't care. I'm too concerned about getting out the door, getting them to school, getting to work, trying to get through every day. One time my daughter and I were fighting about how to hem her dress for her junior prom. And I said, "I think I know how to do this—I have four Oscars!" She doesn't let me live it down.

WHERE THE OSCARS LIVE NOW

They've been in our house in New York. We have a room with a piano in it, and we put the awards there on the shelves and they stand as a little cluster talking to each other. Sometimes people ask whether they can touch them or take photos with them—particularly when people have had a few martinis.

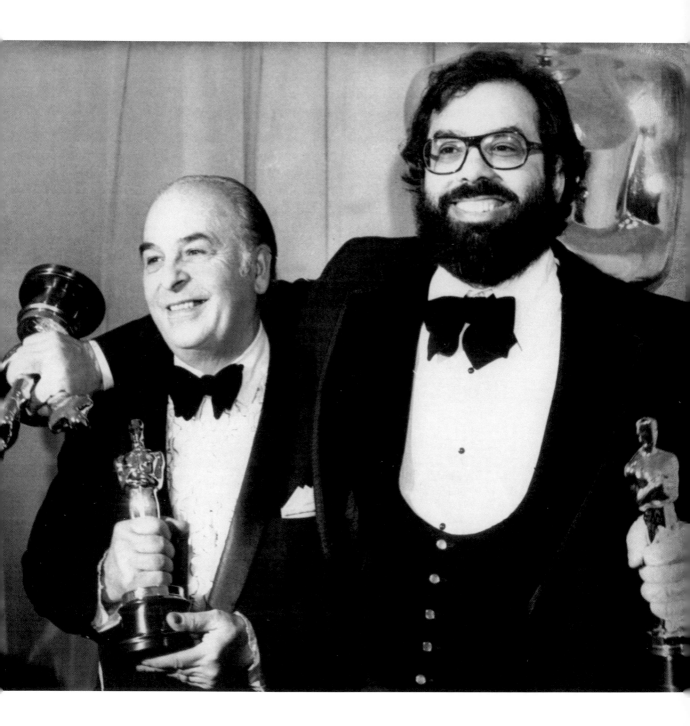

Coppola celebrates with his father (and fellow Oscar winner), Carmine.

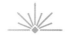

FRANCIS FORD COPPOLA

BEST PICTURE, BEST DIRECTOR, AND BEST ADAPTED SCREENPLAY

The Godfather Part II

1975

"I almost won this a couple of years ago for the first half of the same picture!"

Anyone watching the 1975 Academy Awards ceremony must have felt they were hearing the word *Coppola* just as often as they were hearing the word *Oscar*. Francis Ford Coppola was personally nominated five times: for producing, directing, and writing *The Godfather Part II*, as well as for producing and writing *The Conversation*. And his sixty-four-year-old father, Carmine Coppola, was nominated—and won—for his original score for the *Godfather* sequel. Although the younger Coppola lost the Best Original Screenplay award to *Chinatown*'s Robert Towne, he ended up winning all three of his *Godfather* nominations. But he stayed in his seat when he won for Best Adapted Screenplay, allowing *Godfather* novelist Mario Puzo to accept that award on his own. Still, Coppola became only the fourth person (after Walt Disney, Billy Wilder, and Marvin Hamlisch) ever to win three Oscars in the same night.

THE BACKSTORY

The first *Godfather* won Best Director at the Directors Guild Awards. And that pretty much meant that it was a slam dunk that I'd win the Oscar. And of course, I didn't; it was Bob Fosse, who was someone I really admired. I was very shocked that I didn't win, not because I thought I deserved to win particularly, but because the film had been so surprisingly successful. On the second picture, again, we had this amazing success, which I didn't anticipate.

Coppola with Al Pacino on the set of *The Godfather Part II*

BEST ORIGINAL SCORE

I got to see my father win an Oscar, and I can't tell you what that meant to me. He was a classical flute player for the top orchestra in the country, the NBC Toscanini Orchestra. He was at the peak of his career, but he didn't want to be a flutist. He wanted to be George Gershwin. When we were little kids and we said our prayers, it always ended with ". . . and give Daddy his big break." I thought it meant a brake for the car; I didn't know what a "break" was. So to see my father win the Oscar—it was a moment of indescribable joy for me. It was like a dream come true. And my father's remarks when he won the Oscar were great. He said, "Well, it's clear that I wouldn't be here without my son. But on the other hand, he wouldn't be here without me."

BEST ADAPTED SCREENPLAY

I wanted Mario to just enjoy that for himself. If you look at all my movies, if I didn't write the original material, I always put the writer ahead of the title when I have the ability. On *The Godfather*, it says "Mario Puzo's *The Godfather*." I put that on; Paramount didn't put that on. Or Bram Stoker's *Dracula*, or John Grisham's *The Rainmaker*. I have always said that whoever writes the original literary material, that's the heavy lifting. The screenwriter who adapts a book doesn't deserve his name above the title, and neither does the director. The only one who deserves a name above the title is the original writer who did the hard part, which is to write the story and create the characters. And that's what I did with Mario.

BEST DIRECTOR

When I won that one, it was pretty unreal to me. I remember watching the Oscars even as a twelve year-old. We used to go in my parents' bedroom, which is where the only television was, and sit on the floor and lean on their bed with them and watch the Oscars. It seemed so magical to me: *How do you get your name on a movie?* When I was really young, I was doing little stupid jobs, editing nudie films and stuff. But I would always say, "Directed by Francis Ford Coppola," because I thought I was never going to see that credit on a film. To this day, I still have these early films that say "directed by" when I had nothing to do with the direction. So that was a thrill.

BEST ORIGINAL SCREENPLAY

I had no problem losing that one. Bob Towne was always very kind to me in many ways. When the first *Godfather* was made, no one thought it was any good. I had a lot of people tell me what was wrong with it, and no one said anything to me in the slightest encouraging way. And then I showed it to Bob Towne, and he looked at it, and he said to me, "Francis, the film is great, and Marlon Brando is great in it. It only needs one thing: It needs a scene between just Marlon and Al Pacino, where they just talk about what their expectations of one another were." I said, "Would you write it?" He said, "Sure, if you want me to." And he wrote that scene. And then when I did win the Oscar for the *Godfather* screenplay, I credited Bob Towne because he wrote that wonderful scene. I have great admiration for him.

BEST PICTURE

I was still thinking about the fact that my father won an Oscar. That's all I had on my mind. And then later I got to see my daughter [Sofia] win an Oscar. I got to see my nephew Nicolas [Cage] win an Oscar. I can't tell you how proud I am of our family because we were nobodies. We were kids from New York.

THE PERSPECTIVE

The honest answer is all the Oscars in the world and all the checks in the world aren't worth as much as a young filmmaker coming to you and saying, "I'm making movies because you inspired me to." That's the award of the test of time, and that's the most precious award you can get.

WHERE THE OSCARS LIVE NOW

They're in our winery in Geyserville for folks to come and see. The only one that's in my home is the Irving Thalberg honorary award.

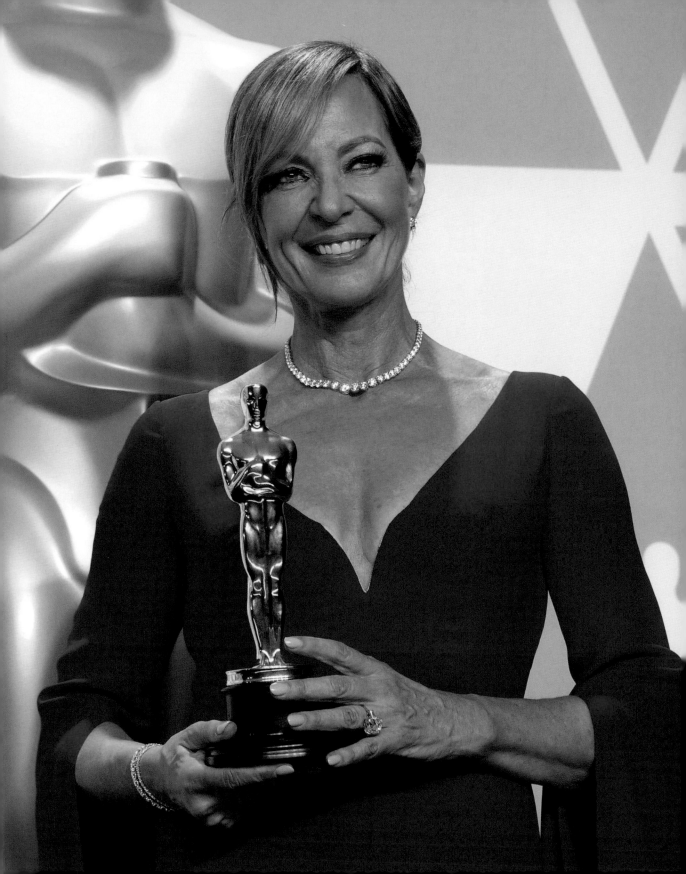

ALLISON JANNEY
BEST SUPPORTING ACTRESS
I, Tonya
2018

"I did it all by myself."

Allison Janney already had seven Emmys and seven Screen Actors Guild Awards to her name when she arrived at the Oscars in 2018 as a nominee for her priceless performance as figure skater Tonya Harding's foul-mouthed mother, LaVona, in *I, Tonya*. When Janney took the stage as the Best Supporting Actress winner, she began with the above (perfectly delivered) quip before thanking her longtime friend Steven Rogers, who wrote the *I, Tonya* screenplay for her. She finished by dedicating the award to her younger brother, Hal, who had died by suicide in 2011 after years of struggling with substance abuse and depression.

THE BACKSTORY

Steven Rogers and I met at the Neighborhood Playhouse in the eighties. We would watch the Oscars together at his apartment. He wanted to be an actor then; he didn't become a writer until we both moved out to Los Angeles [*The Help* director] Tate Taylor, Steven, Octavia [Spencer], and I were all friends in L.A. back in our early days in the 2000s. There were countless times where we were at parties together, the four of us. It just makes me laugh to think if someone had said, "Tate, you're going to direct Octavia in her Oscar-winning performance, and Steven, you're going to write Allison her Oscar-winning role." I mean, it absolutely blows my mind to think about the odds of that happening. But that's what did happen.

THE PRODUCTION

I remember Steven, when he was writing the *I, Tonya* script, said, "You're going to wear a fur coat and you're going to have a bird on your shoulder." I was like, "Oh my God, that sounds too crazy." It sounded very over-the-top and camp. I never thought, *This is going*

Janney as LaVona in *I, Tonya*

to be my Oscar. Steven has always said that he knew it would be. It was eight days of filming—that's all I did on that movie.

THE FULL CIRCLE MOMENT

I remember seeing Aaron Sorkin on the carpet. Years earlier, during the *West Wing* days, he said, "You're going to get an Oscar. Your first one will be Supporting Actress." I just remember making eye contact with him and just nodding across the way. That was

kind of fun.

THE LOOK

I remember there being four other dresses that were in contention. But that beautiful Reem Acra one—it had these long, beautiful sleeves, it was very elegant and memorable and classy, and it was *red.* I feel like that's my power color. I remember I decided to vacuum wearing my Oscar gown, and we did a little post of me, like, just doing a little light housework before the Oscars. In my purse I

had a silver peanut that I had given to Steven Rogers, because we always have this expression when I go onstage or if he has to do an interview or something: We'll just go, "Sparkle, peanut." So I had a peanut in my purse and it was sparkly and silver.

THE PINCH-ME MOMENT

I never took any award for granted. I didn't ever think, *This is a done deal.* I was more nervous at the Oscars than I was at any other award show because of that being the ultimate award. I may have taken a beta blocker. Right before they called my name, I was like, *It's Lesley Manville from* Phantom Thread. *She's going to win it, because she's British and she's unbelievably talented, and it's going to be the big surprise of the night.* So when they said my name, it was almost more of a relief that I didn't let everyone else down. If I lost, I think I probably would have fainted.

THE SPEECH

I'm terrible at writing. When I have to speak, I get tongue-tied and my brain shuts down. I went to Nick Bakay, who was a writer on the *Mom* show, and I said, "Give me something funny to start with if I should win this award." And he said, "I did it all by myself." I didn't know if I was going to use it that day. I thought, *I gotta wait and see what the room feels like.*

So when I was walking up those stairs, I was like, *Am I going to do it? Am I going to do it?* When I finally held the award and just took a breath, I thought, *Yep, I'm going to do it.*

THE DEDICATION

I think it would have given my brother enormous joy to see me there getting an award like that. He was such a champion of mine. I felt a special connection with him, and I wanted so much to help him want to be here. But he just couldn't find a place to land. So I'm grateful that I *did*, and I feel like he's part of that. I just miss him so much, every day.

THE CELEBRATION

I remember going to get my Oscar engraved—that was a really fun moment. I remember telling the engraver, "Oh my God, my name is spelled wrong," and I gave the guy a heart attack. I was like, "I'm just kidding!" I felt so bad. I did have a good time at the *Vanity Fair* party. I remember standing there with Kobe Bryant. I just fell in love with him in that moment, congratulating each other on our Oscars. He was like a kid and he was so lovely to me. I know there were a lot of parties to go to after, but I was so overwhelmed, I just wanted to go home with my family, put on a bathrobe, wash my face, have a glass of champagne, and sit there and just go, *Oh my God, what just happened?*

THE PERSPECTIVE

I just felt like I was getting to be of a certain age, and I'd been on two long-running TV shows, which I loved being a part of. I thought, *Maybe the Oscar's not in my future, and it's okay.* But I was wrong!

WHERE OSCAR LIVES NOW

He moves around a bit. Sometimes he ventures out on top of the piano. And then other times he comes out into the kitchen. Right now he's on a bookshelf in my office, and he's surrounded by the Emmys and SAG Awards and the BAFTA. Jimmy Kimmel gave me underwear for him—they're in a drawer for when it gets cold. I love looking at the Oscar and picking it up every once in a while. It always brings me a great big smile.

Janney with friend and *I, Tonya* screenwriter Steven Rogers

MEL BROOKS
BEST ORIGINAL SCREENPLAY
The Producers
1969

"I'd also like to thank Gene Wilder.
I'd also like to thank Gene Wilder.
I'd also like to thank Gene Wilder."

Mel Brooks's screenwriting Oscar is that very rare entity: an Academy Award for a comedy. But Brooks's unforgettably irreverent screenplay for *The Producers* was a surprise winner over its much heavier competition. His acceptance speech began with a sweet comedy bit and ended with a touching tribute to his *Producers* star Gene Wilder, whom he thanked no fewer than three times. Brooks was already a recent Emmy winner for writing *The Sid Caesar, Imogene Coca, Carl Reiner, Howard Morris Special*; decades later, he would go on to win three Grammys and three Tonys (most of which were for the Broadway adaptation of *The Producers*). And of course, Brooks's Academy Award wasn't the only Oscar in his household—his wife, Anne Bancroft, had won Best Actress six years earlier.

THE BACKSTORY

My aspiration was to become a well-known comedian in the Borscht Belt. That was my goal. My dream was to be Myron Cohen or Henny Youngman. I don't know if I knew what the Oscar meant then. I knew I loved Fred Astaire and Ginger Rogers movies. But to tell you the truth, I had no notion of the Oscars. Never, never, never even thought of it. As a matter of fact, when I got a call from the Academy that said, "You're nominated for an Oscar," the voice sounded like Speed Vogel, a friend of mine. So I said, "Very funny, ha ha, I got to go back to work. Up yours!" Then they called back and convinced me. I said, "I'm sorry!" I apologized profusely for giving the Academy an *Up yours*.

Christopher Hewett and Gene Wilder in *The Producers*

THE BIG DAY

I called everybody I knew in the world and said not to root for me because it was a waste of time. When I went over my competition, it just seemed impossible. First of all, I was up against *The Battle of Algiers*, one of the greatest movies of all time—Pontecorvo directed it. I said, "It's going to win everything if they have any sense." And then Stanley Kubrick, *2001*—it's a masterpiece. I said, "It's going to be a big fight between Pontecorvo and Stanley Kubrick and I'll be on the sidelines." Then there was *Faces*—a very good director, John Cassavetes. And then there was a Peter Ustinov picture, a very, very good comedy, *Hot*

Millions. I thought I couldn't make it against *Faces* or *Hot Millions*, let alone *The Battle of Algiers* or Kubrick. So I didn't want to go. Joseph E. Levine, who distributed *The Producers*, and Sidney Glazier, who produced it—they begged me to go, just in case. At least I'd do some interviews and help the movie. So I said, "Sure." And I rented a tuxedo, and I went to the ceremony. My wife was in New York doing *Mother Courage* at the Martin Beck Theater, the Bertolt Brecht musical. I just got a single ticket and went.

THE WINNING MOMENT

I couldn't believe it when Frank Sinatra and

Don Rickles called my name. I never thought I had a chance, really. When I got up there, I was really, truly not acting. I really didn't have much of a speech. I was going to say, "I think you made a big mistake here, and it's going to be embarrassing for all of us when you discover it later." I was thinking it, but I didn't say it. I imitated my heart pounding, right? I said, "I want to tell you what's in my heart: *ba-bump, ba-bump, ba-bump.*" I never stopped being that Borscht Belt comic! I was so grateful to Gene. He just was astonishingly good. And he was me. I mean, I was Leo Bloom. I guess he cried after my speech, and he said, "I can't thank you enough." He really cemented my early career. He was extraordinarily talented and simple and honest and wonderful. I miss him a lot.

THE CELEBRATION

Anne and I were up all night on the phone, just laughing and crying about how wonderful it was. She said, "I told you you were good. You wouldn't believe me!" Because *The Producers* had not made a lot of money. I got a very bad review in the *New York Times*. Renata Adler did not like *The Producers*. That was a tough night when that came out. My wife and I got through it together.

THE PERSPECTIVE

It meant a lot. It meant that I belonged. I thought I didn't belong to that crowd. The Oscar told me that, yes, you belong in this business. It really gave me the courage to continue. I wasn't an outsider anymore. I made *Blazing Saddles*, and against all odds, *Blazing Saddles* was a big hit. And then I was really ensconced in the moviemaking business.

THE EGOT

The Producers is still the number-one Tony collector on Broadway: twelve Tonys. It's an amazing triumph—I'm very proud of it. People told me about the EGOT when it happened, in retrospect; they said, "Hey, you're an EGOT!" I said, "What's that? Is that anything like being a Jew?" And they said, "No, it's a different thing."

WHERE OSCAR LIVES NOW

I originally had all my awards on my mother's TV set in Florida, because she had four o'clock tea and cookies with everybody in the building who came to see my awards. It was important—she needed it for her showings. The Oscar resided there until she passed away. And then I took it back. Anne had an Academy Award for *The Miracle Worker*. And Anne had hers on *her* mother's TV set. Now I have a lot of my awards on a table behind my desk at the office. But I don't have the Oscar there, because I heard about a robbery and somebody took an Oscar. I keep that one at home.

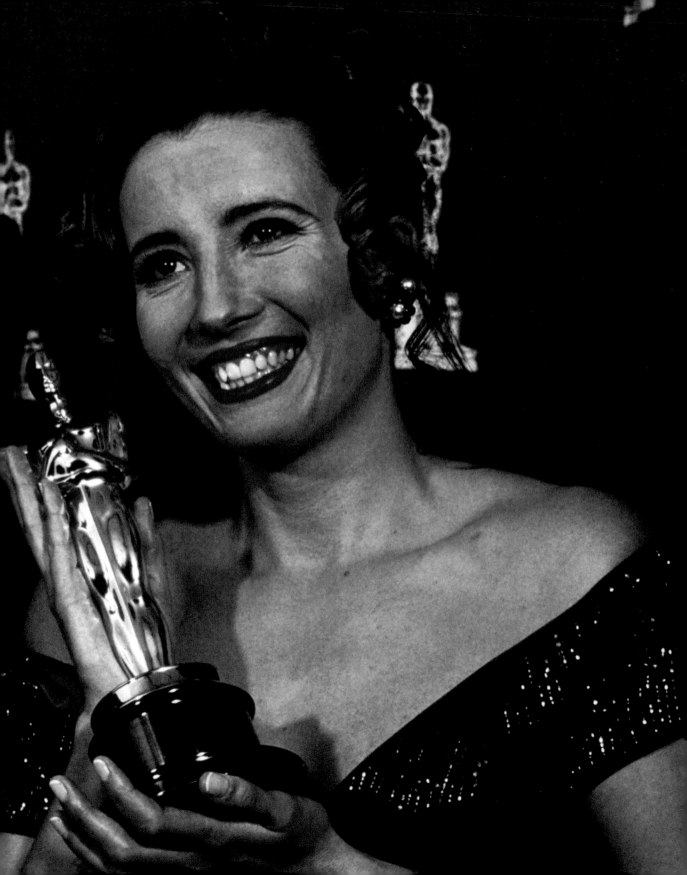

EMMA THOMPSON
BEST ACTRESS
Howards End
1993

"I would like, if I may, to dedicate this Oscar to the heroism and the courage of women, and to hope that it inspires the creation of more true screen heroines to represent them."

Many of Emma Thompson's recollections of her first Oscar win involve her mother, veteran actress Phyllida Law, who accompanied her that evening. Still, when Thompson won the Best Actress prize for her sensitive and sympathetic performance in *Howards End*, she decided not to thank any of her family or friends, instead using her time onstage to pay respect to her collaborators and plead for stronger film roles for women. She also chose to wear an unorthodox outfit—a beaded bodice top and wide trousers—in lieu of a couture gown. Three years later, Thompson would win her second Oscar, Best Adapted Screenplay, for *Sense and Sensibility*, and become the first person ever to win Oscars for both acting and writing.

THE BIG DAY

We were, my mom and I, in a very small room at the Bel-Air Hotel. We had two people come in the afternoon. Actually, one of them was a young Frédéric Fekkai. He did my hair wonderfully. What a gorgeous, lovely man he was. And he did Mum's hair, so she looked like a duchess. We both looked a bit duchess-y, actu-

ally. Anyway, Frédéric Fekkai came to do our hair, and my friend Val did our makeup. So we had a lovely afternoon. Lots of cups of tea in a wee, tiny room. And I remember the doors were open to what was a tiny, little courtyard so we could be outside a bit. I had no expectations at all. I was happy to be there. We had the radio on in the limo and the commentator said,

Thompson as Margaret Schlegel in *Howards End*

"This is definitely Susan Sarandon's year." And I thought, *Oh, right-o. Okay, that's fine.*

THE PINCH-ME MOMENTS

Mum was wearing a long train, and people kept stepping on it and choking her, and she turned round, and it would be Placido Domingo or Al Pacino. I said, "Hello, Mr. Pacino, this is Phyllida Law, my mother." "Oh, my God, is this your mom? Isn't she beauti-

ful?" All that went on endlessly. In fact, as we were sitting in the theater, there was a tap on my shoulder and it was Richard Gere. He said, "Could you introduce me to your mom? She's so beautiful." It got quite irritating after a while. But everyone was just so delightful.

THE LOOK

I thought it was important to wear a British designer, so I asked Caroline Charles, who

had a lovely little shop in Knightsbridge. Occasionally, if I had any money, I would buy something there. I wasn't rich at the time. I said, "Do you fancy making me an outfit for the Oscars?" We talked about color; that teal-green color is my favorite color. I still love that outfit, but it was not generally regarded as anything special by the fashionistas. I remember there was a fashionista on the stairs of the theater who said, "Oh, God love her. She looks dowdy in anything." But I don't mind about that.

THE SPEECH

I meant it from the bottom of my heart, because I had grown up identifying with male heroes. And I knew that no one was going to pay me to ride into town on a horse and sort out the bad guys anytime soon. So I thought, *It's time to really try and work out how to show female heroism, without which we would not have any society. We would have nothing. We would be empty shells and dead.* We are starting to see movies made by women and written by women—and I've been lucky enough to be in some of them—that are really telling new stories about women, and I'm very glad about that. I think there needs to be a lot more, and there needs to be a lot more about older women because there's not much going on there. I've been very lucky to sort of be that change, but I don't think there's enough of it. I'm British—

there's no way I'm ever going to say, "I love you, Mum" on a stage. That's a private matter. Awards ceremonies are professional ceremonies for professional people who've done something that other professionals like. That's how I feel about them. And then you celebrate personal relationships in private.

THE AFTERMATH

Going backstage afterwards was just the best. All the people backstage, they're just so lovely. And because I wasn't famous, and they didn't know who I was, they were even nicer to me somehow. I said to the security guard, "Could you hold this a minute? I have to pull my tights up." And he held it like it was the fucking Ark of the Covenant. We had to go to the Governors Ball—that's just a blur, and I kept losing Mum. Then we went to Elton John's party, and I sat next to Prince and Tim Roth and we just giggled. We went back to the Bel-Air and we all had something to eat. And then I spoke to my friends at home in England until four in the morning. I had to talk down the adrenaline and the excitement. So I just sat in my frock holding the Oscar until quite late.

THE PERSPECTIVE

It was an extraordinary feeling of joy and pride and happiness, really. It was so unexpected. And I was proud of the work. So I didn't think, *I don't really deserve this.* Whereas the follow-

ing year I got nominated for *In the Name of the Father*, which is a terrible performance. I did not deserve that nomination. Now I just feel grateful. They're really wonderful things to have. They mean a lot. There's something about the old Hollywood of it that's very touching to me—their connection with history, their connection with the olden days and the old legends. There's something about that statue that's just so Hollywood.

— WHERE THE OSCARS LIVE NOW —

I keep mine in the downstairs loo in my house because they just look so great. Someone will come in to use the loo and they will rush out and say, "Oh my God, they're so heavy!" I have no other awards on display. All my awards are on the top shelf in my library. You wouldn't see any of the other awards unless you looked up. Not to be rude to any of the other awards. I don't want to look at professional things in my house. But the Oscars are my little golden boys in the loo. They're my friends.

Thompson with her mother, Phyllida Law

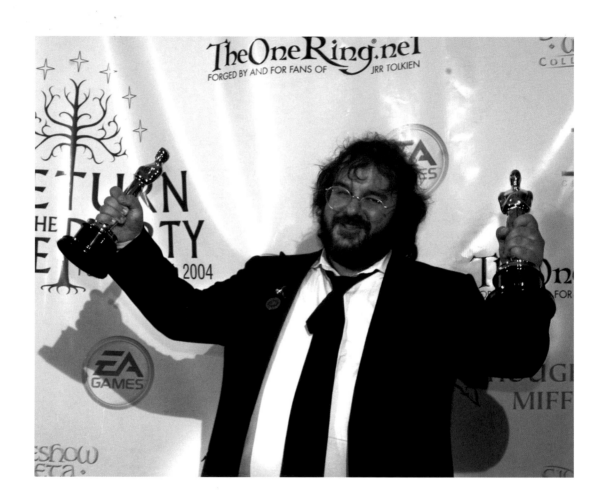

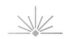

PETER JACKSON
BEST PICTURE, BEST DIRECTOR, AND BEST ADAPTED SCREENPLAY
The Lord of the Rings: The Return of the King
2004

**"You're giving us an incredibly overwhelming
night, and we just appreciate it so much."**

Peter Jackson and his wife, Fran Walsh, had lost a combined total of seven Oscar nominations for the first two *Lord of the Rings* films, in 2002 and 2003. When they entered the 2004 ceremony with three nominations each—together for Best Picture and Best Adapted Screenplay, plus Jackson's Best Director nomination and Walsh's Best Original Song nod alongside Annie Lennox and Howard Shore—it was a foregone conclusion that they would each go home with at least one victory. But in a historic sweep, the final *Lord of the Rings* film went eleven for eleven, bringing the couple's combined Oscar tally from zero to six in a matter of hours. In his Best Director speech, Jackson paid tribute to his late parents, who supported him as a child but didn't get to see his iconic trilogy.

THE BACKSTORY

I was a kid in New Zealand making films with my parents' Super 8 camera. Did I wonder if I was ever going to be up there picking up an Oscar when I was nine or ten? Yeah, I did have that thought. I wouldn't call it an ambition because I certainly never made award-friendly movies particularly. But I certainly had a dream: *Wouldn't it be amazing if one day I got an Oscar?* I never really thought that it would actually happen.

THE BIG DAY

We live in New Zealand, so any time we go

all very strange. But it did fit okay. I remember being fatalistic, just thinking, *Well, everybody who is going to vote has done that. The ballots closed, so our fate's sealed. There's no point being tense or worried or anxious. Whatever's going to happen is going to happen. And there isn't anything we can do to change it now.*

THE FIRST WINS

If somebody said to me, "You're only going to get one award tonight, which one do you want?" it would have been Best Song for Fran. That was the one I desperately wanted her to win because I'd seen her write the song and I knew the emotional place it came from, about a young man that we knew who was dying of cancer. If she won for that, I didn't need the directing one or the screenwriting one or anything else. And

to L.A., it's a trip. We were in the Four Seasons Hotel and I can remember hoping that my suit was going to fit. Versace made me a free suit. I was amazed that somebody would actually want to make me a free suit. It was the first time I had ever been measured for a garment. I'm not a suit wearer. So that was

the song was the first one up of our collective six. She won, and that was just great. What I hoped for that night had been achieved very fast. And so from then on, it was all just sort of gravy. When I won the screenwriting one, Fran and I went up, and that was like, *Okay, well, Fran's got two, I've got one. If the rest*

of the night is a washout, we're good. We don't need to win any more. So I enjoyed the show a lot more after that first win that I had than before.

THE SPEECH

I was an only child. And my parents were wanting me to become an architect because I was good at technical drawing. But they had this kid who was wanting to make films, which was a completely alien idea to them because neither of them had any background in that. They could have easily just not supported me or said, "You should really do something that's a bit more sensible." But they never did. They loaned me money to buy my first 60-millimeter camera—it was two and a half grand. They were always just there to support me, never to criticize, never to throw cold water on what to them must have been a very strange hobby for their son to have.

THE FINAL WIN

Our two kids were home, and they were watching on TV live. And all night long the envelopes were being torn open and it was "*The Lord of the Rings: The Return of the King.*" When it came to Best Picture, Steven Spielberg was the presenter. And he tears it open, and our kids are sitting in New Zealand watching TV, hoping that he's going to read out "*The Lord of the Rings: The Return of the King.*" But he doesn't—he looks at the envelope, and he says, "It's a clean sweep." And our son began to cry because he thought that a movie called *It's a Clean Sweep* had won, and we didn't win. A few years after that, I told Steven that story because it's something that we always laugh about. But he didn't really laugh—he was shocked and horrified that what he said caused a child a long way away to burst into tears.

THE CELEBRATION

We had had a lot of support from the fans. There was a website called TheOneRing and we got to know those people quite well. They had a huge party near the Kodak Theater for all the fans. We had tickets to the *Vanity Fair* party. And we thought, *Well, let's not go just yet. Let's go and do a surprise visit to the OneRing party,* which was a room full of thousands of fans. So quite a few of us who had won that night showed up there, and we waved our Oscars and posed for photos. And I just wasn't keeping an eye on the time. I said to somebody afterwards, "Okay, we probably should get out of here and go to the *Vanity Fair* party." And I was told, "The *Vanity Fair* party's actually ending now." We went there to look and see if there was anything happening and it was all just quiet. So all the winners of our eleven Oscars went to our suite in the Four Seasons. We put all the Oscars in a row

on a table, and there were twenty-seven of them. Then we started to get stick from the hotel. We phoned down trying to get some more champagne. And they said, "We can't sell you alcohol after a certain time at night." Then they started to try to close us down. They said we were making a lot of noise, and we said, "We've just won all these Oscars!" It was made clear that we were causing a disturbance in the hotel. So as a result, I've never stayed in the Four Seasons since then.

THE PERSPECTIVE

The Lord of the Rings wasn't made as an Oscar-bait film. If you wanted to win an Oscar, you'd pick a different type of film than a fantasy film. So everything was a really amazing surprise. And since then, it just takes the heat away. I've been able to enjoy myself a bit more because now I'm an Academy Award winning filmmaker. And they can't take that away, no matter what I do. When you have three, you don't need to win four or five. I've done it, and the pressure is off.

— WHERE THE OSCARS LIVE NOW —

Fran and I have six together. Fran especially is not the sort of person to put the Oscars in a pride of place. She agreed that we could put them in our office if she could make them a little bit less self-important. So she's named them all and stuck torn Post-its on them. There's Neville, Muzza, Trevor, Lysander, Brent, and Gary.

Jackson with fellow *Return of the King* producers Barrie Osborne and Fran Walsh

MARCIA GAY HARDEN

BEST SUPPORTING ACTRESS
Pollock
2001

"Members of the Academy, thank you for even taking the time to view the tape and consider our film."

If there's one thing the Oscar pundits could agree on in 2001, it was that Marcia Gay Harden was *not* going to win Best Supporting Actress. Her four fellow nominees had split the precursor prizes—Kate Hudson won the Golden Globe, Judi Dench the SAG Award, Julie Walters the BAFTA, and Frances McDormand the Critics Choice—while Harden wasn't even nominated for any of them. But thanks to her ferocious performance as artist Lee Krasner opposite director and star Ed Harris (who was nominated for Best Actor) in *Pollock*, she provided one of the most surprising Oscar wins ever—not to mention quite a memorable experience for the actress and her family.

THE BACKSTORY

Ed Harris, along with Michael Barker from Sony Classics, had brought me in to see an early cut, and they were like, "You're amazing, you're going to be nominated." I looked at it, and I thought, *I'm good, but I wouldn't nominate me for it.* Then Ed re-edited it more generously for me, to really allow audiences to identify with Lee Krasner, even though she was someone

incredibly strident and her vocal tone is not easy to listen to. When I went back to see it the second time, I was like, *Okay. Maybe I could be.* But then I wasn't for SAG and I wasn't for Golden Globes. And I was like, *Okay, maybe not.*

THE NOMINATION

I didn't know that the nominations were being announced that morning. No one had

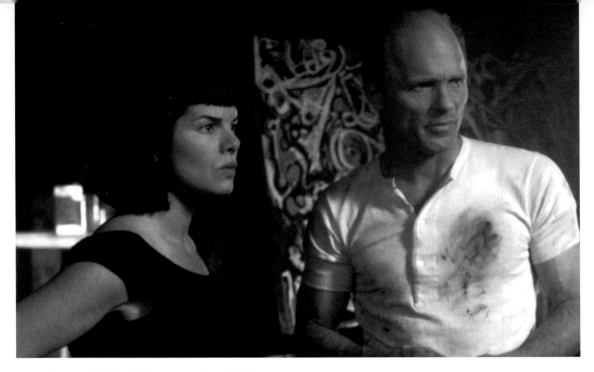

Harden and Ed Harris in a scene from *Pollock*

said, "Be ready. You might get some phone calls tomorrow morning." They must have all thought I knew, and they just didn't want to get my hopes up. I was in a hotel room doing press for *Pollock* when the phone started ringing off the wall. They said I'd been nominated, and it was this huge, like, scream festival by myself in this hotel. I was gobsmacked. When the waitress came to deliver the food that morning, I said, "I've just been nominated for an Oscar, and I have no one to hug!" And she said, "Well, you can hug me." So I hugged her.

THE LOOK

Randolph Duke designed the red gown. It was just solid, scarlet, old-world Hollywood. Harry Winston's son had written me: "We'd love to offer you to wear our jewels." In the

fitting, they had a bodyguard bring some jewels. I was told, "You can wear $500,000 worth of jewels with no bodyguard. If you go over that, you'll need a bodyguard on the night." And we were like, "We don't want a bodyguard on the night. $500,000? That's a lot of jewels. No worries." Then they got wind of the dress and they were like, "Okay, you can have $1,000,000 worth of jewels with no bodyguard." I was like, "What, are you kidding me?" Then they opened up the necklace. I said, "Okay, how would that necklace look with these earrings? And of course I need a ring. And maybe one little bracelet." And my mother's like, "Well, I'd like some too!" And then I said, "Can I see some little diamonds for my sister?" We were up to 3.5 million. I said, "I'll take the bodyguard!"

THE WINNING MOMENT

I thought Kate Hudson would win. Everyone was deserving, but I thought it was her time. I felt like I was the newbie. I did not know that my award was the second one in the show. And then they said my name. I could hear the press cheering up in the balcony. And Ed just jumping up and hugging me. I thought his glasses were going to break or I thought my bra was going to unclasp or something. I walked up to the stage, and I could see and hear my father, the former navy captain, standing up in the audience going, "Bravo!" My mother was tugging him down and crying. I was racing through the thank-yous, worrying that the other actresses would be hurt. Worrying that other people who'd voted for the other actresses wouldn't think that I deserved it. All of that. Like, that's the stupid shit that goes through your mind. I was devastated for Ed that he didn't win. I felt like I was holding the baby that was his. There's not a doubt in my mind that if anybody else directed it, it wouldn't have been that performance.

THE AFTERMATH

At the end of the Governors Ball, we have a limo full of people, and we're dropping everybody at different places. At some point, my publicist is looking out of the car and says, "I think we're being followed." We go to the next place and sure enough, we're being followed. So now it's my husband, my mother, me, my sister, and her husband. Now we get on the highway and the bodyguard's on the phone. And he's like, "They could be jewel thieves who are trying to pull us over." It wasn't quite a high-speed chase, but it felt like one. My mother at one point—this is not a lie—says, "I just want to fling the jewels out the window. I want to *live!*" Then we're like, "These are paparazzi. That's what it is. I'm famous now—this is what it feels like to be famous." We pull into the police station in Santa Monica, we have police cars around us, so that car is caught and we go back to the hotel. And now they've got word, and they said, "So it wasn't jewel thieves—it was paparazzi. And they thought you were Russell Crowe."

WHERE OSCAR LIVES NOW

It's in California, on a bookshelf, and the bookshelf has little lights on it. It's next to my Tony. It used to be next to all of the kids' basketball and baseball trophies, all together. But they were like, "Mom, take our trophies down—that's stupid!" I don't want it on the mantel because I feel like it's too much attention. I feel like among the books and everything, it feels just kind of right to me. I'm so proud of it.

MARK BRIDGES
BEST COSTUME DESIGN
Phantom Thread
2018

**"First, I want to thank Paul Thomas Anderson for writing
this amazing script and having me design it. Thank you, Paul."**

Costume designer Mark Bridges' win for his sumptuous work on Paul Thomas Anderson's couture-house drama *Phantom Thread* was not his first Oscar victory; he had already taken home the Academy Award for the old-Hollywood tribute *The Artist* six years earlier. But on this night, he won not only an Oscar but also a truly unique bonus prize, thanks to his brief thirty-six-second speech and a brilliant, bonkers gag by that year's ceremony host, Jimmy Kimmel.

THE BACKSTORY

Growing up in Niagara Falls, movies captured my imagination. They used to make little dime-store paperbacks about the Academy Awards each year—who won for Best Picture and Best Actress, and then they'd list all the technical awards. I would *X* off which ones I'd seen. This started at about age twelve or thirteen. I still have the books. We'd watch the Academy Awards every year, and I'd be like, *Someday I'm going to be up there.*

THE PRODUCTION

Phantom Thread was my eighth collaboration with Paul Thomas Anderson. He basically dropped this script in my lap. And I'm thinking, *Wait, it's about a fashion designer; does that mean I have to figure out the fashion and the world that they live in? Oh, okay, I'd love that.* You just see a plum job coming down the road. It seemed really interesting to me, the challenges of creating those two worlds. I think Paul looked to me to really flesh out this world that he had researched and written about.

Bridges and Helen Mirren atop his brand-new personal watercraft

Daniel Day-Lewis and Vicky Krieps in *Phantom Thread*

THE SPEECH

I felt I had a pretty good chance. I do try to work out my speech beforehand, and I try to keep it to a minimum. They don't really want to hear a lot from the costume designer. Eva Marie Saint comes out to present the award—legendary Hitchcock femme fatale, beautiful actress for all these years. So then I really got nervous. She called my name, and I was up and over there. I was excited to meet her. Then I said my few lines and I was like, "Thanks, gotta go." I try to keep it short and businesslike, because if it gets too personal, I'm going to lose it.

THE PINCH-ME MOMENT

That night, Jimmy Kimmel had done a gag, which I later found out was something that his wife had thought of, that whoever gave the shortest speech would win a Jet Ski and two nights at a motel in Lake Havasu. I never thought about it for a minute. But I guess they were clocking it every so often during the show, like, "Mark Bridges has still got the shortest speech." I wasn't hearing that; I was just enjoying the evening. At some point, a stage manager comes to me in the audience during a commercial with a clipboard and headphone. "Uh, Mark Bridges, could you

come with me, please?" And I'm like, "Oh no, I'm winning the Jet Ski." I walk backstage and there's Helen Mirren, and there's this huge Jet Ski in front of us. "Could you get up on the Jet Ski, please?" And there are two life jackets in the Jet Ski. So I slipped a life jacket on over my Brioni tux, as a costume designer would do. Then Helen Mirren gets up there behind me, and we're waiting for them to do like Best Picture sitting on the Jet Ski. I was nervous, and I said to Helen Mirren, "All I can think of is Gene Kelly in *Singin' in the Rain*, saying, 'Dignity, always dignity.'" And she goes, "Oh, I like to poke holes in dignity sometimes." And right there, her saying that to me kind of gave me permission to relax with it and have fun. They push us out there, and I look out in the audience, and I can see Paul Thomas Anderson cracking up. Then I knew all was well; it was a great gag. Then, gag's over, everybody just leaves me on the Jet Ski. So I get down, I take off my life jacket and someone hands

me a form, like a W-9 or something. I had to sign something if I was going to pay the tax on it. They had *just* turned off the cameras—I thought it was hilarious. I signed it, and I said to my agent, "We've got to get rid of that Jet Ski." I had no use for an $18,000 Jet Ski. I never took possession of it. I donated it to the Motion Picture & Television Fund and they put it on Omaze for an auction and raised money from it. I never went to Lake Havasu. I think I still have the two nights' voucher in my dresser drawer.

THE PERSPECTIVE

Winning the second one means that the first one wasn't a fluke, that you're really part of a community that you always wanted to be a part of. And it's a great punctuation mark to all the beautiful work that I've been able to do with Paul—it honors his brain, his writing, and our collaboration. It makes me very proud.

WHERE THE OSCARS LIVE NOW

My two Oscars are in my bedroom, on my dresser, in glass domes that I found at Pottery Barn. When I won the first one, I put it away in a closet for a few years. I'd get it out occasionally and look at it, but it was a lot to live up to. I didn't want it to influence how I thought about my work or how I thought about me. But now they're both out, and I've come to terms with that I am, in fact, a dual Academy Award winner. When I see them, it makes me happy.

SOFIA COPPOLA
BEST ORIGINAL SCREENPLAY
Lost in Translation
2004

"Every writer needs a muse; mine was Bill Murray."

Sofia Coppola grew up surrounded by Academy Awards. Her father, Francis Ford Coppola, won a total of five Oscars for his work on *Patton* and the *Godfather* films, plus an honorary award, and her grandfather, composer Carmine Coppola, also won a statuette for his score for *The Godfather Part II*. With *Lost in Translation*—her droll, uniquely beautiful, Tokyo-set friendship study starring Bill Murray and Scarlett Johansson—Coppola, then thirty-two years old, became the first American woman ever nominated for Best Director as well as the first woman ever to earn nominations for producing, directing, and writing in the same year. In a lovely moment during the ceremony, she even copresented the Best Adapted Screenplay prize with her father, who was beaming with pride at her accomplishments. That year's *Lord of the Rings* sweep kept her from taking home the awards for Best Picture or Best Director, but when Coppola won the Oscar for Best Original Screenplay, she used the opportunity onstage to acknowledge not only her family and her leading man but also an international group of filmmakers—Michelangelo Antonioni, Wong Kar-wai, Bob Fosse, and Jean-Luc Godard—whose work had inspired her while she was writing *Lost in Translation*.

THE BACKSTORY

My dad has a lot of awards, and I remember in the seventies, they used to give the winner a little necklace with an Oscar charm on it, a little mini Oscar, I guess for their wives or whoever. So I remember having a necklace with a little Oscar that I wish I could find. My mom has saved hers. As a young person, we'd order pizza and watch the Oscars. It was always fun to talk about the movies and see what people

Coppola on set with her *Lost in Translation* star Bill Murray

are wearing. It was much different than it is now; it was more messy. And people dressed themselves, so that was always entertaining. But when I was making my movie, I never thought about awards. It was a personal film that I wrote late at night at my dining table. I thought it was really indulgent, and I never expected people to connect with it.

THE WINNING MOMENT

It was nerve-racking. I remember when they called my name, I was just relieved because there was a lot of anticipation, like, "Oh, you guys are going to win something." And I just thought, *I didn't let everyone down; what a relief.* That was my first feeling. And then having to go up and speak—I get nervous with public speaking. That's always scary for me as someone that's not a performer. I was just glad that I got to thank some of my film heroes that inspired me. Recently I met Chloé Zhao, who said that she saw that as a kid, and she was so excited that I talked about Wong Kar-wai because she loved Wong Kar-wai. It was sweet to bond over Wong Kar-wai with another filmmaker.

THE CELEBRATION

My brother Roman has an old sixties limousine, and he had "We Are the Champions" all cued up, and he cranked it, and we drove down Vine Boulevard listening to "We Are the Champions." That was my favorite part, that moment. Because we were so nervous, so tense, all night. So getting in the car with Roman blasting "We Are the Champions" was definitely the most memorable moment.

THE FAMILY CONNFCTION

My dad always talked about screenwriting and wanting us to be writers and make personal films. So it was gratifying to be there with him in the work that he loved, and that now I love doing. I'm proud to carry the line on, I guess. I think it's important to him, and it was sweet to see how proud he was.

THE AFTERMATH

I feel like it was really a novelty when I was nominated and was in that group of men. And it's so nice to see now that that's becoming more normal. Of course we want more and more of it. But it's exciting just to see that it's not as big of a deal. It was a really big boost for me in my work and my career because people take you more seriously and you have more opportunities. That is a big plus.

WHERE OSCAR LIVES NOW

It's on a shelf in the dining room in our apartment in Paris. I thought it'd be more exotic for it to live there.

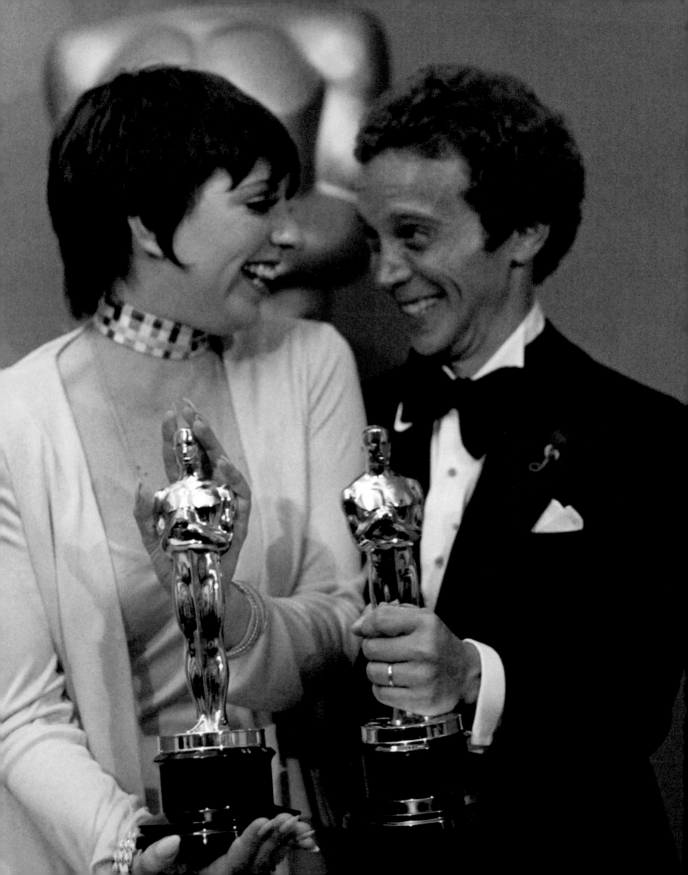

JOEL GREY
BEST SUPPORTING ACTOR
Cabaret
1973
"Don't let anybody tell you this isn't a terrific thrill!"

Winning the Oscar was the end of a roller-coaster seven-year journey for Joel Grey as the Master of Ceremonies in *Cabaret*. He had originated the puckish role in the Broadway production in 1966 and won a Tony Award for his stage performance in 1967. Years later, filmmaker and choreographer Bob Fosse signed on to direct a film version of the musical, but he excised virtually every musical number that didn't take place in the production's central nightclub setting. Furthermore, he decreed that no members of the Broadway cast reprise their roles in his film—including Joel Grey. Fosse ultimately gave in to the producers' wishes and cast Grey alongside Liza Minnelli and Michael York, but Fosse and Grey had a rocky relationship during filming. Still, in 1973, they each went home with Academy Awards—Fosse over *The Godfather*'s Francis Ford Coppola (even though Coppola's film would eventually take Best Picture) and Grey over three members of the *Godfather* cast: James Caan, Robert Duvall, and Al Pacino. For Grey, who attended the ceremony with his then-wife, Jo Wilder, part of the thrill was receiving the award from pop icon Diana Ross.

THE BACKSTORY
You know, Bob Fosse didn't want me for the movie. I never knew who he wanted. Ruth Gordon and Anthony Newley—those are the only two names I ever heard that were mentioned to play the MC. One day Bob came into a meeting with the producers and said, "Well, it's either Joel Grey or me." And the producer, Marty Baum, said, "Then it's Joel Grey." Can you imagine?

THE BIG DAY
I was living in Malibu, two houses down from Larry Hagman, who was my best friend. He

Grey with his *Cabaret* costar and Best Actress winner, Liza Minnelli

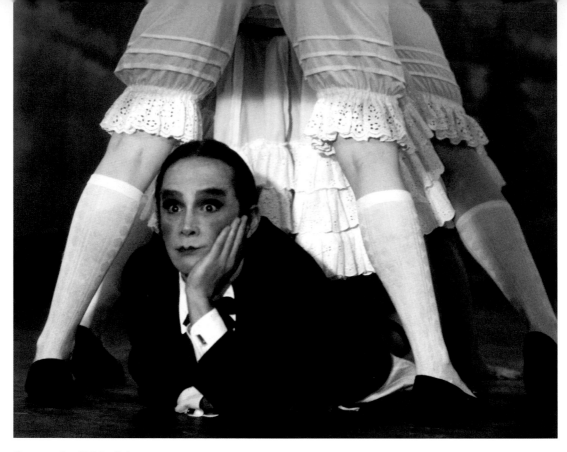

Grey as the MC in *Cabaret*

was the sweetest, kindest guy. He had this reputation for being a big drinker or smoker or whatever, but he was wonderful. He took me out during the day in his camper, so that I wouldn't be thinking about the awards too much. We just drove around and got ice cream or whatever it was. Maybe I got a haircut. I was just holding on. And before I left, it was, I think, four in the afternoon, we were walking out to the limo, and Larry comes over and plants a big kiss on my forehead and a hug to my wife and into the fray we went. My wife was wearing Halston and looking spectacular, and the kids were waving to us good

luck. It was as exciting as I could ever imagine. The whole thing down there was surreal and yet it was real.

THE WINNING MOMENT

I guess I thought I might get a nomination when the movie came out and everybody liked it. But I never thought I was going to win. I was sure it was going to be Al Pacino. But one always has a tiny bit of imagination and hope. And I had a tiny bit. "And the winner is . . . Joel Grey." That's what I heard. And I thought, *Diana Ross is saying my name.* And I ran up the aisle. It was as good as it gets. This was

Grey accepting his Oscar with presenter Diana Ross looking on

we walked on the beach and there was Diana Ross. I didn't speak to her because I think she was sort of incognito. "And the winner is . . ."—I'll never forget the sound—"Joel Grey." She was so great.

THE AFTERMATH

I saw Liza win Best Actress, which was very important to me. I thought she would win and she deserved it. We all deserved it, but once in a while the arrow points to you. All the dark and negative stuff between me and Bob—it was forgotten. I remember just sitting there holding my wife's hands at a party afterwards, and she was thrilled too. She was very supportive. We got home, and there was this big trophy in front of my door by itself. It said "World's Best Fucking Neighbor Award." It was from Larry Hagman. That topped it off. In case I didn't win, he wanted to make sure I had something. That's why he did it.

not supposed to happen but here it is, a dream come true. Just like that. I knew Diana Ross a little bit, before she had become Diana Ross. My wife and I went on a vacation to the Virgin Islands after I did *Cabaret* on Broadway, to this fancy place, Frenchman's Cove. And

WHERE OSCAR LIVES NOW

It's in my office in my apartment in New York City.

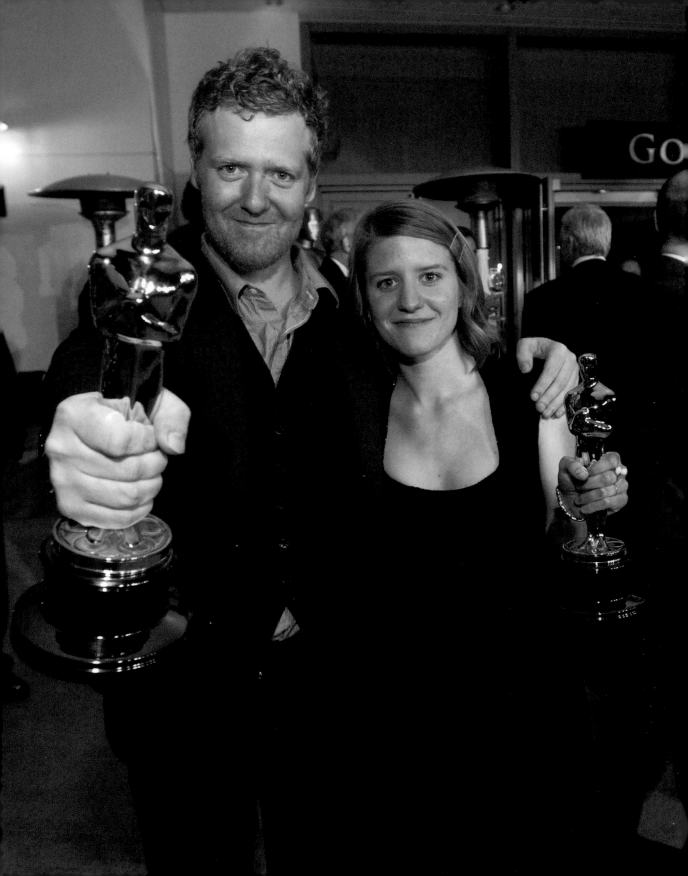

GLEN HANSARD & MARKÉTA IRGLOVÁ

BEST ORIGINAL SONG
Once
2008

**"Fair play to those who
dare to dream and don't give up."**

In many ways, Glen Hansard and Markéta Irglová were the unlikeliest Academy Award nominees of 2008. Both musicians with no acting experience, the pair starred in writer-director John Carney's intimate, micro-budgeted drama *Once* and wrote and performed several songs in the film. They also fell in love during filming and were still a couple on Oscar night two years later. The odds were against them, given that their category included three splashy *Enchanted* numbers cowritten by eight-time winner Alan Menken. But their victory for their hauntingly beautiful ballad "Falling Slowly" provided the most memorable moment of the evening when nineteen-year-old Irglová, to this day the youngest-ever winner in a music category, was drowned out by the show's orchestra, prompting host Jon Stewart to invite her back onstage to finish her remarks.

THE BACKSTORY

GLEN: John had come to me maybe two years before he made *Once*. He was the first bass player in my band, so he knew me from the industry, and he told me that he was working on a script for a film called *Busker*. I was a busker, and he was really curious about all of this stuff, and we talked a lot about it. I was working with Markéta at the time. John asked me, did I know anyone who was Eastern European who was a really good singer? The person needed to be thirty-five or older. And I was like, "Well, I do know a really great Czech singer, but she's seventeen."

"A bold and poignant modern love-story that restores your faith in music, romance and film"
TIME OUT

"Close to perfect"
A.O. Scott, NEW YORK TIMES

How often do you find the right person?

once

In Cinemas October 19
www.myspace.com/oncethemovie

THE SONG

MARKÉTA: Me and Glen were good friends before we were cast in the movie. We often had ideas bouncing around or melodies that we were trying. I remember we were making some tea, and I had heard him humming this melody in the kitchen when we were waiting for the kettle to boil. It was almost like a melody that I knew from somewhere. I said, "What's that?" He said, "It's just an idea that I'm playing around with." I was like, "Well, shall we go and work on it right now?" So we took our cups of tea, and we went to the piano in my house. And in a day it was written. You write a lot of songs as a songwriter, but every now and then you get one that feels like a kind of gift.

GLEN: I remember John came to a gig, and he heard us play this one, and he's like, "I really want that song. That one has to be in it." When he heard that song, he wrote a scene for it. He loved Markéta's voice, and he loved the connection between the two of us onstage. He said, "She's perfect."

THE BIG DAY

GLEN: Markéta and I didn't get a chance to really see each other because we were just being pampered by everyone, getting the makeup on, getting the clothes on. And there was a lovely moment where we were in the bathroom, and she might have been doing eyeliner or something, and she said, "I don't know what's going to happen tonight, but if we're called up there. I just want to say 'Thank you.'" That was what we agreed.

MARKÉTA: I was worried about the possible situation of overstaying our welcome. I felt like we were already sort of chancing it by being there at all.

GLEN: We thought that Alan Menken would win. And we met Alan a few days before, and he came to us and said, "My money's on you guys."

THE PINCH-ME MOMENTS

GLEN: We had some very warm interactions. George Clooney was very warm. Daniel Day-Lewis kind of took us under his wing for the night because he was on his own and maybe because we were from an Irish film. So we hung out with him a bit. Frances McDormand was very, very kind. Laura Linney was an absolute sweetheart. Tom Hanks and his wife came and said hello. There was a genuine sense that we were such an underdog.

THE SPEECH

GLEN: I certainly was utterly out of my depth. All I wanted to say was "Thank you, John Carney, for having faith in us and for having us in your film." And it's the only thing I didn't say! No matter what you plan, it doesn't make any sense up there.

MARKÉTA: I was just going to say "Thank you." I didn't notice that the mic was off or that the music was playing. We walked offstage and that was it as far as I was concerned. We were handed a glass of champagne, and we were ushered into a room to take some photos. Then when we were on our way back to the seats, we were stopped. Somebody said, "Jon Stewart really wants you to go back onstage and finish your speech." They mentioned something about the ads, so I thought I was going onstage to address the room while the advertisements were on. I didn't realize that it was going to be televised until I was onstage. I didn't have anything prepared. But thank God I said something that made sense. I actually am really proud of what I said, because it really came from the heart. When I was on that stage, and I could see the people in the room, and I could somehow feel all the people at their TVs, I really felt connected to everyone. I will never forget it, and in fact, it's the highest moment probably in my life ever. It changed everything for me. I'm really grateful that they let me do that because I know it doesn't happen very often.

THE AFTERMATH

GLEN: When I met Mar, I met somebody who I had known an awfully long time. She made me better at music. That's an incredible thing, to meet someone who has such truth. In a way, the film really does reflect the truth of the relationship because this lady comes into your life and tells you to dig deeper. And eventually they achieve something really big together. I feel she came into my life and walked with me through an experience that I couldn't reach alone. All the potential was reached, and all that's left now is just absolute love and respect.

MARKÉTA: I always felt like I was kind of hopping on to Glen's journey, that I came on to a train that was already moving, and I jumped on. And then we kind of spent

some time traveling in the same direction, and our paths were connected. Throughout all of these years, the Oscar has been like the golden key that seems to open a lot of doors—suddenly I had this golden stamp of approval. I will never tire of the story or the song. It was a miracle, that it happened in the first place. It reinforced my idea that anything is possible. The friendship has always been the core of our connection. There was a little bit of a period where I had to get used to not being romantic anymore and just being friends, but it was still never a question in my mind whether our friendship would survive, despite the ending of our romance.

── WHERE THE OSCARS LIVE NOW ──

GLEN: It's on my piano, next to dolls of Evel Knievel, Beaker from the Muppets, and Bert from *Sesame Street*. And it has this little woolly hat on it. Every so often I look at it and it's kind of a reminder of the things that can be done, you know?

MARKÉTA: I have it in my studio. People come in and record here, and some notice it, and some don't. My family and I watch the Oscars still every year, and whenever we do we put the statue on the coffee table in front of us.

Irglová and Hansard perform "Falling Slowly" at the Oscars ceremony.

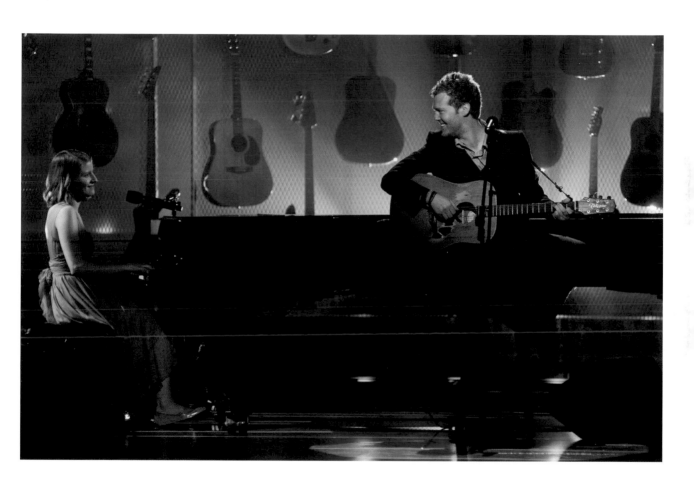

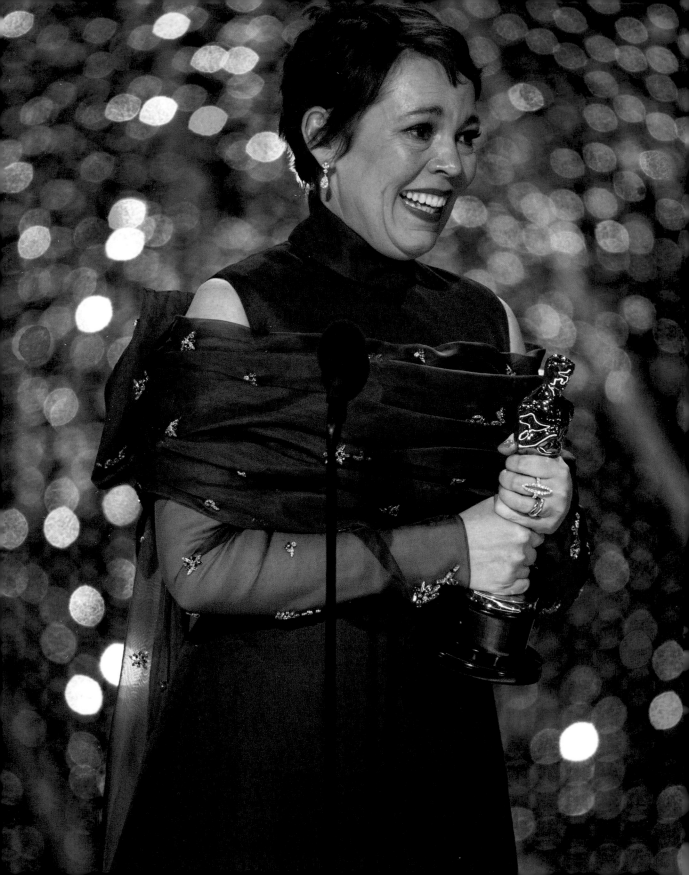

OLIVIA COLMAN
BEST ACTRESS
The Favourite
2019

**"This is hilarious!
I got an Oscar!"**

First-time nominee Olivia Colman may have starred in one of the two films that earned the most Oscar nominations in 2019, but it was her fellow Best Actress contender Glenn Close who was tipped to win, having earned her seventh career nomination for *The Wife*. But when presenters Frances McDormand and Sam Rockwell announced Colman as the winner, it led to an emotional roller-coaster of an acceptance speech that alternated between laugh-out-old hilarious and deeply moving. For Colman, much of the joy of the evening resulted from being there with so many cherished people: her husband, Ed Sinclair; her director, Yorgos Lanthimos; her longtime friend Paul Rudd, who happened to be sitting in the row behind her; and her two Oscar-winning costars from *The Favourite*, Emma Stone and Rachel Weisz, who were both nominated that year for Best Supporting Actress.

THE BACKSTORY

Emma and Rachel and I—we were all three equal parts in the film. At the Oscars, you have to put forward whether you're going to go up for lead or supporting. And I refused. I said, "It's not right, unless they can put us all together." What I found out is that Ems and Rachel had both said, "Well, we've both got one—so let's put her in lead." I will forever love those two women because that's an extraordinary feat of kindness. They didn't have to do that. So it's all down to them, really.

THE BIG DAY

We stayed at Chateau Marmont just for the night of the Oscars. In the buildup, I had been really anti anyone talking about it because I didn't like the pressure. And Ed, my husband,

kept saying, "Well, what if?" "I don't want to talk about it!" I tried to pretend it wasn't happening. I had half a beta blocker on the day because I was so nervous, which was a total game changer. That was amazing—it took away all my fear. I shouldn't probably be recommending that, but it was great.

THE LOOK

I said, "I want a high neck." When I get nervous, I get the most awful red rash. So most of my evening dresses have a high neck to hide my panic. Apparently, the gorgeous woman from Prada who flew it over from Milan put it in its own chair with a seat belt and refused to move it. I remember, as I was getting fitted for that dress, I said, "I promise I'm going to try and lose some weight to wear your beautiful dress." And she went, "*Sí*, it would be good." She was very blunt. It was an absolute honor to wear.

THE PINCH-ME MOMENTS

I was with people I loved—we were all sitting together and just giggling. And what's great about the Oscars is the bar is right there. So

we spent a lot of time in the bar and these panicked men and women with clipboards going, "Your category's coming up! You've got to go!" That Paul was there, it meant so much. One of my first theater jobs was with Paul, and that's how we all met. He used to sleep on the floor in our little shitty flat—he'd come for lunch and stay on the floor. And then suddenly, we're both at the Oscars.

THE WINNING MOMENT

I saw Sam Rockwell and Frances McDormand come out and I just thought, *Whoever goes up there is so lucky because they get to hug those incredible people.* And it was me! And then Ed and Ems were just both kissing me. Then I just panicked: "I can't do it! I can't do it!" Ed had to sort of give me a shove, I think. I remember I just hugged Frances and said, "I'm so pleased it's you."

THE SPEECH

I think my adrenaline had conquered the beta blocker, and it was all happening weirdly fast and weirdly in slow motion. And then I blew a raspberry, didn't I? Once you're there, it's like, "I don't want to leave this moment! This is amazing!" I think we were in Palm Springs when I met Glenn. I didn't know what to say. And she introduced herself to me, and I went, "Hello, I love you." She was so sweet that she made the first move. She is an icon, and I've

watched her for years. And she's always brilliant. I felt bad that it went the way it did for that reason. I'm pleased I remembered to say something to her.

THE CELEBRATION

I don't like the big parties where there are lots of people. There's always someone taking photos, and I'm not comfortable there. Bless Fox Searchlight and David Greenbaum: He knew that I preferred a little private party, so he hired a house that had a karaoke room. And we just went around at the Oscars whispering to Melissa McCarthy and Amy Adams and people that we had grown to love over the course of the year. And everyone went and got changed. Melissa came in a tracksuit with her husband, and Paul and his wife, Julie, came, and the loveliest people were in this house eating pizza and singing karaoke. It was the best party ever. I probably sang Kate Bush and Bon Jovi. That was the moment when we felt we could let our hair down and jump up and down and squeal with everybody. At some point I took a sip of champagne, I didn't know whose glass it was, and I went, "Oh, Eddie, it's daylight! We have to go to bed." It was the longest night and the night that went the fastest as well, in a weird way. We didn't sleep very much because I was so excited. And I wanted to make sure that Oscar was okay. I made a little bed for him in my suitcase.

THE PERSPECTIVE

It was a sort of culmination of daydreams. I think that I hadn't admitted that I really did want it. And it's not something I felt comfortable admitting; it felt wrong. I'm so lucky to work. I love my job; anything else is such a lovely bonus. But secretly, without telling anyone—I didn't even tell Ed—I dreamt of it. I had worked as a cleaner and dreamt of it. And I practiced my speech. I wish I had those speeches because I clearly was all over the shop when it actually happened. But it meant much more than I was willing to admit.

WHERE OSCAR LIVES NOW

I decided I should have it out in the open for a year, in the middle of a mantelpiece in our sitting room. But I was worried it felt a bit vulgar if people came around and he's out on show. So he's now in a lovely old cupboard that was handed down from my mum. He's in my secret chamber where every now and then I go and have a look and I polish him.

Colman being congratulated by her close friend Paul Rudd

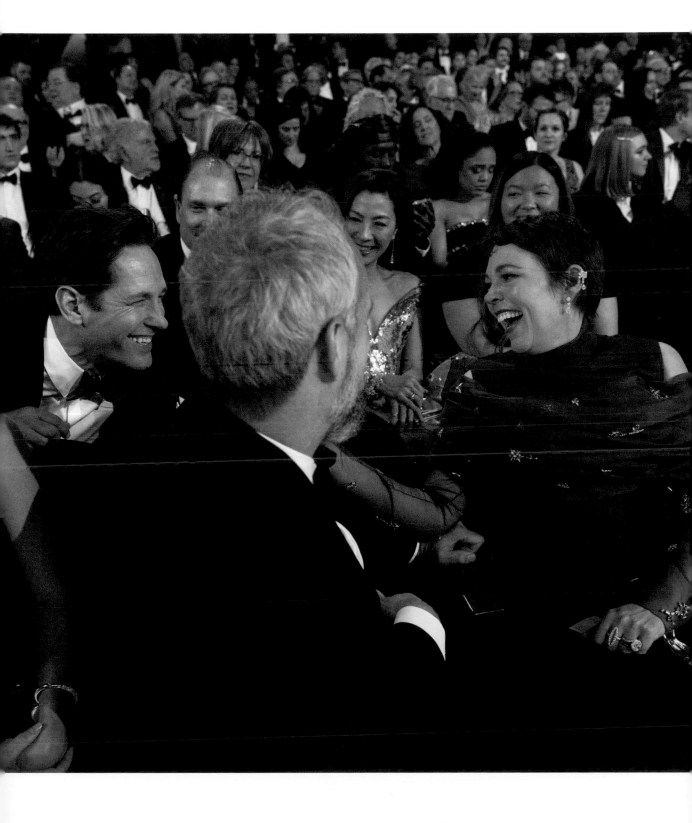

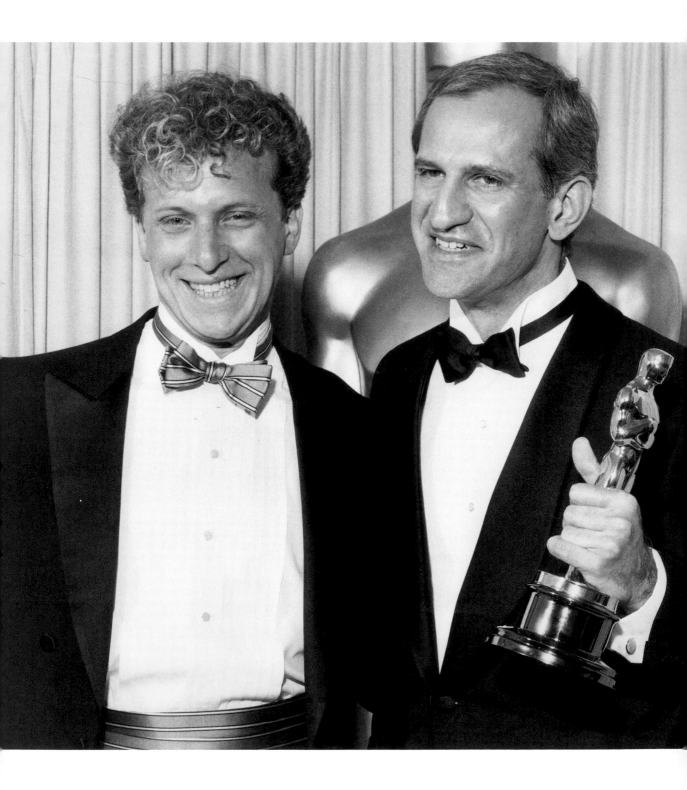

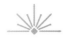

ROB EPSTEIN
BEST DOCUMENTARY FEATURE
The Times of Harvey Milk
1985

"A simple thank you to Harvey Milk for reminding us that it's possible to live life with a sense of social responsibility and a sense of humor."

The late San Francisco politician and activist Harvey Milk is quite well known today, but in the mid-eighties, just a few years after he was assassinated by a political rival, Rob Epstein's seminal documentary *The Times of Harvey Milk* effectively introduced him to the country at large, in good part due to Epstein's Oscar win for Best Documentary Feature alongside producer Richard Schmiechen. The victory was historic because of the film's subject matter and for Epstein's public acknowledgment of his same-sex partner, a first on the Oscars stage. Five years later, Epstein would win a second Oscar in the same category for *Common Threads: Stories from the Quilt*. Schmiechen, meanwhile, passed away from complications of AIDS in 1993. And Milk's life was dramatized in the 2008 film *Milk*, for which Sean Penn won an Oscar for Best Actor.

THE BACKSTORY

I started watching the Academy Awards as a young boy. My sister and I would line up her Barbie dolls to watch, and I've been a faithful viewer and attendee ever since. It was the big annual TV event for my mother, sister, and me. Later I came to understand that the Oscars were my first introduction to the various crafts and forms of filmmaking, including documentary.

THE BIG DAY

I hadn't spent much time in Los Angeles at that point, so everything was new and exciting. The day of we spent by the hotel pool. I was feeling relatively calm, that is, until I was

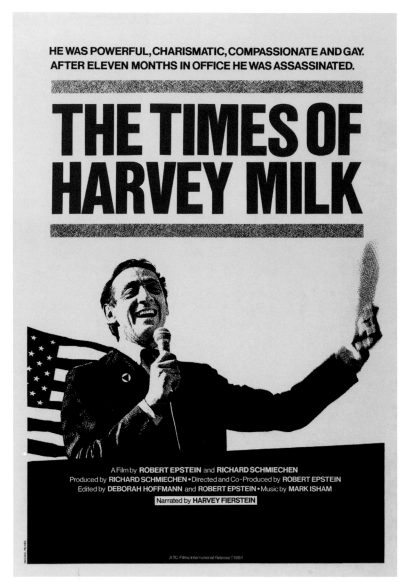

HE WAS POWERFUL, CHARISMATIC, COMPASSIONATE AND GAY.
AFTER ELEVEN MONTHS IN OFFICE HE WAS ASSASSINATED.

THE TIMES OF HARVEY MILK

A Film by **ROBERT EPSTEIN** and **RICHARD SCHMIECHEN**
Produced by **RICHARD SCHMIECHEN** • Directed and Co-Produced by **ROBERT EPSTEIN**
Edited by **DEBORAH HOFFMANN** and **ROBERT EPSTEIN** • Music by **MARK ISHAM**
Narrated by **HARVEY FIERSTEIN**

A TC Films International Release ©1984

THE LOOK

A very good friend, Robert Gerber, presented me with a blue silk Charvet bow tie and cummerbund as an Oscar ceremony gift to go with my rented cropped tuxedo. I wore white socks, which I only remember because you can see them as I'm running up onstage. It was a fashion choice inspired by Michael Jackson.

THE WINNING MOMENT

When Kathleen Turner announced, "And the winner is *The Times of Harvey Milk*," it was pure elation. Richard and I hugged, and I made a mad dash to the stage while the audience cheered. Did they know this was an historic win? Who knows, but it sure felt like they did. Richard was much cooler and more collected in his walk to the stage. After we gave our speeches, we were ushered to the wings, where I had a moment with Kathleen Turner, who was very obliging as I jumped up and down.

THE SPEECH

Richard and I knew that if the film were to win, it would be an important moment for us to

handed a copy of *USA Today* predicting *The Times of Harvey Milk* as the documentary feature winner. Then it started to feel real, and the nerves kicked in. After that, Richard and I went up to my hotel room to work on our speeches, which we wrote in note form on Beverly Hilton cocktail napkins.

somehow acknowledge. This would be the first LGBTQ-themed film to be recognized by the Academy, and we would be the first openly gay filmmakers to accept the award. We wanted to use our forty-five seconds to give some context to who Harvey Milk was, and that he was part of the LGBTQ community, and that our film was part of that community. I also wanted to acknowledge my then-partner, John Wright, who had been so supportive in the making of the film. I came up with the term *partner in life*, so I've been told.

THE CELEBRATION

We went to the Governors Ball, and then when we returned to the limo, our drivers, two men, had champagne on ice waiting for us. They lowered the glass divider to toast—they had champagne as well—and said, "We've been together for fifteen years, and this is a night we've been waiting for." We then went to Spago's, which was where the big Swifty Lazar afterparty happened, but they wouldn't let us in. They didn't even want to let us out of the limo, despite my holding an Oscar. The crowd across the street got wind of this, and after seeing the Oscar started chanting, "Let them in! Let them in!" but to no effect. We ended up going to Canter's Deli, and with the Oscar plopped on our table, we made one waitress's night.

THE TRIBUTE

Richard was one of most solid human beings one could ever meet, ethical to his very core. In the early stages of the making of the film, Richard came to a fundraiser in New York City and watched the trailer I put together. Afterwards he said, "What can I do to help?" He moved to San Francisco for a year to produce the film. He helped professionalize the project, and it wouldn't have been the same film without Richard.

WHERE OSCAR LIVES NOW

The statue is currently at the Academy Museum of Arts and Sciences as one of a couple dozen historic Oscars on display. It will venture back home when the exhibition is over.

WHOOPI GOLDBERG
BEST SUPPORTING ACTRESS
Ghost
1991

**"Ever since I was a little kid,
I've wanted this."**

Before Whoopi Goldberg became a four-time Academy Awards host, she was a two-time acting nominee, first for Steven Spielberg's *The Color Purple* in 1986 and again five years later for Jerry Zucker's *Ghost*, opposite Patrick Swayze and Demi Moore. With her victory for her hilarious performance as *Ghost*'s questionable psychic Oda Mae Brown, Goldberg became the first Black actress to win an Oscar since *Gone with the Wind*'s Hattie McDaniel in 1940. Years later, she still feels a special kinship with her fellow nominees: Annette Bening, Lorraine Bracco, Diane Ladd, and Mary McDonnell.

THE BACKSTORY

I wrote an Oscar speech every year when I was a kid. And my mother and my brother had to sit there while I accepted my Oscar. My brother, Clyde, who had to sit through many speeches, decided to come with me to the ceremony. My mother didn't want to come in case I didn't win again.

THE PRODUCTION

I went off to do a movie in Montgomery, Alabama, with Sissy Spacek, *The Long Walk*

Home. I get a phone call from my agent, Ron Meyer, who says, "Patrick Swayze has been hired for this movie. Patrick is not going to do this if you don't do it. Can you make some time for him and the director to come up?" So they flew in, I meet Patrick, and out of the blue, we're old friends. About forty minutes go by and Patrick says, "Please do this with me." I was like, "Yeah, okay." And that's how it happened. I said yes, not really knowing what it was going to be. I've done that a lot in my career, just said yes to stuff because I like

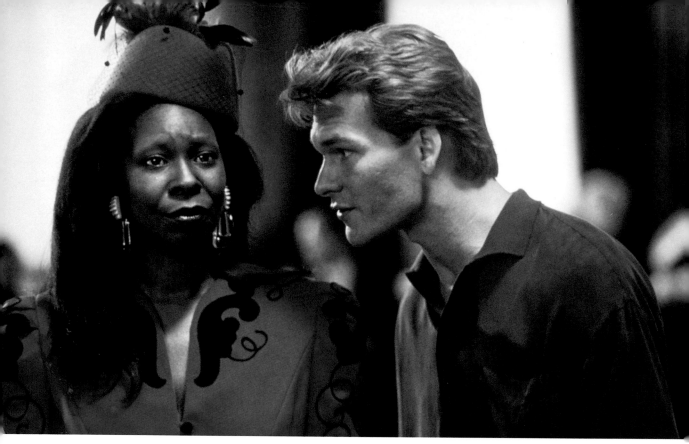

Goldberg with Patrick Swayze in a scene from *Ghost*

working. It wasn't until we all saw the film that we realized what we had. Patrick and I saw it at the same time. He looked over to me and said, "Do you remember making this movie?" I said, "I remember some of this, but I don't remember all of this!" It was kind of like, "Oh my God, this is *great*!" He was sexy and sweet and just a terrific human being to me.

THE WINNING MOMENT

The plan was, if I win, I will walk up, and I will be dignified. But the plan went right out the window because I actually won. I got up there and just started talking. I was so excited. It just

all came out. I ran over there, and I saw all of the people who embraced me when I came to Hollywood, Gregory Peck and Sophia Loren and Billy Wilder. I said, "I grew up watching you all. I'm here because you brought me, you told me to come over here. So thank you." And then I remembered to thank Patrick because without Patrick, I would not have gotten the job.

THE AFTERMATH

People started talking about the fact that Hattie McDaniel had won it fifty-some-odd years before and that it hadn't happened since. You think about all of the people who it should

have happened to, whether it's Dorothy Dandridge or Pearl Bailey or Diana Ross or Rosalind Cash. I was like, "You couldn't find *anybody*? There was *nobody*?" There were all of these boxes that were surprisingly filled when I won: Black *and* funny. I was dark chocolate and not the sexiest thing on two legs—you know, different looking.

THE CELEBRATION

We all went back to the hotel and called my mother and said, "Did you watch?" And she said, "I didn't." She didn't want to see me get my feelings hurt in case I didn't win. They showed her the footage later, and she was just like, "You know, you always said this is where you wanted to get to, and look at what you've done." And I said, "Well, yeah, look at what *we've* done. We're all in it together. If you hadn't allowed me to be me, I couldn't have gone on this road."

THE CELEBRATION, PART 2

All of the women who were nominated, we all made a pact that whoever won had to take everybody else out for lunch. I really thought it was going to be Mary McDonnell. But it turned out to be me. And we went out to lunch. I took those dames out, got permission to make gold Oscar chocolates so that I gave them all gold Oscar statues made out of chocolate. And we laughed. And we may have drunk some things. We had a good time.

THE PERSPECTIVE

To me, the Oscars always meant that the people who do what you do thought you did it spectacularly well. So for me, it was always people in the industry celebrating people in the industry. People say it shouldn't be a competition, but sometimes it is. So for me, it told me that I was at the top of my game, even when I didn't have a game.

WHERE OSCAR LIVES NOW

I live in a three-story house in New Jersey that was built in 1925. It's on the third floor in a corner. I give it to everybody who I allow to go past the second floor to make their speech, because the mythology is if you hold one and make a speech, it's quite a possibility that you'll get one.

ALAN MENKEN
BEST ORIGINAL SCORE AND BEST ORIGINAL SONG
The Little Mermaid
1990

"I'd like to thank my collaborator, Howard Ashman,
who encouraged me to take the opportunity to compose
my first film score with *The Little Mermaid*.
Thank you for your support, Howard."

Today, Alan Menken is an EGOT honoree and the most decorated Academy Award winner alive, with eight competitive Oscars on his shelf. (Only Walt Disney, art director Cedric Gibbons, and composer Alfred Newman have won more.) But in 1990, Menken and his songwriting partner, Howard Ashman, were just a pair of past nominees whose rollicking *Little Shop of Horrors* number "Mean Green Mother from Outer Space" had lost a few years earlier to the chart-topping "Take My Breath Away" from *Top Gun*. Menken and Ashman wouldn't be also-rans for long: Thanks to their instant classic *The Little Mermaid*, Menken would take home his first pair of Oscars, for Best Original Score as well as for Best Original Song (shared with Ashman) for the joyous, calypso-flavored "Under the Sea." But the celebratory evening was mixed with impending tragedy: Although Menken didn't then know it, Ashman had been diagnosed with HIV in 1988 and was already showing symptoms of AIDS. A year after their win, Ashman passed away at the age of forty, and in 1992, he and Menken would win a second joint Oscar for their sumptuous title song from *Beauty and the Beast*. Menken, meanwhile, has won dual song-and-score prizes for Disney animated films a total of four times, including for *Pocahontas* and *Aladdin*.

Menken and co-songwriter Howard Ashman

The Little Mermaid's Ariel and friends

THE FIRST TIME

The Oscars were just this Mount Olympus of the entertainment business. It was all Hollywood royalty who were beyond our feeble peasant existence. Howard and I were seated in the middle of this big row, which should have told us something. Levi Stubbs came out and sang "Mean Green Mother" and brought the house down, and I'm reaching into my pocket for my speech, thinking, *What if we win?* And Howard just stops my hand from reaching and says, "You can relax, you're not winning any awards tonight." So that was that.

THE PRODUCTION

When we were starting *The Little Mermaid*, it was Howard who insisted, "You really need

to write the underscore." I said, "I don't know how to do this." So I had to learn. I wrote this very simple, kind of crude score. But it obviously worked.

THE BIG DAY

People were preparing us that we were going to win for both. My insides were churning, totally churning. The Oscars are not fun. They might be fun if you're a major star and you know that everyone wants to see you and celebrate you. If you're essentially somebody whose work is behind the scenes, it's a very strange night. They'll alternately treat you like something very special, but also you'll find there are people who have no idea who you are. For me, going to the Oscars is like trying on someone else's clothes. There is always

that feeling of *I know they love the music, but do they want to see me in particular?*

THE FIRST WIN

That time we were right on the aisle. Steve Martin calls my name for Best Score, and I get up, and I felt like a donkey had kicked me in the back. It was just a really bad pain. I still don't know what it was, whether it was my kidneys or whether it was my back just constricting. I got up there, and I did what I would do from then on, which is just say what you got to say and get off the stage and make it as painless as possible for everybody.

THE SECOND WIN

Howard had been suffering from hiatal hernias, and due to the medication, he was breaking out. I remember he was sweating a lot that night. He wasn't well. But even though AIDS was all around us—I had already lost one collaborator—I just wouldn't bring my brain to even think it. We win for Best Song, and Howard and I both get up. He gave his speech and he was sweating. He was standing in front of the world, hiding the fact that he had AIDS and was very symptomatic.

THE AFTERMATH

We go to the Governors Ball and Howard says, "What a great night. When we get back to New York, we have to have a serious talk. I have to talk to you about something." I spent the next few days just thinking, *Is he saying he doesn't want to collaborate anymore? Is he upset with me?* I couldn't figure out what it would be. And then I went over to his house, and he said, "I'm sick. I have AIDS." It was just like, *Oh, my God.* Because I knew it was a death sentence. He was obviously waiting until after the Oscars to tell me.

THE PERSPECTIVE

I wish I could say that it's just this moment of pure joy. The visceral memory I have of Oscars are these wildly conflicting emotions, from joy to terror to disappointment to loss to deep gratitude. I think about Howard. I think about the most talented person I've ever been in the room with. He was a genius. We were like brothers. I still have recurring dreams about him. In a way I feel like I'm in Howard's unlived life. But there's only one Howard. For me, the miracle is that he at least got to have that moment. For that, I'm deeply, deeply grateful.

WHERE THE OSCARS LIVE NOW

They're in my studio. There's the eight Oscars, the eleven Grammys, the seven Golden Globes, the Tony, the Emmy, and the Razzie for Worst Song of the Year for *Newsies*. It's a ridiculous awards cabinet. I look at it and I just go, "How the hell did this happen?" Sometimes it just makes no sense.

MELISSA ETHERIDGE

BEST ORIGINAL SONG
An Inconvenient Truth
2007

"Mostly I have to thank Al Gore, for inspiring us, inspiring me, showing that caring about the Earth is not Republican or Democrat, it's not red or blue. We are all green."

Prior to 2007, only one song from a documentary had ever been nominated for an Academy Award: "More" from 1962's *Mondo Cane*. But Melissa Etheridge's inspiring anthem "I Need to Wake Up" from Al Gore's landmark climate-crisis film, *An Inconvenient Truth*, managed to beat out no fewer than three songs from *Dreamgirls*. For Etheridge—a Grammy winner, breast-cancer survivor, and LGBTQ activist—the win allowed her to provide some gay-positive representation (helped along by ceremony host Ellen DeGeneres) and fulfill a private premonition she'd had a few years earlier.

THE SONG

It started with a call from Al Gore, who told me that his slideshow on global warming was going to be made into a documentary. And at that moment, I thought, *Won't that be nice—it'll be shown in some high schools or something*. This was before documentaries were, like, a cool thing to watch. You didn't put music to documentaries—that wasn't a thing. But he wanted specifically for me to write a song. I said, "Absolutely, sure." I had been a friend of his, and I like to tell people I helped get him elected in 2000. They sent me the film, and it was just beautiful. I had just gone through my cancer experience, and I was in a place of newness about life and

By far the most terrifying film you will ever see.

aninconvenient**truth**

A GLOBAL

THE LOOK

I had a stylist back then. And the stylist hooked me up with Domenico Vacca. I had to memorize how to say his name so I could say the right words. Because, you know, I'm not a dress kind of girl. I wanted to look sharp and nice—it was the Oscars. I went and got fitted in this beautiful blue tux. Just gorgeous. And my hair was still short from chemo. Everything worked.

THE PINCH-ME MOMENTS

I remember being backstage. Steven Spielberg was a friend of mine. I was waving at him as he was passing by, and he accidentally stepped on Jodie Foster's dress, which was like a strapless sort of thing. It was almost a disaster—that moment happened right in front of me. After I performed, I was sitting in the audience, and during one of the commercial breaks, Clint Eastwood gets up, and he's walking in front of me. I'm on the aisle, and he looks down at me, and he makes, like, a gun with his hands and winks and clicks. I was like, *Oh my God, Clint Eastwood just did that to me. There's not many people that can say that.* But I think that my favorite part was meeting James Taylor.

wellness inside of me. So the minute I saw the last frame of the movie, I went into my room, and I just started writing. Not about global warming—I didn't want to write "Give a hoot; don't pollute." It was more about the feeling of, *Wow, I need to wake up. I need to change.* The way we had been participating in the world in the nineties and early 2000s I thought was important to change. That's where the song started to come from.

He sang right before me. I had never met him before, and he was just a beautiful man.

THE WINNING MOMENT

I'll let you know something. In early 2005, I was going through this sort of spiritual awakening inside myself. It was a time where the phrase *You create your own reality* was really coming into my understanding. I had been through chemo, and I came to this point where I said, "Okay, I understand that I can have anything I ask for if I just ask for it and get out of my own way." I was really deep in thought: *What do I want in the world? I want to have time with my family. I want to enjoy my work and enjoy my music.* And after a list of altruistic, spiritual things, I said, "Oh, I want to win an Oscar." I just threw that on the end of it. And I never thought about it again, except I told my yoga teacher, I said, "Look, I want to tell somebody: I've put this into the ether." This is a year before Al Gore even called me. So when I'm sitting there in the audience, even though I had lost the Critics Choice Award and there was another one I had lost, I said to myself, "I know this is going to happen because I manifested this." Then when John Travolta said, "Melissa Etheridge," I was like, *That's right! Here I am!* I've never told anybody that.

THE SPEECH

Oh, it was the big gay Oscars. It was great. Ellen was hosting. And then the funny thing is when he said my name, I got up, and I turned to go up, and I went, *Oh shit, I was going to do the first lesbian kiss on the Oscars.* So I turned back around and kissed my girlfriend. At the time, gay marriage was just a very hot issue. I had had a ceremony with my girlfriend Tammy, who I was then calling my wife because we'd had the ceremony, although it legally wasn't recognized. When I was giving my speech and I said, "I'd like to thank my wife," and everybody applauded, for a second there I thought, *Oh, yeah, she's pretty great. Oh, no, no, they're applauding because I'm saying 'my wife'—they don't* know *my wife.*

THE CELEBRATION

I carried that Oscar around, which is so much fun—and how damn heavy that thing is! The next day I woke up and my bicep was sore because I was holding it the whole time. I went to the *Vanity Fair* party, and that was my favorite because I smoked a joint with Sean Penn, Harry Dean Stanton, and Bill Maher. I had two one-year-olds back in Malibu, so Tammy and I drove home about ten or eleven. When I got home, I got ready for bed, and I put the Oscar on the nightstand right next to me because when I woke up, I wanted to be able to see it and make sure that it was not a dream.

THE PERSPECTIVE

The biggest part of it all was understanding the law of attraction and how you create these things. It's always been this really sweet message to myself that "See, you manifested an Oscar—that's how you do it." And not only did I manifest an Oscar, but it was for something that was important in the world. As we've seen the last fifteen years unfold, exactly what Al Gore said is happening, and it's really a bummer. It highlights how our division as a society, our differences that we seem to be fighting over now, are all not going to matter when we're underwater.

WHERE OSCAR LIVES NOW

For the first couple of months, I told everyone that the Oscar was the only naked man who'd ever been in my bedroom. Then after a while I put it in my office. I have a bookcase that has a lot of my favorite memories: the harmonica that Bruce Springsteen gave me for my birthday, my two Grammys, and my wife Linda's Golden Globe for producing *Cybill*. They're all in one place.

Etheridge performs "I Need to Wake Up" at the Oscars ceremony.

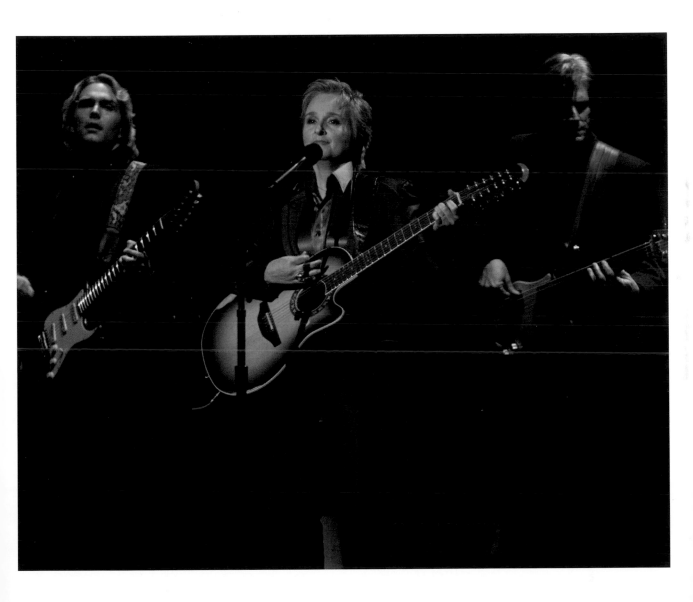

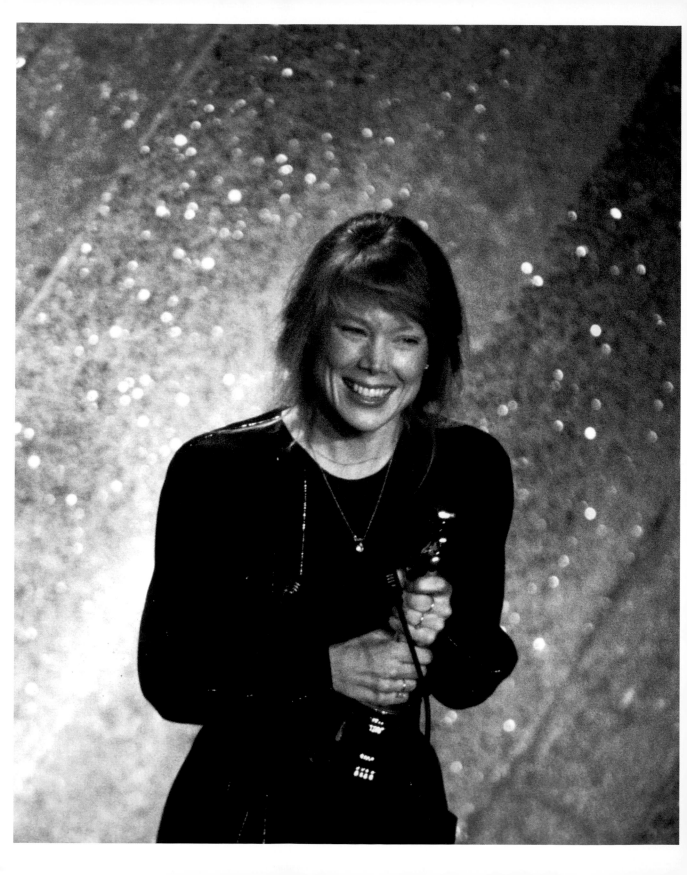

SISSY SPACEK
BEST ACTRESS
Coal Miner's Daughter
1981

**"I started to work on *Coal Miner's Daughter*
with a bunch of strangers, and I finished working on
Coal Miner's Daughter with a bunch of friends."**

The 1981 Oscar ceremony was postponed one day after the assassination attempt on then-president Ronald Reagan. Once the awards were handed out, *Ordinary People* took home the prizes for Best Picture and Best Director. But Sissy Spacek emerged victorious over *Ordinary People* star Mary Tyler Moore, thanks to her astonishing, decades-spanning performance as country singer Loretta Lynn in *Coal Miner's Daughter*. For Spacek, then thirty-one years old and a past Best Actress nominee for the 1976 horror classic *Carrie*, playing Lynn allowed her to showcase her impressive musical talents as well as her phenomenal acting range.

THE BACKSTORY

I considered myself a singer. I sang and played my guitar. I ordered a Silvertone guitar out of the Sears and Roebuck catalog for $12.95. And I remember when it came, I was probably twelve or thirteen. And I'd saved my allowance. My parents were so shocked that a package came in this little town in Texas. They had no idea I had a secret life. I would sit in my room and try to figure out how to tune the guitar and put the strings on. My dad had played banjo when he was a young man, so he was musical. And he would sometimes knock on the door and say, "The E string is a little flat." But that was how it started—it was just my mode of expression when I was a teenager. If you needed a program for the Garden Club or the Rotary Club or the Lions Club or the church bazaar, I was always the program. I was more confident then than I am

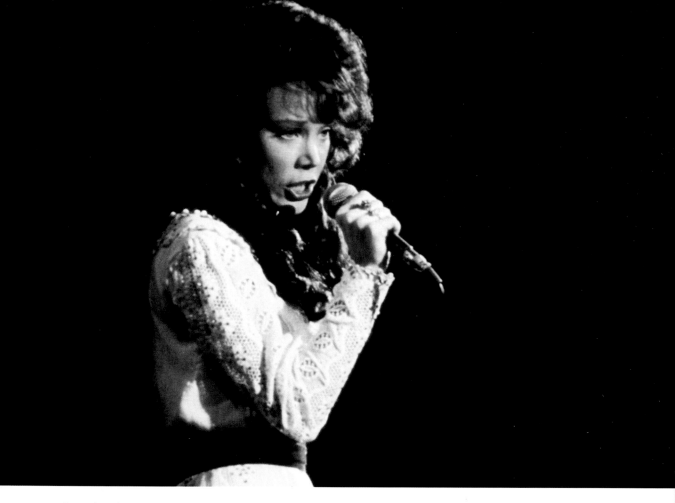

Spacek as Loretta Lynn in *Coal Miner's Daughter*

now. Now I'm very introverted and shy. When I went to New York, I had two guitars: I played a twelve-string and a six-string. That was really what opened doors for me and gave me my career, I think.

THE PRODUCTION

I was hesitant to do *Coal Miner's Daughter*. At that time I was trying to steer away from country roles and branch out and do other things. Loretta Lynn was on Johnny Carson's show saying, "Little Sissy Spacek, she's going to play me." At that point in my life, I thought that I was in control of my destiny. Little did I know I wasn't. My mother-in-law said, "Well, ask the man upstairs." And jokingly I said, "God, give me a sign!" My husband, Jack, and I got in her car. We didn't even know the radio was on. She kept it on a classical station, but at night it became a country station. And I swear to God, what came on was "Coal Miner's Daughter." I said, "Stop the car! I'm doing

the movie." It was the weirdest thing. Nothing like that had ever happened to me before. Loretta was very involved. I spent time with her, and she taught me the songs. She really let me in to her whole life. I wanted to sing the songs—I had to fight for that. Then when they let me do it, I was terrified. But Loretta was the one who said, "She should definitely sing the songs." She was just spectacular. I understood Loretta in her beginning; when she first gets that guitar, that meant something to me.

THE LOOK

This was when you got your own outfit to wear, and you did your own hair and makeup. Or at least I did. I had a silk jumpsuit that I loved. Joe Tompkins, who did my costumes for *Coal Miner's Daughter*, copied it for me. He made it less casual and put a little sparkle in it. I wore a necklace that my mother gave me. It had been hers and she gave it to me. And I wore my mom's ring.

THE WINNING MOMENT

For the president, who was an actor, to be shot? It just seemed appropriate that it not be held when it was originally planned. There was a cloud hanging over that evening. It was a little more somber than ordinarily. I remember being really nervous as my category got closer. There were some really spectacular performances that year. I really felt like Mary Tyler Moore would get it. When I heard Dustin Hoffman call my name, I was sort of somewhere else. I'm really an introvert. Being up in front of that huge room full of movie stars and filmmakers—it was daunting. Certainly I was pretty wet behind the ears at that point. So it was an out-of-body experience.

THE SPEECH

I remember looking out and right away I saw Loretta and her husband, Doolittle, in the audience. I loved the people I worked with. I just wanted to speak to them directly and thank them because you really don't get there by yourself. You know what's so funny though, is while I was having an out-of-body experience, I think my husband was also, because for years he said, "You forgot to mention me!" I was like, "I couldn't have forgotten." And then, years and years later, I saw it on YouTube. And he was the second-to-the-last one I thanked. So that was great—I was able to say, "See?"

THE PERSPECTIVE

You have no idea when you get it in your hands what it's going to mean. What it means comes later. It meant that I was probably going to work again. *Coal Miner's* success was really not about me. It was about Loretta. She wrote the songs; I worked with her musicians; I worked with her record producer. Getting to be her was just like the thrill of my career. She

supported me in that role. She picked me out of a stack of 8 x 10 glossies, had never seen me act, had never heard me sing. She just said she knew. We stayed very dear friends forever. I'm still very close with the family. So it was a real special gift, not only being able to portray her, but getting to know her from the inside out and who she was and what her fans meant to her and what her family meant to her. She was the real deal. The hardest part of *Coal Miner's Daughter* was stopping being her. She was so hilarious and had such a wonderful self-effacing sense of humor. It was hard to let all that go. But in the end, I got her. I got the real Loretta.

WHERE OSCAR LIVES NOW

It's in my office—it's sitting on the top of the bookcase with my gold records from the *Coal Miner's Daughter* soundtrack and other awards and stuff. I kept it in my closet for a long time, because I would just see it all the time. My daughter just told me that she used to play with it when she was little. I was like, "I'm glad I moved it on a high shelf in my office!"

Spacek and her real-life alter ego, Loretta Lynn

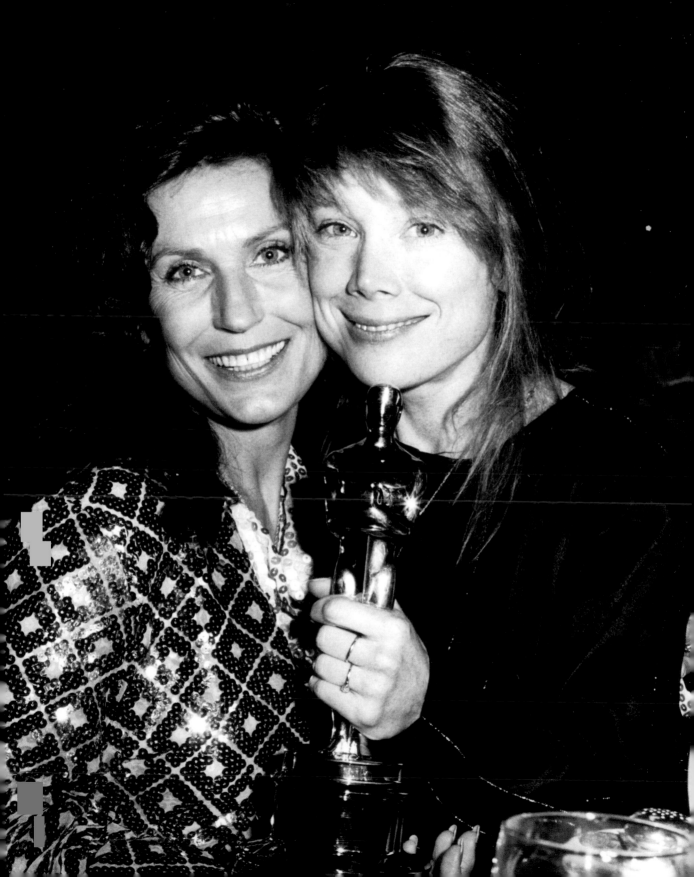

KEITH CARRADINE
BEST ORIGINAL SONG
Nashville
1976

"First person I want to thank is Robert Altman, because he's done more for me than anyone, I think."

The son of the prolific actor John Carradine, Keith Carradine was already a regular in Robert Altman's films by the time he costarred in Altman's sprawling 1975 musical drama *Nashville*. Playing the womanizing singer Tom Frank, Carradine memorably delivered his own beautifully spare love song "I'm Easy" at the famed Exit/In club. His Oscar win for Best Original Song over Michael Masser and Gerry Goffin's *Mahogany* theme "Do You Know Where You're Going To?" resulted in a hit single and helped kick off an acting career that has lasted for more than fifty years and included Grammy, Tony, and Emmy nominations.

THE BACKSTORY

I had worked with Bob [Altman] the first time on *McCabe & Mrs. Miller*. That was a great experience. And then Shelley Duvall and I wound up doing *Thieves Like Us* with Bob, which we shot down in Mississippi. During the filming of *Thieves Like Us*, which Joan Tewkesbury had written the screenplay for, Joan was making weekend trips up to Nashville and doing her research for this idea that she and Bob had of this film that they wanted to make about that world. Bob loved to throw a party, especially when he was working. He had rented a house in Jackson, Mississippi, and he had a party one weekend. We were all there just enjoying the sunshine, and I had my guitar, and I was playing songs. Joan and Bob heard what I was doing, and they took note of it, and it fit in with their idea of how they wanted to make the film, that they wanted to cast actors who were songwriters themselves.

THE SONG

I wrote "I'm Easy" when I was nineteen years

Carradine with presenter Angie Dickinson

Carradine as Tom Frank in *Nashville*

in the story, it had a bunch of other layers to it. It was a remarkably cynical romantic device that Bob employed. He was a mad genius, man.

THE BIG DAY

I was on another planet. It was an incredibly exciting time. I knew that I was going there to perform the song on the show. So I was terrified about that. The producer of the telecast, Howard Koch, had said, "I want you to do the song the same way you did it in the movie—just you and your guitar." So there I sat, on the stage of the Dorothy Chandler Pavilion, just me and the guitar, and performed that song, kind of naked. I don't think that had ever been done on that show;

old in New York in the Broadway cast of *Hair*. When you listen to the song itself, it's a straight-ahead love song and it's performed in all sincerity as that. But the way Bob designed that song to play in the film had everything to do with its impact and how people responded to it. When you put it in the mouth of my character, singing it to that roomful of people at the Exit/In, to these different women

most of the numbers were highly produced. And I had my dad there—he'd never been to an Oscars ceremony. It was an extraordinary night. I had no expectations. I just wanted to perform it without messing up completely, that was my goal. And I did okay. I made one little mistake that most people won't notice, but I've never forgotten it. But I got through it, and people felt it was a moment.

THE LOOK

I didn't own a tuxedo, man. I came of age as a sixties hippie. I went to a tuxedo-rental shop in Woodland Hills, and I rented a tuxedo. I had no fashion sense. But I went and rented this tuxedo. It had a ruffled shirt. Oh, my! And the tuxedo itself was *brown*. It's on YouTube, and you can look at it, and if you really pay attention, you can see: That's a brown tuxedo.

THE WINNING MOMENT

I was up against Diana Ross and the Motown machine for "Do You Know Where You're Going To?" I thought, *Well, of course, that's what's going to get the Oscar.* Ergo, I had nothing prepared. I managed to get up to the stage without falling down, and it was pure. I've looked at it, and that was a very young man doing his best at the time. I forgive myself. Burt Bacharach and Angie Dickinson handed me the award. Angie and I have had a connection based on that ever since. She's a dear friend, and I see her on a somewhat regular basis because we play at a poker game together.

THE CELEBRATION

I went to the Governors Ball for a little while. I was there long enough to be able to walk around and enjoy being recognized by people like Jack Nicholson. He said, "Way to go, kid."

Then I got my dad home; he was ready to call it a night. And then I went back down into town and went over to the Lionsgate offices on Westwood Boulevard and hung out with Bob and everybody. It was weird because that was the only Oscar the film won. I had a strange kind of survivor's guilt. It was an odd sensation that night because I wasn't sure that I was all that deserving. I was elated and a little embarrassed all at the same time, if you know what I mean.

THE AFTERMATH

We had all recorded everything for the soundtrack album. ABC Records was the company that was going to release the soundtrack album from *Nashville*, and their A&R people decided that there were no singles on the *Nashville* soundtrack album. And at the same time that they were making that decision not to release a single, David Geffen called me up. He said, "I just saw the movie. I think you're really good. Do you want to make a record?" And I said, "Sure." We recorded another version of it. It was a little different. The song won the Oscar, and I performed it on the Oscars, and the song took off, and it made it into the top twenty on the *Billboard* charts as a single.

THE PERSPECTIVE

At the time, it meant that I was seen. So

much of what all of us in this business are trying to do is just trying to be seen and feel worthy of being seen. I got a lot of attention for a moment. And I do mean a moment—I mean, it is so ephemeral, and that's a lesson in itself. I was on the party list there for about six months; that was fun. I'm proud of my songwriting and whatever my musical gifts are. That's still a big part of my life. But that ceased to be the focus of my professional life because I had this acting career. And it was an odd time in our business because there was kind of a hard line between those two crafts. If you were good at one, it was considered that you couldn't possibly be very good at the other and that you were just a dabbler or whatever. In a funny way I got more respect for acting than I ever got as a singer-songwriter. The lyric to that song—there are a couple of things in there that are sort of clunky. But it's heartfelt, and I think that it touched people for that reason, because I think that there was a basic truth to the song. I don't consider myself a *great* songwriter, but I do consider myself a songwriter.

WHERE OSCAR LIVES NOW

We have a great room in Santa Barbara that's got great big, tall ceilings. There's a tall Asian knickknack shelf thing. And one of those shelves has my Oscar and my Golden Globe. And I honor them. I'm proud of them. It's not a bad thing to be able to look across the room and see that and know that that happened to me and that it was real, you know?

Carradine performs "I'm Easy" at the Oscars ceremony.

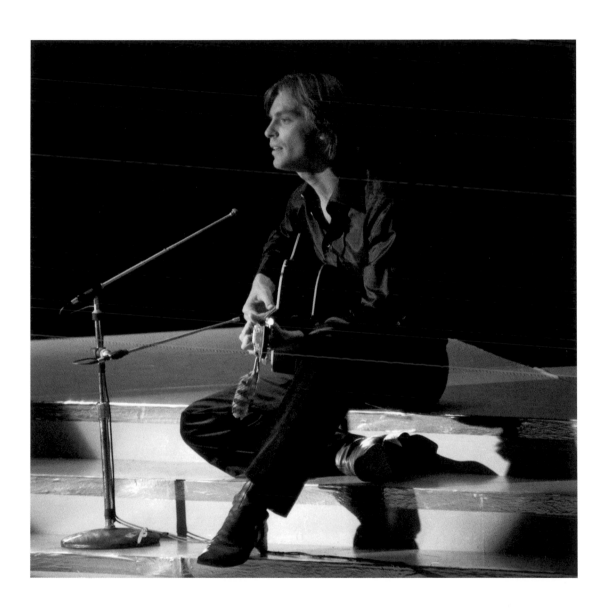

ESTELLE PARSONS
BEST SUPPORTING ACTRESS
Bonnie and Clyde
1968

"Boy, it's heavy!"

Estelle Parsons was largely unknown outside New York theater circles when she costarred in director Arthur Penn's groundbreaking crime drama *Bonnie and Clyde* in 1967. But she exhibited remarkable range as the prim, combative, and often hysterical preacher's daughter Blanche Barrow opposite Warren Beatty, Faye Dunaway, and Gene Hackman. Despite not earning a BAFTA or Golden Globe nomination, she became the only cast member from the film to win an Oscar in 1968 (it also won for Burnett Guffey's cinematography but lost its other eight nominations). Parsons almost didn't attend the ceremony and felt out-of-place as an East Coast theater performer in a sea of Hollywood stars, including Walter Matthau, who presented her with the trophy.

THE BACKSTORY

Professionally speaking, I was kind of anti-awards. When I won my first one, a Theatre World Award way back in the early sixties, I didn't go. And I got this call from my agent screaming at me: "Where are you? Why aren't you here?" And I said, "Well, I don't really believe in awards." I was, am, and will always be totally interested in live theater. I started when I was about eight in a community theater, and it's been my whole life—acting and directing and just observing. So I thought awards were not really good for people, and I was very happy to be unknown, because if you walk out on the stage and you're unknown and you thrill them, they're thrilled because they discovered you. But once you're discovered, they expect things of you. It's not at all the wonderful experience it is before you're discovered.

THE PRODUCTION

I'd never really done a movie before. I did the film because I wanted to work with Arthur Penn again. I'd been working with him in the live theater, and it changed my life as an actress, my attitude toward my work. He said, "Will you read this movie script?" I said, "I'll read it, but I'm not really interested in that kind of thing." I had left New York; I was on my way to join a regional company in San Francisco. I can't believe I ever thought this, but I thought the greatest thing in the world would be if I could join a company. I read it and I thought, *Why don't they get Madeleine Sherwood for this?* Then the more I read it, I thought, *Gee, this is an extraordinary story and an extraordinary woman.* Then my theater company went belly up before it even got started; the guy lost his funding. So I was back in New York, and I said, "Well, I guess I need to do your movie, Arthur."

THE BUZZ

I remember we were shooting in Dallas, and all my costumes came out of an eighteen-wheeler that had come from Hollywood. I had, like, Barbara Stanwyck's jodhpurs and Dorothy Malone's shirt. I'd go in there with the wardrobe person and just pick out what I was going to wear. I'd done so much research for the movie that I knew exactly what it should be. I remember when we were shooting the movie, some-

body on the crew said to me, "Oh boy, you're really going to get an Oscar for this one." That film was very rare in a lot of ways. Everybody wants to have a film that sweeps the world; that film swept the world in a way you can't plan. It's just a phenomenon, which was amazing and a wonderful experience for me.

THE ULTIMATUM

I was in a Tennessee Williams play on Broadway, *The Seven Descents of Myrtle*, and so I said to my agent, "I'm not going out there for the Oscars; I have a performance, and this is what I do, so I'm not going." Then I got a call from Warren: "I'm sending you a ticket; you gotta come out." Then the producer of our play, David Merrick, who was kind of a flamboyant, famous-for-his-antics theatrical producer, said, "I'm putting your standby on that night. So if you don't go out there for the Oscars, you can sit home and watch it on television." Of course he wanted me to go because it was wonderful publicity for the play. But even the Oscar only helped us limp along on Broadway for maybe a couple more weeks.

THE BIG DAY

I flew out that day. I went to the Beverly Hills Hotel, and I had my hair done, which is why I look like somebody different at the awards. I had a black evening dress that I bought at a discount store on upper Broadway in New York for thirty bucks. It was a very simple and good-looking black evening dress. The Oscars was a lovely experience. I often thought of it as somebody giving me a very nice piece of candy, because I had a wonderful time. I loved walking up there on the stage, I loved saying hello to Walter Matthau. But I was pretty tired and jetlagged. Frankly, I was so overwhelmed with the whole thing. I thought I looked ridiculous. There was a party afterwards but I only remember sitting at a table there with Jackie Gleason and a lot of old friends, and then getting on the plane the next morning and flying back to my job. I mean, I had the best performance of the year, that's for sure. If you look at the films, I think there was no contest there, so why wouldn't I win?

WHERE OSCAR LIVES NOW

It always just sits on the floor of my apartment on the Upper West Side because it's heavy. I have put away all my awards. I used to have a shelf with all my awards in a cabinet. I stashed all my awards away, but I keep this one out because people want to see it and hold it. That's why I don't have it on a shelf, because I couldn't reach it. So I've just kept it on the floor beside my bureau.

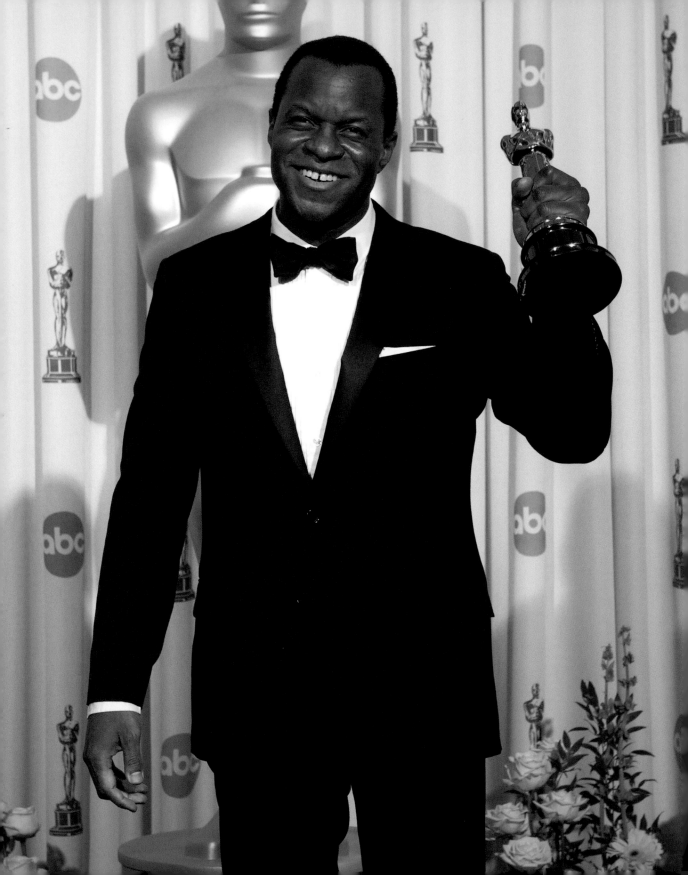

GEOFFREY FLETCHER

BEST ADAPTED SCREENPLAY
Precious: Based on the Novel "Push" by Sapphire
2010

"This is for everybody who works on a dream every day; precious boys and girls everywhere."

Geoffrey Fletcher's enormously affecting script for *Precious*, which won the Grand Jury Prize at the 2009 Sundance Film Festival, made him only the sixth Black screenplay nominee in the history of the Oscars, and it wasn't looking likely that he would become the first-ever Black winner for writing. Rather, the comedy *Up in the Air* had swept the adapted-screenplay prizes throughout the season. But the Harvard-educated filmmaker, who finally had his first produced screenplay after years of struggling in the industry, brought his tight-knit family with him to the ceremony, and his surprise win gave him the opportunity to acknowledge how their early support had led to such a monumental achievement.

THE BACKSTORY

I remember one day during senior year in college, I was bored, sort of coasting through senior spring, and I had some aluminum foil. I started playing with it and I made an aluminum-foil Oscar. I still have it somewhere in the bottom of a box. But years later, after film school and really hitting a brick wall in the industry, I put that dream aside. While I was writing the script which turned out to be *Precious*, I knew only two things. One, it really felt good. And two, no one would ever see it. But that was okay. Even after it won at Sundance, I didn't anticipate

Gabourey Sidibe as the title character in *Precious*

what its ultimate reach would be. A very good friend of mine said, "Oh, you'll probably get nominated." And I got angry at him. I thought it was outrageous, impossible. I'd been struggling for so many years, and all I heard was no. I was just so happy to have a film made. So when I was nominated, I couldn't believe it. I was so proud of the work. But even if you do inspired work, it doesn't guarantee it will be recognized in any way.

THE BIG DAY

I was at peace with the fact that my name wouldn't be called to receive the Oscar. I was there with my family. My father passed away in 1990, but I was there with my mother and my brothers, my girlfriend at the time. And I

told them before we left the hotel, I said, "Look, I'm not winning, but please just have a good time. And if there's a camera on you, smile." Then in the last split second, when Jake Gyllenhaal was on the stage and he was opening the envelope, only then did I think to myself, *Well, I suppose it's not impossible.* And then he said my name. I was literally stunned. I didn't have a speech ready because I didn't want to occupy that mental real estate. I tried to smile and think as fast as I could of something to say, all throughout the journey to the stage and up the steps. I get to the microphone, and here is what I remember visually: just the microphone. And everything around it was blurry. I remember it had shades of blue and black and it was really unusual. I had trouble catching

my breath and sort of finding my thoughts. But I wanted to thank my family by name. I wanted to thank my mother and my father and my two older brothers. They were all so instrumental in my getting that far: my mother reading to us and always encouraging us; my father teaching me so many things, including f-stops and how cameras work; my oldest brother telling me how animation works. And so I would make movies with toys fighting each other as a kid. And then with my middle brother talking about ancient three-act structure and mythology. So all of them conspired for that moment, and I feel so grateful, so fortunate. I feel if you plugged anybody into my life, they could have achieved that. I have had some ups and downs in my life, but I do truly feel like the luckiest person in the world. Couldn't have had a more supportive family. Couldn't have had better parents.

THE PERSPECTIVE

My parents grew up in the South. My father, Alphonse Sr., grew up in New Orleans. My mother, Bettye, grew up in North Carolina. So they went to the movies, and they had to sit in the segregated section, which was sometimes the balcony. Years later, when I told my parents I wanted to make movies, they didn't tell me about any of that until I was older. All they talked about was possibilities—despite what the world had shown them. So my mother went from sitting in a segregated section of a movie theater as a child to watching her son win an Oscar. And here's the thing: I fear that if I were in my parents' position, I might tell my child not to bother, to spare him the pain. Mother passed away in June 2022 and I was so close to her and admired her so much. I don't know if I've ever known a greater human being.

THE AFTERMATH

When I got back to my apartment in New York with my Oscar, the first thing I did was take a screenwriting book down from the shelf. I wanted to perform the act of reaching for, grabbing, and lifting a book. I thought that performing that act would send a message to myself, to tell myself that I should always keep learning and stay humble because that's when all the information and the light comes in.

WHERE OSCAR LIVES NOW

This may sound strange, but I keep it out of sight. And every once in a while I'll look at it to make sure it's there or to make sure it's real and to make sure it hasn't been stolen. I'm still deciding if and where to display it.

OCTAVIA SPENCER
BEST SUPPORTING ACTRESS
The Help
2012

**"Thank you, Academy, for putting me
with the hottest guy in the room!"**

Before landing her breakout role in the Southern period drama *The Help*, Octavia Spencer had toiled in the entertainment industry for more than two decades, first as a production assistant and later in small parts in film and on television. Thanks to her delicious performance as feisty maid (and expert pie baker) Minny Jackson, the Alabama native and Auburn University graduate swept the awards season, taking home the Best Supporting Actress Oscar over formidable competition that included two of her close pals: her *Help* costar Jessica Chastain and longtime friend Melissa McCarthy, who was nominated for *Bridesmaids*. Spencer needed a bit of help up the staircase from her director, Tate Taylor, but was met with an affectionate ovation from the crowd. By the end of the evening, she would find herself face-to-face with the night's Best Actress winner, Meryl Streep.

THE BACKSTORY

I was seven or eight the first time I saw the Oscars. I just remember running into the room while my mom and her friends were watching. Seeing all those people so dressed up and sparkly and the glittery, glimmering dresses, I remember thinking, *I don't know what it is that they're doing, but I want to be there.* It just made an indelible mark in my mind. And so early on, I aspired to be a part of the entertainment business. When I was seventeen, I was an intern on a movie with Sissy Spacek and Whoopi Goldberg called *The Long Walk Home*, and I fell in love with both of those women. Whoopi took me under her wing while they were filming in my hometown. And I always have had a deep affection for Whoopi as a human being because I had

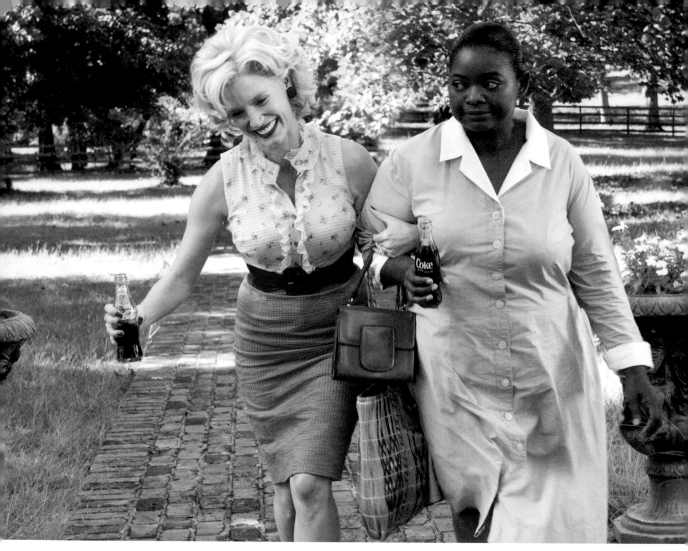

Spencer and fellow nominee Jessica Chastain in a scene from *The Help*

just lost my mom. I was very impressionable and ready to come out to Hollywood at seventeen. Whoopi said to me, "Hollywood will be there. You promised your mom you'd go to college; go to college." I'm glad that I was exposed to Academy Award winners early on. Later I worked behind the scenes as a casting assistant. It wasn't this glittery, glamorous thing. That demystified a lot of Hollywood

to me, being able to physically be on a set. I think anybody who wants to be in front of the camera should start as a production assistant because when you reach those positions of power, it'll have a different meaning.

THE BIG DAY

I was in a suite at the Beverly Wilshire hotel, and I had a couple of my friends there. It was

a celebratory weekend. I remember waking up, getting a little exercise in, having a big breakfast with my team and friends, and then just starting the process of getting ready. It was very surreal. If you think about how Cinderella got ready for the ball and at the time she didn't know she was Cinderella? She just knew she was getting ready to go to a ball. And she had never been to a ball, although she heard all about them and had seen so many beautiful depictions of them? That's exactly what it felt like for me.

THE LOOK

I'm going to be really honest: Tadashi Shoji was the only designer throughout that whole run that would design dresses for me. Because I'm a plus-sized woman, he would build things from scratch. He made this beautiful dress that had these beads that had been hand-sewn to the dress. It was just stunning. I never felt more beautiful because the man has a stunning eye. I have a soft spot in my heart for Tadashi Shoji because I understand now how important the gowns are. To be the one designer who can design for a woman my size or a woman who's a size double-zero, says a lot about Tadashi.

THE COMPETITION

I was nominated against my friend Jessica Chastain and my friend Melissa McCarthy,

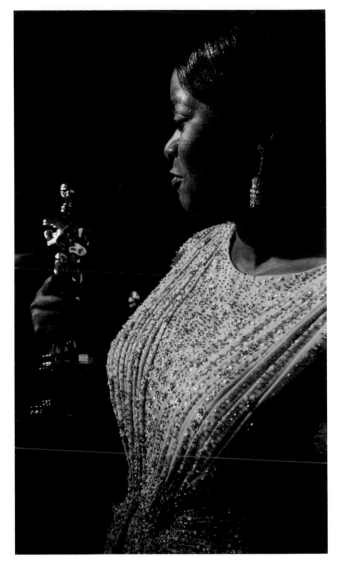

so I was happy if they called my name or if they didn't. Nobody was in competition. We were all excited to be there as nominees. Everything about being a nominee was magical for me. But the fact that I got to share it with friends was amazing. And that's different from a person who is going through it alone. It's something that we still share, all of

us. And we all have continued to succeed. It's indescribable how amazing that feels.

THE WINNING MOMENT

When Christian Bale read the name, I just remember it being a vowel. And I'm thinking, *Whose name starts with a vowel? It's me!* And then, the adrenaline—my knees wouldn't bend. I had to stand up, and my knees wouldn't bend, and I couldn't walk up the stairs. I'm thinking, *They say a billion people across the world watch the Academy Awards. I don't want to fall down, Lord, please don't let me fall down.* I had worked with so many people in that room. I just felt an abundance of love. But I was having a serious panic attack.

THE PINCH-ME MOMENT

After the ceremony, you go to the Governors Ball and they put your plaque on your Oscar. I was there, and I saw Meryl Streep, and we were getting our plaques put on the Oscars, and we made our Oscars kiss. I was like, *Oh, my God, I'm standing here with Meryl Streep, one of the greatest actresses of all time. And we're just having a human moment.*

── WHERE OSCAR LIVES NOW ──

It's in my living room, right next to my fireplace, on a little bookshelf. It's there with some NAACP Image Awards and SAG Awards and the Golden Globe and the BAFTA. It's funny because I don't spend a lot of time in my living room. So when I go in there, when I have guests, they're like completely taken by it, and then I remember. It's an honor that I don't take for granted.

Spencer and Best Actress winner Meryl Streep getting their
Oscar statuettes engraved at the Governors Ball

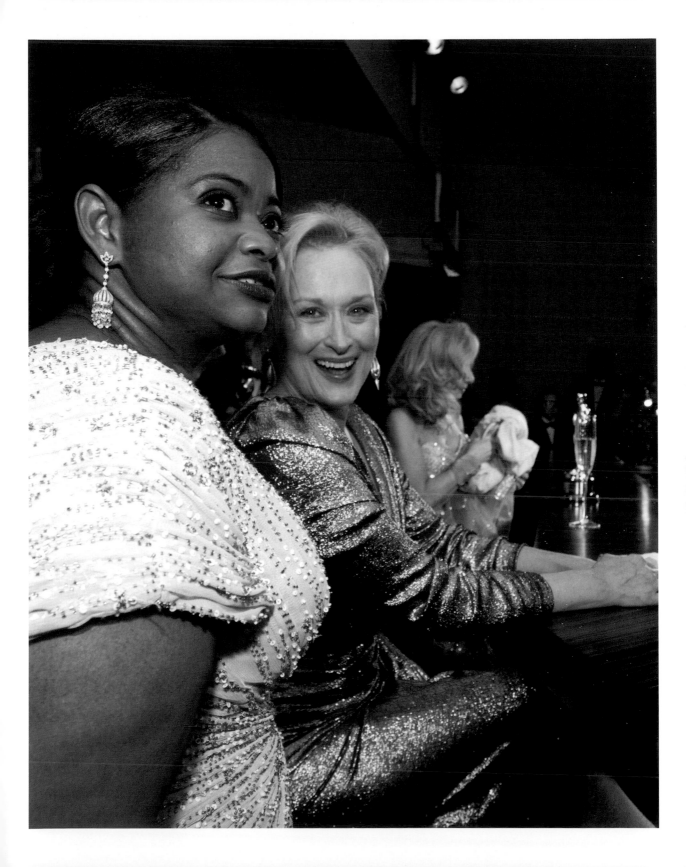

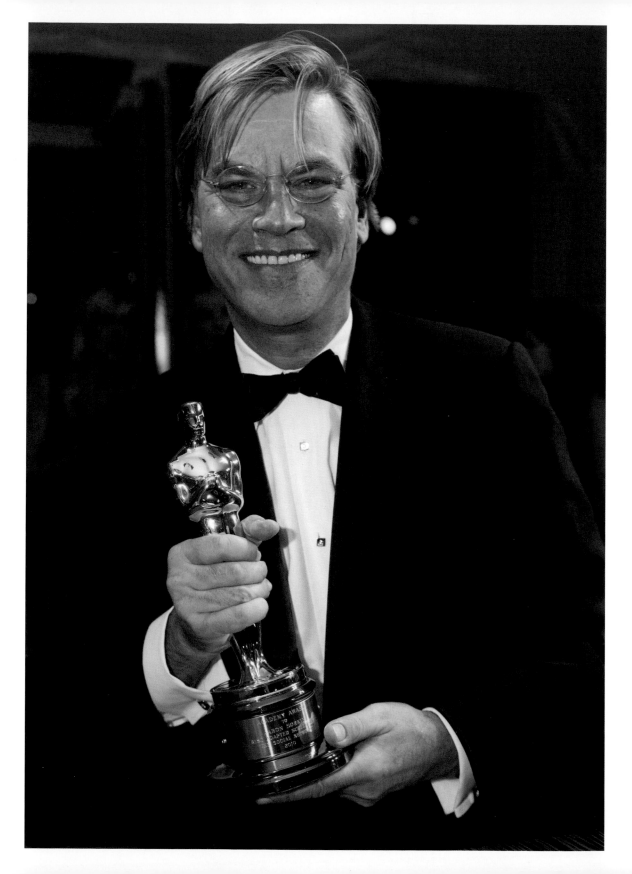

AARON SORKIN
BEST ADAPTED SCREENPLAY
The Social Network
2011

"It's impossible to describe what it feels like to be handed the same award that was given to Paddy Chayefsky thirty-five years ago for another movie with Network *in the title."*

There wasn't much debate over who would win the two screenplay categories at the Academy Awards in 2011: Aaron Sorkin's hyperverbal script for David Fincher's *The Social Network* was a lock for Best Adapted Screenplay, while David Seidler's original screenplay for *The King's Speech* was also a sure thing. The question was which would take home Best Picture and Best Director, since those two films, which couldn't have been more different, ran neck and neck throughout the entire awards season. (*The King's Speech* ended up winning both.) When Sorkin, who at that point had been sober for a decade, took the stage, he acknowledged *Network* screenwriter Paddy Chayefsky before giving a shout-out to his young daughter, Roxy, saying, "Your father just won the Academy Award; I'm going to have to insist on some respect from your guinea pig."

THE BACKSTORY

I watched the Oscars the way everyone else did. But I never imagined being there. I never stood in the shower with a bottle of shampoo and gave an acceptance speech. There was a moment of disappointment that I didn't get a screenplay nomination for *A Few Good Men*, but I was thrilled it was nominated for Best Picture. That was my first movie.

THE PRODUCTION

In the case of *The Social Network*, I was for the first time in any medium writing about an antihero as the main character. Jack

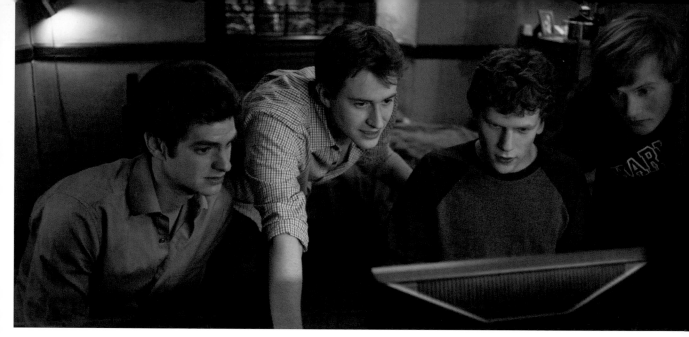

Andrew Garfield, Joseph Mazzello, Jesse Eisenberg, and Patrick Mapel in *The Social Network*

Nicholson in *A Few Good Men* was an antihero, but in this it was the protagonist, Mark Zuckerberg. And the thing about writing an antihero is, as the writer, you can't judge them. You have to empathize with them. You have to write the antihero as if they're making their case to God for why they should be allowed into heaven. That's what I tried to do with *The Social Network*.

THE WINNING MOMENT

I've never voted for myself. I think it's a little weird, and I somehow consider it bad luck. For the life of me, I can't remember who I voted for in my category. It may have been the Coen brothers. I'm not sure. Josh Brolin and Javier Bardem were both presenting the screenplay categories. I remember hearing my name. David Seidler was sitting right behind me; I

remember turning to him and saying, "You're next." Going up there, I remember hugging David, Jesse Eisenberg, Andrew Garfield. Years later, when Javier and I had our first Zoom conversation about him playing Desi Arnaz in *Being the Ricardos*, I said, "Javier, we've actually met once before—you handed me an Academy Award."

THE SPEECH

There isn't a bigger Paddy Chayefsky fan than I am. I meant what I said about being handed the same award that was given to Paddy Chayefsky. It's the people who have won in the past, it's the lineage that you've just joined that informs the value of the Academy Award. That was a big deal for me, and I wanted to say so. I got a big reaction from my daughter. She was ten years old when I won. She

knew what I did for a living, but she wasn't old enough yet to see any of my movies. What father doesn't want to show off for their kid? It was a big dad moment. And I hope it meant something to her that she ended up being the grand finale of my acceptance speech.

THE AFTERMATH

I'm sure that a huge reason why I did win was David Fincher. I was bummed when David didn't win that night. I am crazy about *The King's Speech*, and I think that Tom Hooper did a sensational job. So for a couple of hours after the ceremony that night, I felt a little like I'd won half an Oscar because David didn't win. I got over that, though, sometime during the *Vanity Fair* party. When I finally got home, David had sent me a copy of his acceptance speech—what he was going to say had he won. I'll tell you what the opening line was, which I loved. It was "Well, we finally answered the question: Apples or oranges."

THE CELEBRATION

I'm not a big party guy. Most people outside of the sober world assume, and I understand why, that you're most vulnerable when things are going badly—when a relationship ends or your movie tanks, something like that. But with most people I know, including myself, it's the opposite. You don't know how to celebrate anymore once you've been an addict, so you're most vulnerable in moments like that. What you do is just make sure you're always with people, and you protect yourself that way.

One of the nice things that comes with winning an award is that wherever you're standing, that's where the party is. By the next day, you're thinking, *Well, one Oscar is good, but I should really win two.* So you get to be happy for roughly twenty-four hours.

THE PERSPECTIVE

Winning an Oscar lives up to the hype. It feels exactly the way you'd think it does, and it still feels great today. It hasn't worn off. I'm very grateful for it. I really am. I understand the instinct on the part of a lot of people to say that it's not a big deal. Humility is good. Except it is a big deal. You remember that great moment in *Broadcast News* when Bill Hurt says to Albert Brooks, "What do you do when your real life exceeds your dreams?" and Albert Brooks says, "Keep it to yourself"? That's what I've had to do.

WHERE OSCAR LIVES NOW

My office is at Warner Bros. The Oscar is on a shelf with a picture of me accepting it. I've never liked any picture of me, ever, and this happens to be one that I like. It doesn't have its own box with a light shining on it and a choir, but it's there.

MERYL STREEP
BEST ACTRESS
Sophie's Choice
1983

**"I feel like I owe them this because everything
that I had, I got from looking in their eyes and
for the great love they gave me for five months:
I thank Kevin Kline and Peter MacNicol."**

Meryl Streep was already an Academy Award winner (for 1979's *Kramer vs. Kramer*) when she earned her fourth nomination in 1983. But her shattering and technically astounding performance as a grieving Polish mother in *Sophie's Choice* resulted in her first Oscar win in the Best Actress category. Visibly pregnant with her daughter Mamie Gummer, Streep accepted the trophy in a gold-beaded caftan and delivered a lovely tribute to her two costars from the film. Twenty-nine years later, she would win a third Oscar (also in the Best Actress category) for her definitive portrayal of Margaret Thatcher in *The Iron Lady*. Streep is far and away the most nominated actor in the history of the Academy Awards, with twenty-one nominations to date.

THE BACKSTORY

When I was studying to be an actor, I imagined a life in the theater, so I didn't think about the movies. In fact, when I was just out of college, I was broke and went to audition for a commercial, and I was rejected because I wasn't pretty enough. They tell you things like that: "We want someone not so—" with a smaller nose, basically, is what they said. So, yeah, I never imagined I would be in the movies. The movie stars were, like, Marilyn Monroe and people that were gorgeous. So I wasn't thinking about movies. I thought about the Oscars once in a while—I remember Grace Kelly's dress, seeing the picture of that. But I don't think we watched it at home.

Streep with costars Peter MacNicol and Kevin Kline on the set of *Sophie's Choice*

THE PRODUCTION

My agent at the time, Sam Cohn, got me an audition. He said, "But they're not interested in Americans for this part." Liv Ullman was one of the people that was mentioned, and some Eastern European actresses. I think that [director] Alan Pakula took the meeting as a favor to Sam, just a courtesy thing. I did have an idea for how she might carry herself, because I had a friend at the Yale School of Drama, Elzbieta Czyzewska, who was a Polish actress who had been in some Andrzej Wajda movies. I remember I sort of was fas-

cinated by the way that she spoke English, and so I had already had that in my head. I went in and I auditioned. I remember I did go down on my knees as the character because it was the scene where she was asking the German to let her child go. And Alan said to Sam Cohn, "You've thrown a monkey wrench in my plans." When I got the part, I studied Polish and German and tried to do an approximation of a version of a woman speaking German with a Polish accent. But Elzbieta's intonations and the coloration of her language did influence me a great deal.

THE LOOK

In those days, people didn't have stylists and designers and all that stuff. I went to Saks a couple of weeks before, and I was fat—I was five months, six months pregnant, maybe more. And nothing fit. I went down to the basement to the sales rack, and they had some kind of Indian beaded sequined dresses. And I tried one. It was nice, and it fit over me, but because my belly stuck out, it was too short in the front. But it had a little train, so I wore the dress backwards and the train went over my belly. I thought I was so smart. So you'll notice in the pictures that I'm wearing the dress backwards.

THE AWKWARD MOMENT

Jessica Lange had won for Best Supporting Actress. My husband and I were sitting in front of James Mason and his wife, and when they announced, "the Best Actress nominations are . . ." I heard him say to his wife, "Wouldn't it be great if Jessica won for both?" I wanted to turn around and say, "Once is enough for a night." There's always somebody to take you down a peg.

THE WINNING MOMENT

It's a very weird feeling—that feeling of getting up in front of everyone and a vast audience of people on television. It was unnerving but thrilling. When I got up on the stage to speak, I tripped over the dress and dropped my speech and presented the rear end of me, which was substantial at that point, to the audience. That was nice.

THE SPEECH

It was such an amazing experience shooting that film. It meant so much to me. It was Peter and Kevin and Alan. We were just this little unit of mutual understanding. I loved Alan so much, and the cast was so wonderful, and the crew. We were mutually dependent on each other to tell the story emotionally and with some degree of feeling and truth. I just loved working with them. So I did say everybody's name—except for the producer. I just forgot. I was out of my mind and very excited. The guy paid for [the movie]. When we were all standing at the curb waiting for our cars, everybody was coming up and saying congratulations. I was so happy. And this producer came up and said, "Thanks a lot, and fuck you." I didn't realize how important it is to get every single person, especially the person who pays for it.

THE CELEBRATION

We didn't know there were afterparties, so [my husband and I] went to the main one, the Governors thing. And then my feet hurt, and we went home, back to the hotel. It's like Carrie Fisher said: "The saddest words in the English language: What party?"

THE PERSPECTIVE

It meant a lot to me because I was really proud of the work that we all did. And I wanted to recognize that it was all of us that did it. I won the thing, but I was really nowhere without everybody else's work. We're singled out in a way to help market a movie. But everybody who's ever made one knows that you're all holding hands. I completely recognize how fortunate I've been, how many chances I've had. My singularity feels like an anomaly of the time in which I came up. Now there are so many other performances and pieces that we have access to.

WHERE THE OSCARS LIVE NOW

They are in an undisclosed location where I am part of the year and part of the year I'm not there. They are in a room on a high shelf where none of the grandchildren can reach them to murder each other.

ACKNOWLEDGMENTS

Putting this book together was a feat of organization that required assistance and support from so many people. First, I'm grateful to everyone at Turner Classic Movies, especially Pola Changnon, Genevieve McGillicuddy, John Malahy, John Renaud, and Heather Margolis, for their encouragement and support. The wonderful TCM staffers Angela Carone and Yacov Freedman were both invaluable in offering me the technical help I so sorely needed. And photo editor Eileen Flanagan helped this first-time author comb through troves of archival photos. I also wouldn't have been able to do it without the help of the TCM talent team past and present—Susana Zepeda, Missy Birns-Halperin, Susan Biesack, Dori Stegman, Liz Winter Alvarado, and Nicole Hill—for their help in tracking down some of the harder-to-track-down interview subjects. My attorney, Jeffrey Bernstein, dealt with all the minutia that would have made my head explode. At Running Press, my editor, Cindy Sipala, was a kind and level-headed presence from start to finish.

Big thanks to my pal Chris Isaak for giving me the kick in the pants that I needed to take on this daunting project in the first place. Chris, it's now your turn. And I'll be eternally grateful to Elton John and Nicole Kidman, who were two of the first Oscar winners to agree to take part in this book. Being able to drop their names to other potential interviewees gave the endeavor instant credibility.

Thanks to my parents, Tom and MJ Karger, for their unflagging support of this project and my entire career for almost thirty years now. And most of all, to my partner, Terry Clark, for cheerleading me through this entire process and even personally transcribing one particularly chatty interview. I couldn't have done this without you.

PHOTO CREDITS

INDEX